Learning to look at paintings

art. crit.

Learning to Look at Paintings is an accessible guide to the study and appraisal of paintings, drawings and prints. Mary Acton shows how you can learn to look at and understand an image by analysing how it works, what its pictorial elements are and how they relate to each other. She describes the ingredients of composition, space, form, tone and colour which make up a picture, and discusses the importance of subject matter and the original function and setting of a picture in appreciating its visual meanings.

Mary Acton discusses work by a wide range of Western European and American artists, from the fifteenth century to the present day. The book is illustrated with over ninety images by artists ranging from Rembrandt, Van Gogh and Botticelli to Picasso, Matisse and Rothko. It also includes a glossary of critical and technical terms used in art history.

Mary Acton is a tutor and director of the Undergraduate Certificate in History of Art at Oxford University's Department of Continuing Education. *Learning to Look at Paintings* is based on her experience over many years as an art historian and teacher.

Learning to look at paintings

Mary Acton

London and New York

First published 1997
by Routledge
11 New Fetter Lane, London EC4P 4EE

Simultaneously published in the USA and Canada
by Routledge
29 West 35th Street, New York, NY 10001

Reprinted 1999

© 1997 Mary Acton

Typeset in Galliard and Gill by
Keystroke, Jacaranda Lodge, Wolverhampton

Printed and bound in Great Britain by
Butler and Tanner Ltd, Frome and London

British Library Cataloguing in Publication Data
A catalogue record for this book is available from the British Library

Library of Congress Cataloging in Publication Data
A catalogue record for this book has been requested

ISBN 0–415–14889–8 (hbk)
 0–415–14890–1 (pbk)

Grateful thanks to all the galleries, museums and collectors for their
assistance.

"I enjoy the art of all sorts here immensely; but I suppose if I could pick my enjoyment to pieces I should find it made up of many different threads. There is something in . . . having an idea of the process".

Will Ladislaw to Dorothea Casaubon from *Middlemarch* by George Eliot chapter 21, pp. 238–239. Penguin English Library edited by W.J. Harvey. Penguin Books.

To my husband John and our two sons
Harry and Tim

Contents

Figures

Plates

BLACK AND WHITE PLATES

Artist, title, date, medium and collections are given with measurements wherever possible.

COLOUR PLATES

Artist, title, date, medium and collections are given with measurements whenever possible
Note: all colour plates appear in a plate section between pp. 114–15.

1 J.M.W. Turner, *Interior at Petworth*, 1830–7. Oil on canvas, 35¾ × 48 in. Trustees of the Tate Gallery, London.

2 Peter Paul Rubens, *The Rainbow Landscape*, 1636. Oil on panel, 136.5 × 236.5 cm. Reproduced by permission of the Trustees of the Wallace Collection, London.

3 Claude Lorraine, *Ascanius Shooting the Stag of Sylvia*, 1682. Oil on canvas, 120 × 150 cm. Ashmolean Museum, Oxford.

4 Paul Cézanne, *Still Life with Apples and Oranges*, c. 1895–1900. Oil on canvas, 74 × 93 cm. Musée D'Orsay, Paris. © Photo RMN.

5 Titian, *Portrait of a Man* (sometimes called *The Man with a Sleeve*), c. 1512. Oil on canvas, 81.2 × 66.3 cm. Reproduced by courtesy of the Trustess, The National Gallery, London.

6 Georges-Pierre Seurat, *Bathers at Asnières* (*Une Baignade, Asnières*), 1884. Oil on canvas, 200 × 300 cm. Reproduced by courtesy of the Trustees, The National Gallery, London.

7 Henri Matisse, *Portrait with a Green Stripe*, 1905. Oil on canvas, 40 × 32 cm. Royal Museum of Fine Arts, Copenhagen (Rump Collection). © Succession H. Matisse/DACS, 1997.

8 Reproduction of a Colour Wheel Diagram. © Oxford University Press, reprinted from *The Oxford Companion to Art* edited by Harold Osborne (1970).

9 Jean-Auguste-Dominique Ingres, *Odalisque and Slave*, 1842. Oil on canvas, 76 × 105.4 cm. Walters Art Gallery, Baltimore.

10 Eugène Delacroix, *The Women of Algiers in their Apartment*, 1834. Oil on canvas, 70⅞ × 90⅛ in. The Louvre, Paris. © Photo RMN.

11 Pierre Bonnard, *The Riviera*, c. 1923. Oil on canvas, 79 × 76 cm. The Phillips Collection, Washington, DC. © ADAGP/SPADEM, Paris and DACS, London, 1997.

12 Vincent Van Gogh, *Bedroom at Arles*, 1888. Oil on canvas, 57.5 × 74 cm. Musée D'Orsay, Paris. © Photo RMN.

13 Vincent Van Gogh, *The Sick-ward of the Hospital at Arles*, 1889. Oil on canvas, 29⅛ × 36¼ in. Oskar Reinhart Collection, Winterthur.

14 Paul Gauguin, *Nevermore*, 1897. Oil on canvas, 60 × 116 cm. Courtauld Institute Galleries, London.

Preface

The title of this book uses the word 'learning' because the visual analysis of works of art requires a sensibility which has to be allowed to grow and develop. For most people it is an acquired skill which cannot be grasped immediately; it can be gained through practice and by returning to look again and again. For many years I have been teaching adults, as well as undergraduates, art students and those on 'A' level courses. Whether they are studying for a qualification or not, these are all people with an established interest in the visual arts. I am consistently asked questions about looking at pictures and how to do it in a more analytical way. I have found that there does not seem to be a book which caters for those with some experience.

When I first started teaching I worked in several art schools, where I learned about what goes on in the artist's studio. I discovered that both staff and students were more concerned with the process of how a work of art is created rather than with its historical and cultural background. They wanted to know why a picture looked as it did, how it was done and what the artist was interested in when he or she made it. This added another dimension to my original training as an art historian. More recently, I have spent time learning to draw, paint and make prints myself, in order to gain insight from a practical point of view. In this I have been helped by a number of artists, in particular by the late Biddy Darlow and by Janet Boulton, whose life class I still attend.

I have also been given advice and assistance by my colleagues and friends. Dr Hazel Conway, a distinguished architectural and landscape historian and the co-author of *Understanding Architecture*, was very positive about the central idea behind this book. Caroline Cannon-Brookes, a fellow lecturer in the history of art, has made

constructive suggestions about the writing and offered practical help in many ways. Others have acted as potential readers of the book, looking at the chapters as I wrote them and offering constructive criticism. In particular, I would like to single out Lyn Evans, who was one of my students and has become a good friend. Most of all I want to thank my husband John for his patience, his time, his painstaking attitude and his critical contribution stemming from his work as a designer. My thanks too must go to Barbara Pickles, who did all the original typing and to the publishers who, through my editor Rebecca Barden, have been so encouraging from the outset.

Mary Acton

Introduction

The purpose of this book is practical in the sense that it is about opening windows on some ways of analysing what you see in pictures. I have been encouraged to write it by my students, who say they cannot find out enough about this from the history books they read on art. So, the content here is based largely on my own experience gained over many years of looking, learning, teaching and trying to practise my own drawing and painting. I have tried to involve the spectator/reader rather as one would if one was standing in front of a picture in a gallery and enjoying a conversation about what one is looking at. The interaction between one person and another can be very enlightening in these circumstances, because each one of us sees slightly differently.

There is always bound to be a degree of subjectivity about an endeavour of this kind because of the individual experience one brings to a picture and also one's personal likes and dislikes. This is even more true nowadays, because of the way we are continually bombarded by visual images through advertising, photography, television and the cinema. The way we constantly see reproductions of works of art, often taken completely out of context, on boxes of chocolates, calendars and posters, can make objectivity even more difficult to achieve. So, maintaining contact as often as possible with original paintings is very important, because photographs, however good, can never be the same.

When you are confronted with a picture in a gallery or museum you may be able to see and feel many of its characteristics, but you might not have the vocabulary with which to say precisely what they are. Putting our visual experience of a painting into words and using what can be called a 'language of looking' is important for our understanding of pictorial or abstract qualities which are not talked

about very much outside the artist's studio. These are essentially those elements which the artist has to consider in order to make a painting. Composition, space, form, tone and colour are the basic ingredients which the artist can use and blend into a completed whole. Then there are other considerations like subject-matter, the technique, who the work is done for, its purpose or message and the period to which it belongs. Essentially, a picture is an integrated object in which all these elements are related to form a unity. The question of relationships within a picture is significant because it often concerns items which we would not perceive as connected in the outside world; but in a picture they can be unified by tone and colour, they can be made to feel more or less three-dimensional by the use of form and space, and they can be set in a satisfying arrangement through the control of composition and design.

All the paintings in this book exhibit these characteristics of integration, but they do not necessarily mean that a picture is harmonious in the sense that everything is balanced equally; rather that it is visually satisfying. An illustration of this would be the different compositional solutions presented by Vermeer and Géricault in the first chapter. One is passive and the other active, but they both have unity and a dynamic tension between the different parts of their pictorial organisation. Sometimes it is thought that this is achieved in a flurry of emotion or entirely by intuition and does not require any further consideration. This can be the case with a sketch but not with a more complex work of art. More often, it is the result of long gestation, preparation and alteration involving drawings, studies and development of ideas, during which a picture evolves and grows towards it final resolution. In the end, it may be so well put together that it does not seem possible to take it apart in an analytical way. Some people think you should not attempt such analysis at all, because in the process you will destroy your feeling for the whole. But it is my view that you can enhance your appreciation of a work of art by analysing it methodically.

The qualities you need to analyse are not only visual. A picture often requires setting in a historical context in order that its meaning may become clearer, because what you see in a gallery is often not as the artist intended the picture to be. It might have been part of an altarpiece in a church with lots of different panels or it might have been designed to hang in a specific position as part of a scheme of decoration in a room. It might no longer be in its original frame or it could have been restored or added to in some way which has

altered its original appearance. The spectator's relationship to the picture matters, too, in terms of its size, scale and position and where the artist thought the spectator should stand.

Awareness of the period, context and present state of the picture is important and so is the content or what art historians call the 'iconography'. You can say that this may be of no significance to us today, but the fact is that it may have been crucial to the artist and/or the patron. More often than not, new insights may be added to a subject as a result of the artist's interpretation of it. This could apply equally to narrative paintings, landscapes, portraits, still life or any other genre. Meaning of this kind in relation to a painting is very important, not only in terms of what it depicts but in the way it works in abstract terms. The pictorial elements in a good picture will have been used to enhance the subject. Everything about a picture needs to be understood as far as possible in order for us to make the closest and most accurate contact with it that we can. Some pictures are more complex and many-layered than others. Sometimes it is thought that painting of the twentieth century is more difficult to understand than that of the past. This is often because, superficially, in traditional work the subject is recognisable, but when you discover more about the underlying meaning the complexities can turn out to be greater than those of our own time.

It will be clear from this résumé of the main theme of the book that it will be about looking. It will not be concerned with theories of aesthetics or perception, the development of style or cultural history. Chronology will not be emphasised although in each chapter the pictures will be discussed in a roughly chronological order, so there will be some historical material underlying the text. If there is any chronology, it will have more to do with continuity in relation to artistic preoccupations over the centuries, such as the use of colour, for instance. The examples I have chosen to examine come from Western European art from the early fifteenth century to the present day with some from American art of the twentieth century. The definition of a picture has been taken to include oil paintings, murals, frescos, ceiling decorations, sketches and watercolours. Some of the more recent works will not even be paintings in this broad sense, because much of what has been done in the later twentieth century has moved away from traditional types of art into the creation, for instance, of installations or soft sculpture. There is also a chapter on drawings and one on prints, both seen as part of the general process of picture making. So, a wide variety of techniques

has been included in order to see the different effects they make. The work of some artists, like Rembrandt, Goya, Seurat and Degas, will appear in more than one context. This has been done deliberately to demonstrate that a single artist's work can be looked at from several points of view.

All the pictures chosen can be called good or great, in the sense that they are universally recognised. For the most part they hang in public galleries where there is easy access for us to look at them over and over again. My choices are selective but varied in order to try and stimulate different kinds of looking and to avoid repetition, boredom or visual fatigue; but they aim to demonstrate most clearly the points which are being promulgated. I decided to examine one picture at a time in order to provide focus, otherwise there is a danger of becoming too generalised and losing the kind of concentration required for analytical looking. So, each example is paradigmatic and is used to explore an aspect of visual analysis which can then be taken and tried out on other pictures. The headings are designed to help direct the reader's attention to what is being looked at. All the chapters begin with a general Introduction and end with a Conclusion in order to provide a context for this concentrated examination of individual works. Sometimes there are references to colour when the relevant reproduction is in black and white. This information has been included to give a fuller idea of the picture, although colour may not be strictly necessary for the particular pictorial aspect under discussion. In the Appendices at the end of the book I have devised a number of questions which one can ask oneself in order to help with this, together with a glossary of common art terms.

The English artist William Hogarth described painting as 'a wanton kind of chase' or a puzzle which needs to be pursued and solved. But there are no right or wrong answers here, because the experience of looking at pictures changes and develops the more one does it. Pictures set up resonances and provide layers of meaning so they can continue to be exciting even when they are familiar. This book is not intended as a package of instructions but rather as a series of suggestions which the reader/spectator can explore in any way he or she chooses. By making a voyage of discovery like this we can bring paintings alive for ourselves and make the process of learning about art more inspirational and illuminating.

Composition

INTRODUCTION

Composition is the artist's method of organising a subject, of deciding what to put in and what to leave out in order to make an effective picture. Whatever process the artist uses to achieve his or her design, it must be arranged to establish the main lines of direction. These are not lines in the literal sense, but a way of relating different parts of the composition together so that it forms a coherent whole. Much of the time this is done, not by measurement but by fine judgement with the eye to get the picture to 'look right'. And, because it concerns the overall conception of the picture, the composition can often tell us a lot about what the artist is trying to communicate.

In the course of arriving at a decision about exactly what to paint, a great deal of preparatory work will have been done, such as drawings and/or painted sketches. But most importantly, before starting to make a picture, the artist must consider the material. One traditional way of doing this is to make a fairly detailed drawing, which can then be covered with a grid of squares so that the exact position of each part of the composition can be worked out. A freer, more improvisatory way is to make a charcoal drawing on the final canvas, which can then be covered as it is painted.

Another very important consideration for the artist is the size of the picture. The scale of a painting, and particularly the composition, as this concerns the whole arrangement, can greatly influence the way one looks at it. If it is large, you need to stand back and allow your eyes to range over it in a broad and sweeping way. But, if it is small, you need to look into it more carefully, and sometimes a picture can convey scale even though it itself is not very big.

Therefore, the artist would take considerable care in deciding the size of the picture according to the meaning he or she wants to convey.

In seeking to understand how a painting works visually, we must first and foremost consider some different types of composition, because this would be the artist's own starting-point. The headings I have chosen do not represent all possibilities, merely some of the most obvious ones to look for. Examples have been selected from a variety of periods so as to give as wide a range as possible.

HORIZONTALS AND VERTICALS

Plate 1 *The Baptism of Christ* **by Piero della Francesca, *c*. 1440s**

In his picture of *The Baptism of Christ*, Piero has chosen to show the moment at which St John the Baptist poured the holy water on Christ's head. The picture was originally the central panel in a three-panel altarpiece called a triptych. It radiates a feeling of stability and peace combined with spiritual tension and mystery. If we start to ask how this is achieved, we find it is due in large part to the composition, which is based on vertical and horizontal lines of direction.

The vertical lines run:

1 through the tree and the central one of the group of three figures on the far left,
2 through the foliage and trunk of the tree in the foreground on the left,
3 through the foliage, the dove and figure of Christ in the centre,
4 through the figure of St John the Baptist,
5 through the clouds, the foliage and the figures and their reflections on the far right.

The horizontal lines run:

1 from right to left through the clouds, the dove's wings and the foliage and even out to the horizontal insets of the edges of the panel on either side,
2 through the hands of the figures on the left, the top of Christ's loin-cloth, the hand of St John the Baptist and the waistline of the figure undressing on the far right,
3 from the bottom of Christ's loin-cloth to the hem of St John the Baptist's tunic and the edge of the stream in the background on

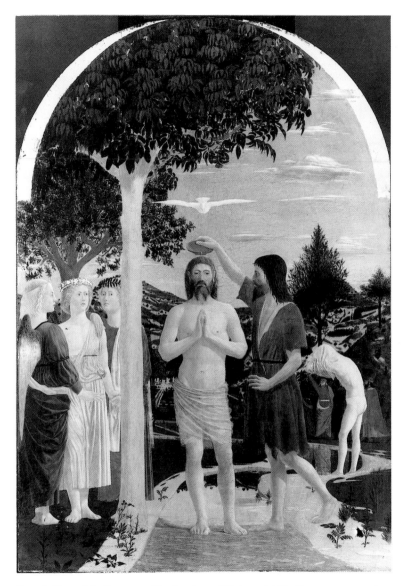

Plate 1 Piero della Francesca, *The Baptism of Christ*, c. 1440s. Tempera on poplar panel, 167 × 116 cm. National Gallery London.

the right, and to the left the same line is picked up by the edge
of the angel's pink scarf, the bended knee of her neighbour and
the shadows in the blue part of the angel's costume on the far
left,

4 near the middle of the composition from between Christ's feet
and the base of the tree and also from the tops of the heads of
Christ and St John, and between the raised hand of St John and
the clouds to the right.

This essentially geometrical arrangement is enhanced by the use of
a proportion known as the Golden Section. It was recorded by the
classical Greek mathematician Euclid in *The Elements of Mathematics*
(Book 6, Proposition 3). Piero himself was a mathematician. Towards
the end of his life he published his theories on perspective and optics
in *De Prospectiva Pingendi* (*c.* 1480–90). He was probably friendly
with great figures of the period like the architect and theorist Leon
Battista Alberti and the mathematician Luca Pacioli. Pacioli regarded
the Golden Section as a divine proportion with mystical properties.
It is a proportion whose regularity occurs, not in its measurement
into equal parts, like a half, quarter or a third, but in the fact that the
relationship of the small part to the large part is the same as that of
the large part to the whole. The actual calculation of the Golden
Section is complex, but in everyday language it is often referred to
roughly as the relation of five-eighths to three-eighths. It can be seen
in many pictures in the history of Western painting and Piero uses it
clearly here in *The Baptism of Christ*:

1 vertically, down through the tree in the left foreground,
2 horizontally, through the wings of the dove and the clouds in the
upper part of the picture. (This line corresponds with the shape
and proportions of the two pieces of poplar from which the panel
was made.)

The underlying geometrical structure of Piero's composition is a
great deal more elaborate than has been indicated here. Marilyn
Aronberg Lavin and B.A.R. Carter have worked it out in detail (see
Lavin, *Piero della Francesca*: 29), but it is difficult to see when you
are looking at the picture in a gallery. Also, all these mathematical
qualities could become very rigid and monotonous were it not for
a number of curves which create movement and variety for the eye:

1 the bend in the river as it swings into the background,
2 the curved folds in Christ's loin-cloth which are echoed in the

placing of the hands of the onlookers and the left hand of St John the Baptist,

3 the pattern created by the feet on the ground moving from left to right. They are all on the same level, but in the way they recede and come forward they also create a wavy line, as do the hills in the background.

But perhaps the most fascinating aspect of the composition of this picture lies in something even more surprising, and this is the fact that many of the vertical and horizontal lines of direction are not actually straight or continuous:

1 the line of the main tree trunk in the left foreground is relieved by the shape of the angel's arm and wing appearing to the right of it,

2 the line from the dove's beak to the stream of water being poured on Christ's head, and the continuation of it through Christ's body is deflected because he is not standing squarely on the ground – in fact, all the weight is on his right foot, almost as though he was walking forwards,

3 St John the Baptist, although apparently vertical, also has unequal weight distribution, as does the figure undressing in the background.

All of this suggests that the making of a composition, just like the other elements of a picture, is not a mechanical but a visual process. Of course, as we have seen, there is very careful and even rigorous organisation in Piero's picture, but the creation of visual relief through curves and subtle irregularities is just as important. This combination of measurement and controlled invention is what gives the image its profound feeling of peace combined with tension, exactly reflecting the point in the story which Piero has chosen to depict.

HARMONY AND BALANCE

Plate 2 *Young Woman in Blue Reading a Letter* by Johannes Vermeer, *c.* 1660s

Vermeer's young woman is caught at the moment of reading a letter in a domestic setting. Through the careful arrangement of his model and the other objects in the room, the artist has made this ordinary

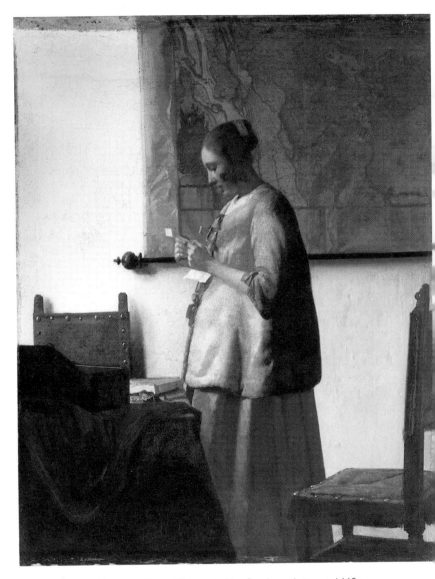

Plate 2 Johannes Vermeer, *Young Woman in Blue Reading a Letter*, c. 1660s. Oil on canvas, 18¼ × 15½ in. Rijksmuseum, Amsterdam

event into a timeless picture of absorbed concentration. Like Piero's painting of the Baptism, this picture is based on strictly horizontal and vertical lines of direction, and we can see the use of the Golden Section at the side of the map and in the shadow of the chair on the left. But Vermeer goes further than Piero in his use of light to hold every aspect of the composition in balance and harmony. This is achieved by subtle tonal contrast moving between dark and light areas and then through a whole range of middle tones.

The darkest parts are:

1 the box and drapery in the left foreground,
2 the dark side of the chair in the right foreground,
3 the two uprights on the back of the chair on the left,
4 the frame running along the bottom of the map,
5 the shadow on the back of the girl's smock,
6 the dark areas in the girl's hair.

The lightest parts are:

1 the sections of off-white wall in the background,
2 the collar of the girl's smock,
3 the top and bottom of the letter,
4 the highlights on the knuckles of the girl's hands,
5 the side of the book on the table.

In between these strong contrasts are the middle tones:

1 the map on the wall,
2 the girl's face and arms,
3 the girl's coat and skirt,
4 the back of one chair and the seat of the other.

In the original painting this tonal arrangement is greatly added to by the use of very restricted colour based on the complementary vibrancy between blue and gold; complementary colours are those which enhance one another when juxtaposed. Although the scientific principles of this were not understood until the nineteenth century, the visual effects were known as far back as the sixteenth century, particularly by Venetian painters such as Titian and Veronese (see Chapter 5). Technically, the complementary of blue is orange, but the range which can be used varies from, say, turquoise through to violet, and from nearly red through to gold like the one that Vermeer is using here. Even the flesh tones have taken on a golden tint, and the white wall is tinged with blue and gold as well.

All of this might just be too rigidly balanced, so Vermeer has deliberately introduced irregularities. This is particularly true of the areas where the wall is revealed to the right and left of the figure, and of the dark shape on the left in the foreground. We have noticed the use of blue and gold, but the objects in those colours vary in size; if they were equal, the composition would be boring. Now, when looking more carefully at the layout of the whole picture, we can see that almost every line is broken and every shape interfered with. This is particularly evident at the edges, where our view of the chair on the right and the map above is cut off.

It is known that Vermeer probably used a *camera obscura* (literally meaning darkened room) to help him compose his pictures. This acts just like a simplified form of modern camera except that the image is not fixed. The light from an object outside comes through a hole in the side of a closed dark box. Its image is reflected on the opposite end to the aperture. This can be made from ground glass or other translucent material so that you can see the reflection from the outside. Also, the whole apparatus can be scaled up to the size of a small room so that you can go inside and look at the image. In Figure 1, a diagram from Vermeer's time, you can see an artist using a camera obscura which provides two images which are upside down. This was rectified later on by using a strategically placed mirror to turn the image the right way up. When you look through a camera obscura the image you see is softer and less detailed than the world outside, making it easier to see the tonal variations. But it is most important as a compositional device enabling the artist to see clearly the outline arrangement of his picture, and in particular where the limits are going to be. As in a photograph, the cut-off points at the sides and top and bottom are deliberately chosen to give the feeling that this is only part of a room and so increasing the sensation of intimacy and privacy.

In and around Delft, where Vermeer worked, there was tremendous interest in all kinds of optical instruments, of which the camera obscura was one. There was a school of artists painting interiors with everyday activities going on. But when you compare Vermeer with his contemporaries (Pieter de Hooch, for example), you can see that he is head and shoulders above all of them in his ability to create atmosphere. This is often the case with the best artists – in their time they are dealing with the same set of ideas as many others, but they do a great deal more with them. Here, within an essentially irregular composition, harmony and balance are created by the careful

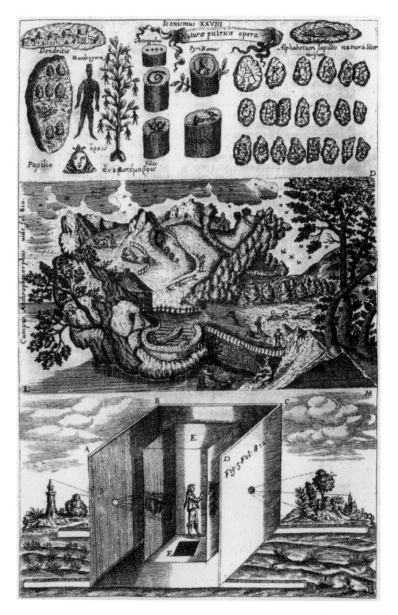

Figure 1 Camera obscura with double-walled, portable chamber; the space between the walls creates the camera obscura effect.
Source: Athanius Kircher, *Ars Magna Lucis et Umbrae* (1649), Rome (Museum Boerhaave, Leiden). Reproduced with permission.

weighing of each tone and colour. This illustrates another point very clearly: that composition is about making relationships between objects in order to make a satisfying whole. Here, nothing jars or feels out of place, and yet there is plenty of visual interest for the eye, creating a contemplative atmosphere totally appropriate to the subject of a young woman reading a letter.

RHYTHM AND THE SPACES BETWEEN OBJECTS

Plate 3 *A Young Girl Reading* by Honoré Fragonard, *c.* 1776

Another element to look for in composition is not just the organisation of the subject depicted but the way the artist has arranged the spaces in between. The interaction between the foreground and the background can set up a rhythm, which enhances the structure of the whole design. This applies to all the paintings we are looking at in this chapter, but it is especially easy to see when the background is simple, as it is in this picture by Fragonard.

The girl sits on what looks like a seat in a window embrasure. The shapes made out of the green area behind her are as much part of the arrangement as the subject herself:

1 the area between the curving line of the back of her head, neck and collar, the corner of the cushion and the straight edge of the window frame,
2 the shape made by her forearms and hands and the vertical side of the picture,
3 the section between the profile of her face and neck, the ruffles on the front of her dress and the hand holding the book,
4 the satisfying shape made by the bow on top of her head interrupting the horizontal line running between the side of the window frame and the left-hand edge of the picture.

The opposition between the curved lines in the body the L shape of the window frame and the straight edges of the picture sets up rhythms within the pose of the girl which are echoed from one part to another:

1 the ruffles on the front of her dress and the folds around the elbow of her left arm,
2 the frills around her neck and the bows on top of her head,
3 the profile of her face and the hair at the back of her head,
4 the curve of the pillow and top of her head.

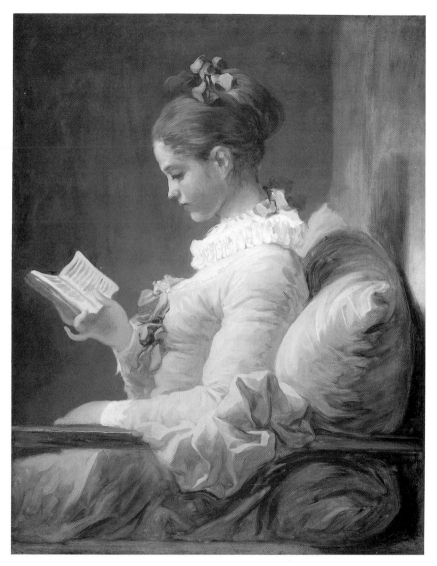

Plate 3 Honoré Fragonard, *A Young Girl Reading*, c. 1776. Oil on canvas, 81.1 × 64.8 cm. National Gallery of Art, Washington, D.C.

In the serpentine line and attitude of her body there is the graceful movement so characteristic of the Rococo style of the eighteenth century, which is aided considerably by the free and flowing brush-work. But we would not see all of this so clearly were it not for the placing of the figure in the foreground, creating shapes in the background which clarify the layout of the composition.

CURVES AND DIAGONALS

Plates 4, 5, 6 and 7 *The Charging Chasseur* and related sketches by Théodore Géricault, 1812

Géricault's painting is different from the other three pictures we have looked at so far, because it is full of movement and drama rather than stillness and tranquillity. It shows a member of Napoleon's equestrian guard riding into battle on a fiery horse and turning to his followers to signal them to charge. This sort of heroic military subject was very popular during the period of Napoleon's reign in the early nineteenth century. The composition is based on curves and diagonals rather than verticals and horizontals. The main lines of direction cross from one corner to the other, meeting at the point where the officer is seated on his horse. The sensation of motion is enhanced because the whole arrangement of horse and rider is based on the form of a figure of eight, which intersects at the point where he is sitting. Further tension is created at the same point by the pull of the horse galloping into the picture and the gesture of the arm with the sword coming out towards us.

Nearly all the lines in the picture are on a slant, making every-thing appear to shift and change as you look at it. This applies as much to the background where the battle is raging, and to the sky, as it does to the foreground. The composition is stabilised only by the vertical direction of the head and the upper part of the officer's body, which is in line with the bend in the horse's right hind leg. In reality, it would be impossible to hold this position for more than a split second, but Géricault has used this vertical to hold the dynamic design of the picture together. It is like a single frame from a frantic film sequence, a split-second observation.

The subtle complexity of this pictorial arrangement was not achieved immediately, but after a whole series of preparatory studies. There is a group of oil sketches for this picture which shows very clearly how the composition developed, and gives us

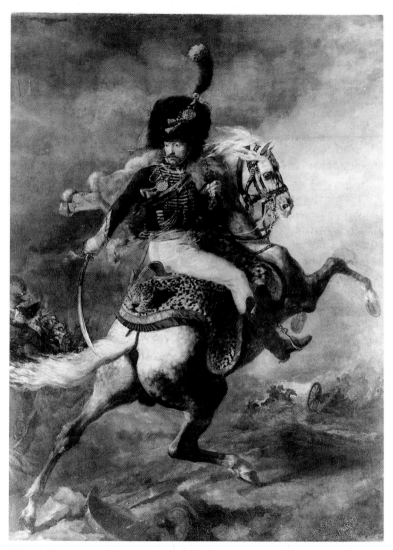

Plate 4 Théodore Géricault, *The Charging Chasseur*, 1812. Oil on canvas, 292 × 194 cm. The Louvre, Paris.

some inkling of the elaborate creative process involved. The original idea for the painting probably came from Géricault's experience of seeing a stallion rearing in a cloud of sunlit dust when out on an exercise at St Cloud. The raw energy of this is expressed in the free and fluid brushwork of *The Rearing Horse with a Tiger Skin*. Then, in subsequent reworkings, the composition changes from, in *Sketch for the Charging Chasseur* [1], a near-profile view facing left to [2] a diagonal structure moving off to the right. In this later sketch, the figure of eight is present but the angle at which it lies is shallower and the rider's position is not as upright. This makes the organisation looser and more confused.

In the finished picture, the horse is rearing more steeply and the head is higher and turning with the rider, who is more taut and vertical. Also, the front foreleg has been lowered, and the alteration Géricault made to it can still be seen, adding to the feeling of movement and spontaneity. The position of the sword is changed

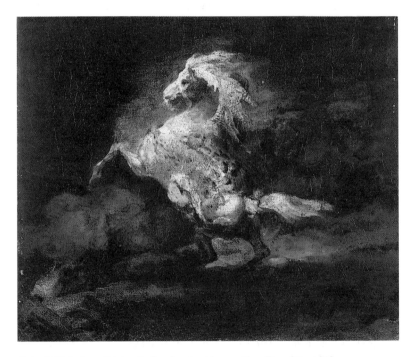

Plate 5 Théodore Géricault, *The Rearing Horse with a Tiger Skin*, 1812. Oil sketch, 45.1 × 54.6 cm. Glasgow Museum (The Burrell Collection)

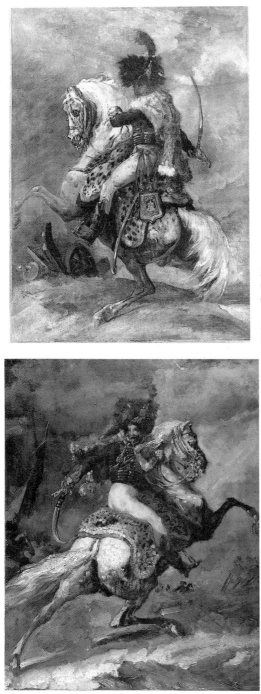

Plate 6 Théodore Géricault, *Sketch for the Charging Chasseur* [1], 1812. Oil on canvas, 52.5 × 40 cm. The Louvre, Paris.

Plate 7 Théodore Géricault, *Sketch for the Charging Chasseur* [2], 1812. Oil on canvas, 43 × 35.5 cm. Musée des Beaux-Arts, Rouen.

so that it crosses the horse's tail, thus completing a circle, which is like a coiled spring poised to explode into forward motion. The brushwork is also more varied, particularly in the contrast between the detail of the horse and rider and the more generalised treatment of the background. By tightening and controlling the composition, the effect of energy is increased and so is our excitement when we look at it. We feel what has happened, what is happening and what will happen in the next few seconds. The drama Géricault has created is the result of very careful rehearsal in the oil sketches, pushing and pulling the underlying structure until it reflects clearly the emotional atmosphere he wants to communicate.

COLOUR

Colour plate 1 *Interior at Petworth* by J.M.W. Turner, 1830–7

Turner's painting is a fairly large oil sketch done during one of his many visits to Petworth Park, the home of his congenial and sympathetic patron, Lord Egremont. Like Géricault, Turner was a Romantic painter interested in taking an emotional and imaginative approach to his subject. His picture relies on colour for its structure and organisation. It focuses our attention on the light and atmosphere in the room rather than the objects or the architectural features.

In the background is the entrance to the room which is white in the shape of an arch. It is surrounded by varying shades of orange and gold. Above it is a beige area which is the ceiling and in the foreground there are various red, yellow and orange shapes, with some bluish-green to the right. Fairly soon one realises that Turner is using warm and cool colours, in the primary and complementary range, to create the effect of light and to lay out his composition. Within the spectrum some colours are warm and have a shorter wavelength, and others are cool and have a longer one. When placed on the surface of a picture, the warm ones will tend to move forward and the cooler ones stay back. But they need not always be used on this basis; sometimes, for instance, a warm colour can be made more recessive by the addition of a cool tint, and vice versa; so the artist can manipulate colour in a wide variety of ways.

We can see this happening in Turner's picture:

1 The red areas in the foreground are warm and so stay in front.

2 The white at the back is cooler and is surrounded in the arch with greys and blues.

3 The pale yellow between these two areas is cooler than the red and warmer than the white, and so stays between the two in the middle distance.

4 To the left of the white archway there is a dark patch, looking like a niche with a statue in it, which tends to recede and hold that side of the picture back.

5 On the right of the white archway is an orange patch, which is warmer and tends to move forwards towards the red in the foreground.

6 The green in the right-hand corner at the front is cool, so it holds the warmer colours in check and stops them from coming too far forward.

From a compositional point of view, it does not matter what the objects represent, as we have a good sense of where they are in relation to one another because of their colour. However, Turner does give us some important clues about the layout of the room by painting some parts with greater definition than others. The right-hand side of the arch, the two arches on either side and the shape of the ceiling are done with some precision. Those areas are juxta-posed with others that are less easy to identify, and this creates visual variety and prevents confusion. You are then led to concentrate on the light and atmosphere without worrying about the detailed identity of objects in the room. Your eye follows the white light cascading down and breaking up into its constituent coloured parts. The use of colour, combined with the lack of all but essential detail, allows you to wander about in the room and feel the atmosphere in an imaginative rather than a literal or descriptive way.

ASYMMETRY

Plates 8 and 9 *The Orchestra at the Opera* **by Edgar Degas, 1868–9 and** *Whaling off the Goto Islands* **by Hokusai,** *c.* **1833**

Degas' picture was intended as a portrait of his friend, Monsieur Dihau, who was a bassoon player with the orchestra of the Paris Opera, and he can be seen clearly in the foreground playing his instrument. To his right is the double bass player Monsieur Gouffé and to his left the cellist and composer Pillet. Behind them are other

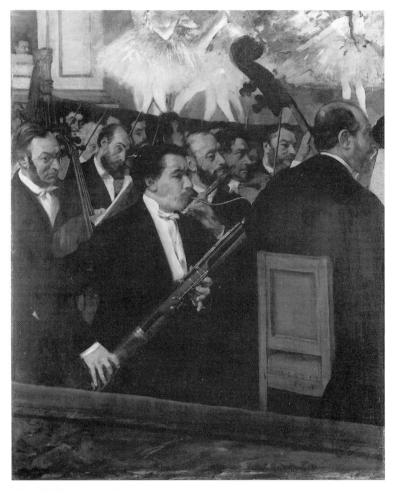

Plate 8 Edgar Degas, *The Orchestra at the Opera*, 1868–9. Oil on canvas, 56.5 × 46.2 cm. Musée D'Orsay, Paris.

members of the orchestra and in the background we can see parts of the dancers' legs and bodies on stage. Degas was a member of the Impressionist movement, which set great store by creating a sense of instantaneity and spontaneity. But, as we shall see, this composition is, in fact, very carefully constructed.

At first glance, everything appears to be asymmetrical. The most important lines of direction are the slanting ones running across near the bottom and near the top. Our viewpoint is from an angle, as if we were sitting in the orchestra stalls and looking up towards the stage. There are strong diagonals created by the top of the double bass on the right-hand side and Monsieur Dihau's bassoon running across the centre. Other diagonals are present in the rows of seated musicians running from left to right.

So, how is it that the composition does not slide off to one side or the other? First, because the horizontals and verticals of the edges of the picture act as counterbalances, particularly along the top and bottom. Then, within the painting, there are important verticals:

1 at the point where the lines made by the bassoon and the double bass would intersect at the back of Monsieur Gouffé's head,
2 in the lines on the panels in the top left-hand corner, which echo the uprights in the back of Monsieur Gouffé's chair in the bottom right foreground.

There are important horizontals, too, in the box in the top left hand corner and the square of red below the face of the man (traditionally supposed to be the composer, Chabrier) accentuates the straightness of his viewpoint.

Degas has created an asymmetrical composition which works by a series of checks and balances. In his methods he was influenced by Japanese prints and by photography. In the Japanese print by Hokusai called *Whaling off the Goto Islands*, you can see how the horizon line has been raised so that you appear to be looking at the view from below, just as you are in Degas' picture (see p. 20). But it is clear where everything is because of the overlapping simplified shapes. This is especially true of the tree, rocks and foliage in the right foreground, which can be compared with Monsieur Dihau's bassoon and Monsieur Gouffé and the double bass in the same position in Degas' picture. The exploration of different viewpoints and the cut-off composition was encouraged by photography, which Degas himself practised.

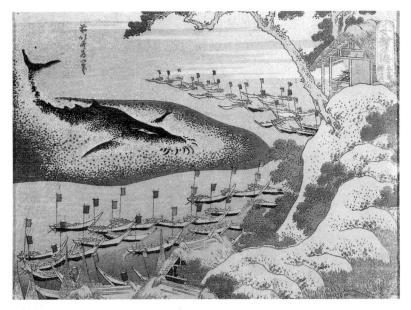

Plate 9 Hokusai, *Whaling off the Goto Islands*, *c.* 1833. Japanese woodblock print, 189 × 255 mm. The Chester Beatty Library, Dublin.

When looking at *The Orchestra at the Opera*, you, as the spectator, are made to feel that you are actually sitting in the audience or even the orchestra pit itself. The fact that your view of the stage is partially obscured adds to this effect and lends a certain ambiguity to your exact position. The movement between the diagonal and slanting lines of the composition creates the sensation of looking through a combination of moving heads, bodies and instruments which is totally appropriate to the buzz, excitement and anticipation of being in a crowded theatre.

APPARENTLY RANDOM COMPOSITION

Plate 10 *The Dialogue of Insects* by Joan Miró, 1924–5

The composition here looks completely random but in fact that is how it is very carefully designed to appear. None of the forms are recognisable as particular species, but they are all insect-like in their curved and whiskery way. The layout is not held in place by any of the means we have considered so far. Instead, the eye is encouraged

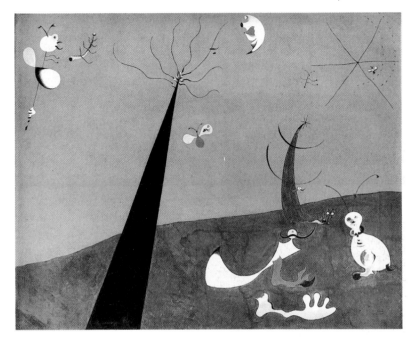

Plate 10 Joan Miró, *The Dialogue of Insects*, 1924–5. Oil on canvas, 74 × 93 cm. Berggruen Collection at The National Gallery, London.

to move all over the surface of the painting and, wherever you start looking, you are led back into the rest of the picture. So, for instance, if you begin with the yellow and black insect (which shows up as black and white in this reproduction) in the top right-hand corner, your eye is carried back by the faint black lines of the 'spider's web' to the other yellow shapes in the picture. On the other hand, if you start with the elongated black triangle in the left foreground, you could be carried to the left and right by the whiskery lines at its top.

The intense blue in the upper section of the background allows the forms upon it to float. It is complementary to the brownish-gold area in the lower half of the picture, which is painted in a more textured way, contrasting with the flatness and brightness of the blue. Although we feel this brown area represents earth and the blue the sky, this is only a suggestion. Miró was associated with Surrealism, which began in the 1920s, where expression of an interest in dreams and the unconscious mind was paramount. The whole composition is

dream-like because of its fluid organisation. However, the organic and geometrical shapes are very precisely painted and the colours are very clear. So, once you have chosen your starting-point, you feel certain about where you are going in the picture, even if you are not quite sure why. There is a dialogue, as described in the title, in the sense that the forms and colours echo one another across the surface of the picture. But the meaning is uncertain in the way that the meanings of dreams often are. You are left to decide for yourself what it is you really are looking at, and the careful randomness of the composition reflects this.

COLLAGE

Plate 11 *Retroactive II* by Robert Rauschenberg, 1964

Composition by means of collage is where found objects or photographs and bits of photographs, are arranged on a flat surface to form what is called a 'composite' image. It is a twentieth-century invention developed by Picasso and Braque in around 1912. The American artist Robert Rauschenberg uses this to great compositional effect in his pictures, called 'Combines', of which *Retroactive II* is an example. The composition is made up of a series of screen printed photographs, some of which are more instantly recognisable than others. There is the head and shoulders of President Kennedy beside an astronaut walking in space. Above them are two less distinct pictures, of the wheels of a lorry and of a woman looking in a mirror, which comes from an Old Master painting. Below, we see a hand with a pointing finger and a dial with a different sort of hand on an instrument pointing at the figure 20, presumably indicating temperature, as the photograph is labelled 'tomorrow's weather'.

These photographs form a series of flat planes arranged at different angles to one another, some tilted to right or left and some over-lapping. In addition, there are some obviously painted areas, for instance, the white around the hand and the red section in the bottom right-hand corner. The hand appears to come forward because it stands out from its white background, and the red seems to recede because it is overlapped by the black dial and by a transparent blue shadow above. Some of the edges of the photographs are brushed over and blurred and some are left sharp. The mixture between hard and soft edges, painted and photographed surfaces, and depth and flatness all helps to create variety and interest for the eye.

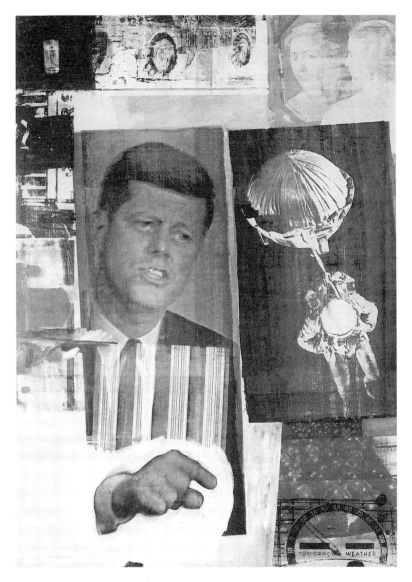

Plate 11 Robert Rauschenberg, *Retroactive II*, 1964. Collage: oil and silkscreen on canvas, 213.4 × 152.4 cm. Stefan T. Edlis Collection.

In this juxtaposition of images, there are important horizontal and vertical lines of direction, which stabilise the composition and square up with the edges of the picture. They are:

1 where the blue and white areas meet on the right at the top,
2 the change in tone of the grey and white stripes below President Kennedy's collar and tie which runs to left and right.

The whole arrangement reminds us of an advertisement hoarding. It points out the enormous influence of photography on our visual world in the form of newspapers, magazines, posters, television and film. The collage layout captures the careless coming together of disparate images so characteristic of America in particular and the twentieth-century world as a whole.

CONCLUSION

Whatever shape it takes, composition is one of the most powerful means the artist has of communicating with the spectator. It is the skeleton or backbone of the picture. The other elements then add to the total expression of the original idea and the creation of layers of meaning. To work really well, each part must interact with the other parts to create the emotional impact of the picture. It is by forming relationships between the composition and all the other elements that the artist creates a whole. In order to understand something of how this happens, we must go on and consider the other essential aspects of picture making.

Chapter 2

Space

INTRODUCTION

The effect of space in a painting is primarily the creation of the illusion of three dimensions on a flat surface. It is concerned with the width and depth, and with the interval and distance surrounding solid objects rather than their own volume. Artists use various techniques to help them achieve this, a key one being the geometrical system known as linear or single-viewpoint perspective. Diagonal lines of direction, called orthogonals, converge at what is called the vanishing point, which is most usually placed on a horizontal line about two-thirds of the way up the picture. Parallel lines are then drawn across at intervals which get smaller as they get nearer to the vanishing point. These create what are known as planes, and the surface of the picture itself is referred to as the picture plane. When objects are placed on these planes at different angles and in diminishing size, they appear to recede, and so an illusion of space is created. The front of the picture becomes like a pane of glass through which you look as if into a box (see Figure 2).

This method of organising space in painting has long been accepted as one of the most effective, because it mimics closely the way the eye sees the world in three dimensions. For this reason, it has long been associated with what can be loosely called 'realism' in painting, and with illusionism, as we shall see. The basic geometrical arrangement was originally discovered by Euclid in classical times and then formally revived by the architects Brunelleschi and Alberti during the Renaissance in fifteenth-century Italy. Alberti described it in his *Treatise on Painting*, which was published in Florence in 1436.

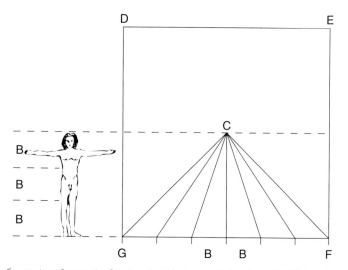

(a) *Constructions of perspective, first stage: parallels drawn to the 'centric point'* DEFG: boundary of the picture or 'window'. B: *braccio* divisions corresponding on the scale of the picture to one-third of a man's height. C: 'centric point'. *Braccio* divisions along FG are joined to C.

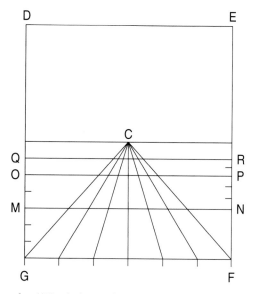

(b) *Incorrect way of establishing the horizontals*
GM = 3 units, and MO = 2 units; NP = 3 new units, and PR = 2 new units; and so on, successively.

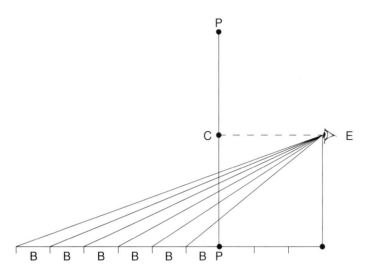

(c) *Construction of perspective, second stage; determination of the horizontal divisions on the intersection.*
B: *braccio* divisions on the 'pavement'. PP: intersection or picture plane. C: 'centric point'. E: eye, three braccia from thje intersection. The viewing distance, EC, is equivalent to half the width of the picture and the viewing angle is 90° (i.e. the shortest reasonable distance before serious distortions start to occur).

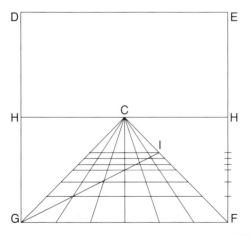

(d) *Construction of perspective, third stage: completion of the squared 'pavement'* DEFG: picture. C: 'centric point'. HH: horizon. The intervals on the intersection PP in Fig. 10 are transferred to HF (or HG), and the successive horizontals of the 'pavement' are drawn at corresponding levels. GI: diagonal through the squares, drawn as proof of the accuracy of the construction.

Figure 2 Single-viewpoint perspective system
Source: Leon Battista Alberti, *Treatise on Painting*, ed. Martin Kemp (Penguin, 1991). Reproduced with permission.

Another related technique, that of aerial perspective, was developed later in the same century by Leonardo da Vinci. Here, cool, recessive colours, like blues, greys and greens, are used in the backgrounds of paintings to increase the effect of distance. It was also discovered that a feeling of space can be enhanced if the larger objects in the foreground are painted in greater detail and the smaller ones in the background are made more blurred. Tonal variations can also help, by making the foregrounds or backgrounds of pictures darker or lighter in relation to one another.

In the nineteenth and early twentieth centuries there was an increased interest in the relationship between foreground and background, and in space that is more closely connected with the surface of the picture. Spatial distortion, multiple-viewpoint perspective and colour were used to create space. Also, there was exploration of the spatial possibilities of the area in front of the picture plane rather than behind it. In the work of Cézanne and Picasso, for instance, the space is demonstrated by the way that the angles of objects and the direction of their planes relate to one another, rather than to an overall geometrical structure, as in linear perspective. For this reason, they were able to incorporate many viewpoints at the same time and to delineate the space on the surface of the picture with little or no strictly perspectival recession.

Whilst the space in the picture itself is important, so also is the spectator's relationship to it. In single-viewpoint perspective, as the name implies, the spectator is expected to see from one angle only, although this can be from above or below, as well as on the same level. Sometimes, as mentioned above, artists employ multiple-viewpoint perspective, where one is made to see from several angles at once, and sometimes the space is between the spectator and the surface of the painting, rather than behind the picture plane. And sometimes, as in illusionistic ceiling decorations, for instance, the spectator no longer quite knows where the dividing line is between real or artificially created space.

Pictorial space, as it can be called, will vary, like everything else in painting, according to the artist's individual way of seeing. In this chapter, examples have been chosen from a variety of periods in which different types of spatial interpretation seem to be a dominant feature.

LINEAR PERSPECTIVE

Plate 12 *The Battle of San Romano* by Paolo Uccello, *c.* 1450s

Uccello is reputed to have been so preoccupied with linear perspective that he would sit up all night studying vanishing points. His picture is a clear example of this method of creating the illusion of space. The vanishing point lies in the centre of the painting behind the right-hand side of the top of the head of the white horse. It was probably originally intended, along with two other pictures, to decorate the walls of a room in the Medici Palace in Florence. For this reason, the spectator's position is in the middle of the picture, but slightly below eye level, and the landscape rises behind, closing off our view of the horizon.

There are many aspects of this picture which direct the eye to the vanishing point:

1 the diagonals through the clusters of horses and figures from the bottom corners of the picture,
2 the long pale slanting line of the lance on the right,
3 the angle of the armoured hand of the captain on the white horse, Niccolò da Tolentino,
4 the sloping angles of the hedge immediately behind the fore-ground figures in the middle distance,
5 the placing of the weapons on the ground, with the middle ones straight, and the others to left and right pointing towards the centre.

In addition, the position of the receding planes is carefully described by:

1 the horizontal angles of some of the weapons on the ground,
2 the overlapping shapes of horses and figures to the right and left,
3 the small scale of the figures in the fields in the background,
4 the angles of the helmet, shield and breastplate on the ground in the centre.

The tonal contrast is also important in helping the onlooker to see the spatial arrangement clearly, as shown by:

1 the white horse in the centre, which stands out against the dark figures and hedge behind, and the almost black forelegs of the horse in the left foreground,
2 the ground on which the protagonists are standing, which is pale,

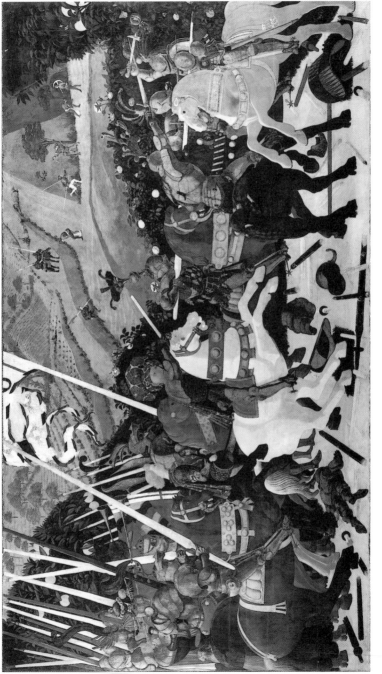

Plate 12 Paolo Uccello, *The Battle of San Romano*, c. 1450s. Egg tempera with some oil on poplar panel, 182 × 320 cm. The National Gallery, London

and the weapons and armour, which are dark are important for directing the eye.

Another skill with perspective that Uccello shows us is that of foreshortening, which is most obvious in the armoured figure lying on the ground to the left. He appears as one would see him, with his back and head shorter than they really would be; but his feet should be bigger in proportion to his body than Uccello makes them because they are nearer to the eye. This reveals something very interesting about this picture: that it is more about the geometrical organisation of space than about the realism of the subject it is depicting. The horses and riders and paraphernalia of war all appear like cardboard cut-outs arranged as if they were pieces in a jigsaw puzzle. The vitality, excitement and violence within the painting come as much from the artist's delight in experimenting with the new science of perspective as from its subject of the Battle of San Romano.

GEOMETRICAL SPACE

Plate 13 *The School of Athens* by Raphael (Raffaelo Santi), *c.* 1510–12

Architectural settings lend themselves to the use of linear perspective because of their essentially geometrical structure. We have seen how perspective was rediscovered and explained by the architects Brunelleschi and Alberti, and tradition has it that Bramante, the High Renaissance architect, designed the layout of the background of Raphael's *The School of Athens*. This painting is part of a fresco cycle done to decorate the private library of Pope Julius II in the Vatican. The theme in the whole room is the representation of Theology, Poetry, Philosophy and Jurisprudence; *The School of Athens* represents Philosophy.

As a spectator you are first made to feel that you could step into the space in this picture, rather like walking into a theatrical setting on the stage. Once there, you would be guided and controlled by its geometrical organisation. You would be led through a series of horizontal planes across the chequered floor, up the steps, past the pillars supporting the barrel vaulting, and into a domed area, which is indicated above the heads of Plato and Aristotle by the curved line under the window. To the left and right you would see transepts leading off behind the walls on either side.

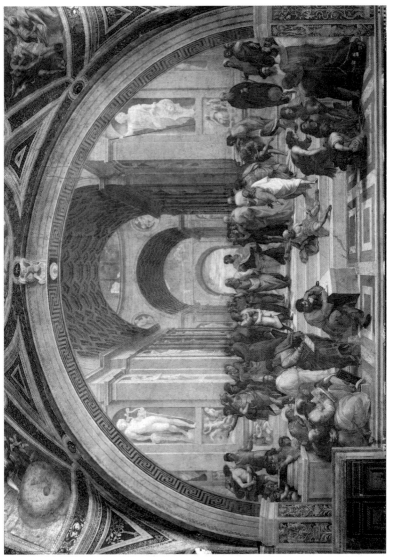

Plate 13 Raphael (Raffaelo Santi), *The School of Athens*, c. 1510–12. Wall fresco, Stanza della Segnatura, Vatican Palace, Rome.

As far as this section, the space is extremely logical, but then it becomes clear, first, that the vanishing point is somewhere in the space between the heads of Plato and Aristotle, and second, that the next lot of barrel vaulting and the furthest archway are open to the sky. The sky is important, because it forms the background behind the heads of Plato and Aristotle, and makes them stand out. And the building could, of course, be unfinished or a ruin. But really, the use of the sky and the incompleteness of the architecture are direct indications that this is not a re-creation of the kind of physical surroundings normally inhabited by ordinary human beings. The fact that the vanishing point of such a carefully constructed space occurs in the heavens communicates this message very cogently.

This combination of the concrete and the abstract is further developed by Raphael's treatment of the lighting and figures. The lighting is very logical and consistent with reality, as it comes from the direction of the window in the actual room, to the right of the fresco, and falls on the figures from that angle. But the people themselves are posed and seen separately, like life models gesturing in the studio; they do not communicate directly with one another.

Finally, we are made to realise that the space exists behind the archway in the room itself, as if beyond a pane of glass. We are gazing into an idealised world of geometrical organisation and abstract ideas. Through his subtle use of figures and architecture in pictorial space, Raphael has visualised the intellectual realm of Philosophy.

IMAGINATIVE SPACE AND ILLUSIONISM

Plates 14 and 15 *The Last Supper* **by Jacopo Tintoretto, 1592–4 and** *Allegory of the Missionary Work of the Jesuits* **by Andrea del Pozzo, 1694**

In the art of Mannerist painters of the later sixteenth century, the main interest ceases to be in the creation of a real world, as it had been in the Renaissance period of artists like Raphael, and becomes directed towards what can loosely be called 'imaginative expression'. This had a great deal to do with the treatment of light, as we shall see in Chapter 4, but it also affected the use of space.

One of the most exciting and original examples of this is in the work of Tintoretto, the great Venetian artist of the latter half of the sixteenth century. In his painting of *The Last Supper* the

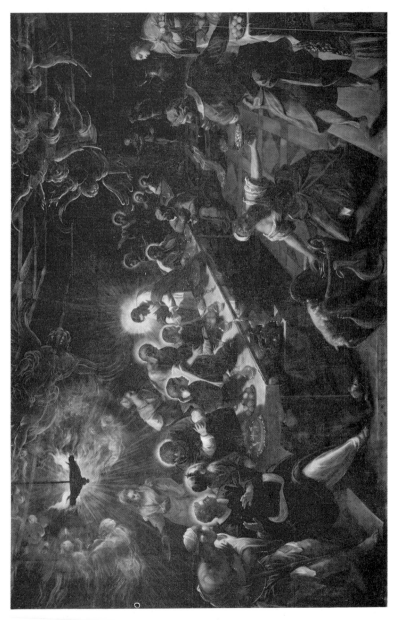

Plate 14 Jacopo Tintoretto, *The Last Supper*, 1592–4. Oil on canvas, 365.5 × 569 cm. Church of Sta Maria Maggiore, Venice.

emphasis is placed on the spiritual dimension of what is happening, created by the spectator's viewpoint and the way the figures are spot-lighted. It was commissioned (along with the Old Testament story of the 'Miracle of the Manna') for the church of Sta Maria Maggiore in Venice and is designed to be seen from the angle of the communicant at the altar rail. Tintoretto creates a deep space at a sharp angle from below, which makes complete sense when you see it from the right place. We know that Tintoretto used models to help him create his compositions and then worked on his lighting effects, rather like a lighting designer in the theatre 'painting with light'. The disciples are illuminated from behind by the flaming lamp high on the left and by the heavenly host of angels, whilst some light is also reflected from the halo of Jesus. At the same time, the figures in the right foreground are lit from the front, leading the eye in and making it possible for the spectator at the altar rail to become part of the picture. The light picks the figures out against a dark background so Tintoretto shows us what he wants us to see from the point of view of communicating the spirit of the narrative. So, when kneeling at the altar rail, the communicants are invited at the same time to witness the mystery of the first Eucharist.

Perspective is concerned with illusion, but illusionism is different because the spectator no longer quite knows where the dividing line is between real and artificially created space. In the illusionistic ceiling decorations of the seventeenth-century Italian baroque style the involvement of the spectator was considered important (see also Chapter 4). The famous fresco by Andrea del Pozzo in the church of St. Ignazio in Rome is called *Allegory of the Missionary Work of the Jesuits* and was finished in 1694. Here, the picture plane is stripped away and whole groups of foreshortened figures appear to float suspended in space. This effect is achieved by following the lines of the architecture of the nave and taking them up to a vanishing point in the centre of the ceiling. As a spectator, looking far above your head, you seem to be gazing into an enormous box or up inside a tower. The space appears to recede endlessly. The luminous lightness of the sky and the figure of Jesus at the focal point help to accentuate this.

This type of architectural painting is known as *quadratura* and its effect is called *di sotto in su*, meaning 'from below upwards'. The position of the spectator is more firmly controlled here than in ordinary single-viewpoint perspective, and Pozzo marked the spot on the floor where the spectator is supposed to stand. If you stand

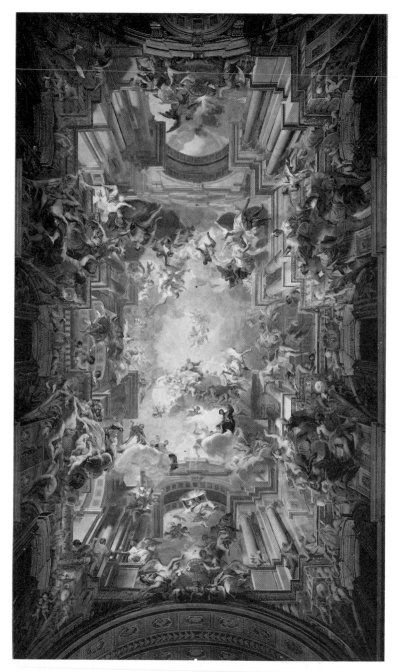

Plate 15 Andrea del Pozzo, *Allegory of the Missionary Work of the Jesuits*, 1694. Ceiling fresco, Church of St Ignazio, Rome.

anywhere else the illusion ceases to work. The visual sensation is much more active than in either the Raphael or the Tintoretto. As you look, you feel as though you are being drawn into the picture and up to heaven.

AERIAL PERSPECTIVE

Colour plates 2 and 3 *The Rainbow Landscape* **by Peter Paul Rubens, 1636 and** *Ascanius Shooting the Stag of Sylvia* **by Claude Lorraine 1682.**

In *The Rainbow Landscape* the view is panoramic, because the spectator is allowed to see for miles into the distance. As spectator, your position is in the centre, as it was in the two previous pictures, but as if you are standing above the landscape on raised ground. Linear perspective is used, with the converging lines of direction starting from the bottom corners of the picture. They move to a vanishing point on the horizon, behind the end of the trees on the right, which diminish in size as they move into the background. The feeling of extended recession is enhanced by the use of diagonal lines from the upper corners of the picture down through the sky above the trees on the left and over the top of the wooded area on the right.

All of this is greatly added to by what is called 'aerial perspective', the device invented by Leonardo, more than 100 years before Rubens, to create an illusion of greater depth than could be acheived by linear perspective alone. The hills in the far distance are blue, a cool colour which tends to recede; the middle distance is green and the foreground a warm ochre brown. This warm colour comes forward, the green goes back a little and the blue recedes even further.

The tonal range enhances the effect of space, because the foreground is dark and the background pale. But the light as a whole is crucial, with its dramatic contrasts moving right into the middle distance, creating an atmosphere very like that of a rainbow. The light and dark areas move in zig-zag fashion around the planes and emphasise the recession. They heighten the drama by making the eye move from light to dark and from one place to the next quite suddenly. This builds an exciting opposition between the weather effects going on in the front and middle of the picture and the calmer atmosphere of lighter tones in the background. The dark

areas under the trees also convey an element of mystery, making you feel that the space goes on beyond what the eye can see.

Other qualities which enhance the effect of space are:

1 The illusion of space *behind* the picture plane as if it were a pane of glass, is lessened by the movement of the figures walking towards the front and the haycart entering from the left. In other words, the picture's surface is opened up by the possibility that the space goes on beyond the frame.

2 The fact that you can see the end of the rainbow on the left-hand side. This helps you to believe in the distance behind the trees on the right, where the other side of it would end.

3 The foliage and the figures in the foreground are painted in considerably more detail than the background.

4 The horizontal rectangle of the shape of the picture gives a wide-angled view, wider in the foreground than you would actually be able to see from a single viewpoint, so heightening its panoramic and all-embracing quality.

Unlike the previous pictures in this chapter, which were intended as wall decorations, this is an easel painting. But it contains within it an enormous sense of scale, far greater than its actual size. Rubens was also a decorator and was used to working on a large scale. The Baroque period of the seventeenth century was a great time for the development of spatial illusion, as we have seen, in murals, on ceilings and walls. The degree of sophistication in the handling of space in this picture is a tribute to another illuminating factor to be borne in mind when looking at paintings. Each artist, working in a particular period, will build on the technical and formal solutions discovered by previous generations. So, Rubens, relying on the understanding of perspective developed since Uccello's time, was able to paint a picture in which the treatment of space is more subtle and complex than that of his predecessor.

Aerial perspective is also used to great advantage in a painting like *Ascanius Shooting the Stag of Sylvia* by Claude Lorraine. Here, it is not just the blue in the distance which enhances the space, but the overall blue tonality of the whole picture. The bluish-green bushes in the foreground, as well as the water, help the eye to connect with the far horizon. This effect is added to by the trees and architecture in the foreground, which create a framework for the eye to look through; this is referred to as the *repoussoir* effect. The word

'*repoussoir*' means 'to push back', so the dark foreground allows the lighter background to recede. Aerial perspective is used to create a poetic atmosphere. This kind of landscape painting is referred to as idealised or classical because it makes it all much more beautiful and more generalised than you would see in nature. The episode from Virgil's *Aeneid* which it depicts provides an excuse to create a view of a dreamworld. It evokes the classical concept of Arcadia, an idealised version of the countryside.

SPACE TO WALK ABOUT IN: LANDSCAPE

Plate 16 *Le Petit Chaville, near Ville d'Avray* **by Jean-Baptiste Camille Corot, 1823–5**

Although it is much smaller than the other pictures seen so far in this chapter, Corot's oil sketch makes the spectator feel that he or she is really there at *Le Petit Chaville, near Ville d'Avray.* Corot often painted outside, trying to capture the unique character of a place on the spot. So, instead of appearing as a set piece, this painting is much more spontaneous.

The composition is cut off at the sides, as if the viewer had just come upon it while passing by. This impression is greatly enhanced by the effect of sunlight, which has been carefully observed in relation to this particular area. It falls from high on the left onto the side and underneath of the tree on the right, the houses in the distance and on the road in shafts, coming through the hedge on the left-hand side. The space does not stretch into a panoramic vista, but is shut off by the hills on the horizon. Linear perspective is there, with a vanishing point to the right of the house nearest the centre; and the aerial perspective is limited to the bluish-white of the sky in the background.

It is the quality of light and shadow, which is most important for giving the spectator a sense of space here. This comes from the limited colour range and subtle tonal variations in the treatment of the houses, the grass, the road and the foliage. The houses are light and come forward, but are maintained in position by the darkness of their windows and the rising ground behind. The shade on either side of the road leads the eye away, and the paleness of the road itself and its highlights hold it in place. The dark sections in the tree on the right and the deep tones of the hedges below and to the left also create depth.

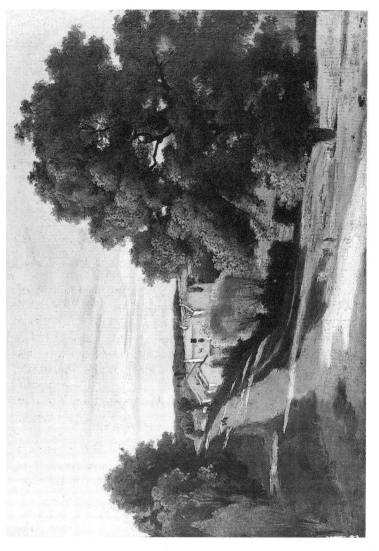

Plate 16 Jean-Baptiste Camille Corot, *Le Petit Chaville, near Ville d'Avray*, 1823–5. Oil on paper laid on canvas, 24 × 35 cm. Ashmolean Museum, Oxford.

But, above all, these tonal values control the recession in relation to the picture plane, so you are aware of the painting itself and of the space created within it at the same time. Instead of being made to look into the view as if it was behind a pane of glass, a balance is struck between acknowledging the fact that it is a painting and creating an illusion of reality. The surface of the picture is rougher and less finished than the others we have looked at, so we are much more conscious of the brushstrokes and the way the painting has been made. Not only do we feel we are there, but we are sharing in the process of capturing the landscape on canvas. And, paradoxically, we have a much greater sense of the reality of it as a result; the lack of detail in the fluid brushwork is much closer to the way we would actually see a view at a particular moment in time. We can visually experience walking about near Ville d'Avray, in the way that Corot must have done when deciding from which angle to paint it.

SPATIAL DISTORTION: IGNORING THE MIDDLE DISTANCE

Plate 17 *The Gleaners* by Jean-François Millet, 1857

The enormous popular appeal of *The Gleaners*, at the end of the nineteenth and beginning of the twentieth century, lay in its simplicity and directness; anyone could understand it. This was one of the main tenets of French nineteenth-century Realism, of which Millet was a leader and with which Corot (discussed earlier in this chapter) was associated. But, as with all great paintings, this simple appearance is deceptive; and in this case it is the artist's manipulation of the space which gives the picture its subtlety, turning it from something which could seem banal and boring into a memorable image.

The women in the front appear large and monumental against a vast expanse of landscape. The horizon is raised above eye-level on the Golden Section of the composition. Along that line to the right there are haystacks and houses which are very small, to create the effect of distance. Then, as your eye moves to the left, there are some large haystacks a little nearer, which help to lead rapidly to the figures in the foreground. You realise that you come upon them very quickly and that consequently there is very little middle distance. This has the effect of making the figures appear larger than life in relation to the background.

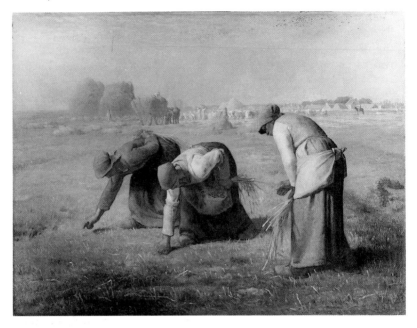

Plate 17 Jean-François Millet, *The Gleaners*, 1857. Oil on canvas, 85.5 × 111 cm. Musée D'Orsay, Paris.

Millet has eliminated, or at least reduced, the middle distance, in order to add to the sense of grandeur and space. This is further increased by the fact that the spectator is looking at the landscape from below. The figure on the right dominates most of all, because her head actually coincides with the horizon, and then the other two, who are bending lower, lead the eye diagonally towards the background. The aerial perspective is modified too. The tones in the foreground are generally darker than those behind, as you would expect, but the figures to the right of the haycart in the distance have the same tonal value as those nearer to us. This helps to stabilise the diagonal movement of the women and relate the foreground to the background. Again, as you would expect, the figures in the foreground are distinct, and painted in some detail compared to the background, which is lighter and more blurred; this further increases the effect of distance.

But, in terms of their individuality, these three gleaners are generalised. They are not portraits of particular people, as their faces are in shadow, and this leads us to concentrate on their relationship

with the extensive area of land they are working in, rather than dwelling on their features. The picturesque details of the view are reduced to a minimum and it is made earthy and subdued, which helps the eye to focus more completely on the overall character of the surroundings. Millet's emphasis on the creation of this deep space encourages the spectator to reflect upon the fundamental interdependence of the people and the land; the way they influence it, in terms of cultivation and labour, and their reliance on it in order to eat and earn a living.

MULTIPLE-VIEWPOINT PERSPECTIVE

Colour plate 4 *Still Life with Apples and Oranges* by Paul Cézanne, 1895–1900

When you first look at this picture, you think you know where your eye-level should be, underneath the fruit bowl holding the oranges. But then you quickly realise that your viewpoint is being shifted about:

1 you can see more of the top of the bowl than you would be able to from that angle,
2 the neck of the jug is more open than it should be,
3 you see more of the sides of the apples on the left and right,
4 the top and sides of the table and its cloth are more extended than they should be.

In fact, you see the still life as if you were standing below the table, to the side of it, on a level with it *and* above it. Rather than using a single viewpoint, Cézanne has employed multiple-viewpoint perspective to create the sensation of a three-dimensional view of the objects and the drapery surrounding them.

In order to concentrate the eye further on this many-sided experience of recession, the space in the painting is restricted. The patterned material behind is used to close off the background, and the feeling of depth is greatly helped by a judicious use of dark tones to the left of the fruit bowl, in the foreground under the table on the left, to the right of the tablecloth at the bottom of the picture, to the right and left of the lower parts of the jug and fruit bowl, and around sections of the apples and oranges. This encourages you to feel that you know where the objects are in space and how they are displacing it.

Instead of the planes lining up logically and geometrically in relationship to the surface of the picture, as they do in the painting by Raphael, they are put at a variety of angles in an apparently higgledy-piggledy fashion. This is particularly noticeable in the apples on the plate on the left. The plate is tilted upwards and slightly towards the centre, and the apples are balanced at many different angles, some of which would be impossible in reality because they would roll about! Here, the planes are revealed and used to describe space and volume. Cézanne developed a technique that he called 'colour modulation', which meant varying the levels of brightness or colour saturation in order to indicate the roundness of an object. This is clear in the apple nearest to us on the plate, where the yellow is the brightest point (see also Chapter 5).

The colour is further used to interpret the space in the way that it is arranged over the whole composition. The warm reds, yellows and oranges of the fruit, together with the predominantly white drapery, tend to come forward, whilst the cooler colours in the patterned material behind tend to recede. But, at the same time, there are reds and yellows in the background, and blues and mauves in the foreground. So, just as in the Corot landscape, but in a more developed way here, the space is continually being related to the picture plane, and in some places even interrupts it. For instance, the tablecloth is arranged on the left so that it appears to erupt from the surface of the picture. The spectator is continually being made aware that the space is an illusion on the flat surface, and that it is the shapes and colours which are making the recession.

All the views that Cézanne shows us are possible, but not all at the same time. However, we learn more about the three-dimensional character of the objects in space than we would from a single viewpoint. Like other Post-Impressionist painters towards the end of the nineteenth century, Cézanne was interested in extending the possibilities of painting. Yet, although reality may appear distorted in this picture, it loses none of its conviction. We realise that the artist could not have achieved this without deeply felt intuitive observation and an intimate understanding of how perspective can be used in the creation of pictorial space.

SPACE IN FRONT OF THE PICTURE

Plate 18 *Lady with a Fan* by Pablo Picasso, *c.* 1909

The creation of space without recession and single-viewpoint perspective is shown clearly in Picasso's *Lady with a Fan*. The form of the figure is constructed in such a way that it describes the area it is sitting in. There is no space beyond the picture plane, which is just behind the seated woman. Almost immediately, you realise that the feeling of three dimensions is in front of the surface of the picture. This has been done by breaking the figure down into a series of geometrical planes placed at different angles to one another.

This can be seen clearly if you look at the face and see how the cheek on the right-hand side is divided into two planes, a pale one on the right and a darker one next to the nose. The pale one comes forward and the darker one recedes. This is accentuated by the deeper grey under the eye, which spreads downwards and breaks into the line down the side of the nose. Even more important is the fact that you know that the light plane of the cheek is in front of the neck, because of the angle at which the neck is placed, and because it is darkest just where it intersects with the jawline. Immediately behind the neck and the ear is an even darker section at an angle, which throws the whole of this side of the head forward.

It does not matter that from a single viewpoint you could not see as much of the side of the cheek or the ear. The crucial point is that you know where they are in relationship to one another. Then, in addition, they appear to come out beyond the surface into the space between you and the picture, rather than receding backwards into a perspective box.

If you allow your eye to move up the picture, you see that the sitter is wearing a cowl-like headdress which extends in a grey band beyond her fringe. Higher up, it comes further forward in a dark triangle, like the gable of a house on top of her head. If you follow the grey band round to the left, you will see it meeting a line which runs along the edge of her fan. The angle at which these two join describes the fact that the fan is on the same plane as the front of the headress and the position of her hand. This construction helps us to locate the whole of the head and shoulders. The golden colour of the cheek and the area behind the shoulder on the left echo the

Plate 18 Pablo Picasso, *Lady with a Fan, c.* 1909. Oil on canvas, 101 × 81 cm. Pushkin Museum, Moscow.

colour of her left hand and further encourage the eye to see the spatial relationships. The arrangement of greens enhances this three-dimensional effect, as do the vase on the left and the cushions on the right. (See colour plate on the cover of this book.)

This figure has literally been built up from a series of intersecting planes whose angles describe the way that the surfaces of the forms lie in space. It is worth remembering that Picasso was a great draughtsman and master of the academic method of life drawing. Had he not been, it is unlikely that he could have masterminded this style, known as Cubism, which requires a detailed knowledge of the human form in order to know how the planes work. Thus, a vivid new way of painting was created without losing the structural integrity of the figure.

The spectator is made to feel that the *Lady with a Fan* is relating to him or her in the space between where he is standing and the picture's surface. It is thought that Picasso and his avant-garde group in the early years of this century were probably aware in a general way of the Theory of Relativity. In its attempt to interpret space in terms of multiple viewpoints, shifting planes and the relationship to the spectator in front of the picture, this painting suggests an intuitive understanding of this new idea.

SPATIAL DISORIENTATION

Plate 19 *Autumn Rhythm* by Jackson Pollock, 1950

The size of this picture is the first thing that strikes you, because it is nearly 3 metres high and more than 5 metres long. When you stand in front of it you feel that you are surrounded by it. Jackson Pollock painted with his canvas stretched on the ground, and he described himself when working as being 'in my painting'. He said that he was trying to record the patterns of his unconscious mind. He dripped the paint from a can while walking and moving about, rather than standing with a brush in his hand in front of an easel. This came to be known as Abstract Expressionism or Action Painting.

At first, the composition appears to be very uncontrolled and chaotic, and you cannot see where you are. There is no fixed viewpoint, so you have to start looking from anywhere and let your eyes wander about. The painting is made up of lines and splashes of paint which do not appear to be ordered in any way, certainly not in terms of linear perspective, aerial perspective or the arrangement of

Plate 19 Jackson Pollock, *Autumn Rhythm*, 1950. Oil on canvas, 267 × 526 cm. The Metropolitan Museum of Art, New York

planes in the way that has been discussed earlier in this chapter. Nor has it any recognisable subject, except possibly by association with a hedge or a pile of barbed wire. Gradually, as you look at it, you seem to become part of it, not by going back into an illusion of space but more as if the configuration of lines was coming towards you and surrounding you. Then you start to notice that the paint does not go right to the edges of the canvas and that the patterns appear to stand out from it, so the space is not within the picture, but between you and it.

Slowly, as you go on looking, some order becomes apparent:

1 there are dark, light and medium tones represented by the black, white and oatmeal areas all over the surface,
2 some of these are opaque and some are translucent,
3 the lightest sections come towards you, the darkest ones recede and the medium parts stay between the two,
4 the buff-coloured background appears through all but the densest areas,
5 the abstract shapes weave about in front and behind one another.

All of this creates space and movement, but still there are no angles or landmarks to tell you where you are in relation to anything else. You can, as it were, get lost and experience a degree of disorientation. None of the shapes is really recognisable as representing anything familiar; nothing is resolved and everything appears to flow into everything else. Moreover, no forms or shapes are repeated exactly.

So, how does the space in the picture hold together? Why do you not feel overwhelmed and enveloped by it? Because:

1 the edges of the canvas contain and stabilise the movement within in that they provide the only vertical and horizontal lines in the picture,
2 the composition appears as a whole to stand out from the surface.
3 the arrangement of dark, medium and light tones is carefully balanced throughout,
4 the opaque and translucent areas are related subtly to the background,
5 the background appears to create a varied perimeter around the outside.
6 There is a curving rhythm divided roughly into three sections which moves across the painting and helps to make the general

arrangement more coherent. It also connects in your mind with the title of the picture, enabling you to make more sense of it.

Therefore, although you feel disorientated, the experience is controlled and so can become aesthetically satisfying.

Finally, we come back to the point where we began. The size of this painting is crucial to its effect, because you cannot see the edges all at once, and this enables the eye to wander about within it. If you could encompass it at a glance, you would be able to see it as an object entirely separate from yourself, and you would not feel the same sense of disorientation. Earlier artists had painted huge decorative schemes like the frescos of the Renaissance and the ceilings of the Baroque era, but they always had a focal point. Because he painted his pictures on the ground, Pollock was able to make them without a viewpoint, thereby allowing the illusion of space to appear to surround the spectator. In creating the sensation of no apparent order, no resolution and no recognisable subject-matter, Pollock's painting does indeed resemble the mysterious and irrational workings of the unconscious mind.

CONCLUSION

In the last 40 or 50 years, some artists' interest in space has become more actual than illusory; rather than simply creating on a flat surface, they have been more concerned with the creation of what are called 'environments'. One of the most interesting of such artists is Richard Long, with his idea of communicating the experience of walking through a particular landscape. But his works are not paintings and are therefore beyond the scope of this chapter. Three-dimensional work, sculpture and painting have grown closer together in the last half century, and this development will be explored more fully in the next chapter.

Chapter 3

Form

INTRODUCTION

Plates 20, 21 and colour plate 5 *The Death of Ananias* **(detail) by Masaccio, 1427–8** *Jonah and the Whale* **by Michelangelo Buonarroti, 1508–12 and** *Portrait of a Man* **by Titian,** *c.* **1512**

Form is the term artists use to describe the feeling of volume in a painting. It is illusory in the sense that the artist is trying to convey a sense of solidity on a flat surface, and one could say for that reason that the term belongs properly in the world of sculpture. But, the fact remains that, certainly from the time of the Renaissance, artists have tried to render these so-called 'plastic' qualities in their painting. One of the best examples of this is the series of frescos painted by Masaccio in the Brancacci Chapel in Florence in about 1427–8. Looking at the famous detail of the woman carrying her child from *The Death of Ananias*, we feel the form of the baby's bottom solidly resting on his mother's arm. We mean by this that we can actually sense the weight of the child and the tension created by his tendency to fidget. The image has a weighty physicality which makes us identify with its three-dimensional reality. The artists of the Early Renaissance, like Masaccio, admired the sculptural qualities that they found in the art of the ancient world and drew much of their inspiration from the study of classical sculpture. They combined this with acute observation of the natural world and the desire to create a sense of reality, particularly in relation to the human body. So, like the use of perspective in the creation of space, the ability to convey the feeling of three dimensions became an important part of what were considered to be the painter's skills.

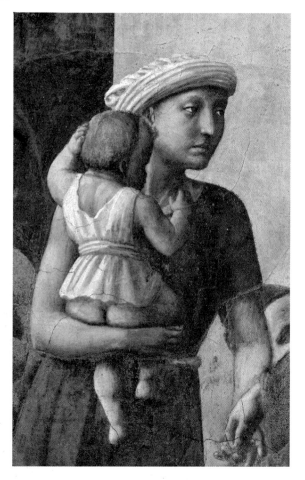

Plate 20 Masaccio, *The Death of Ananias* (detail), 1427–8. Wall fresco. Brancacci Chapel, Florence.

In painting, the relationship between form and space is very close, because the one enhances the other. In Michelangelo's figure of Jonah on the Sistine Chapel ceiling, the body leans back, his left arm gesticulates to the side, his head looks up and his legs point forward. Thus, the angles and twists of his body describe the space and thereby communicate the sensation of three dimensions. This painting is a wonderful example of foreshortening, which is the process of altering the length of an object by means of perspective so that it appears to recede or come towards you. You can see it

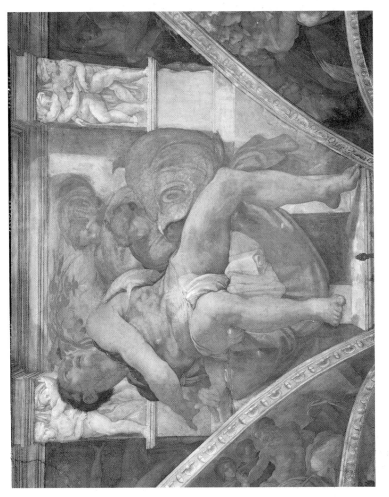

Plate 2 / Michelangelo Buonarroti, *Jonah and the Whale*, 1508–12. Fresco. Sistine Chapel ceiling, Rome.

working in the foot, thigh and elbow on the left of the picture and the head of the whale on the right-hand side; it shows the artist's understanding of perspective and anatomy brilliantly. The way that both Michelangelo and Masaccio have painted their pictures is tonal, because the forms are conveyed by the contrast between light and dark, and for that reason they have a startling sculptural quality.

Another method of creating form has less to do with drawing and sculpture and more to do with colour and the use of the brush. In Titian's painting *Portrait of a Man* (sometimes called *The Man with a Sleeve*), the figure is presented in profile with his head turning towards us to give a feeling of the form in space but it is the use of colour and brushwork and the understanding of texture in the painting of the sleeve that really conveys volume. The form is created by the variations in the blue and the yellowish-grey highlights heightened with white. It is not in the shape of the shoulder against the background that we see the form (as in the Michelangelo), but in the surface pattern of the sleeve coming towards us as it catches the light and bulges over the straight line of the parapet in the foreground. Masaccio and Michelangelo were designing their pictures to be seen from a distance, and so they needed greater simplification. Titian does not seem to be looking for the edges of things but for the structure of the body within and the way it affects the shape of the sleeve and expresses the sensual quality of the material.

These different methods of creating form were recognised in the Renaissance and arose between the followers of Poussin and Rubens in the seventeenth century and between Ingres and Delacroix in the nineteenth. In this context, they are sometimes referred to as the 'linear' and 'painterly' traditions. In Chapter 5 we will explore these ideas further. It is also recognised that making sculpture for a period can help artists to develop a greater understanding of form. Two of the most famous examples of this were Picasso and Matisse when they were inventing Cubism and Fauvism at the beginning of the twentieth century. More recently, artists have been concerned with breaking down the divisions between painting and sculpture and with exploring form by other means, such as Schwitters' *Merz* paintings and Oldenburg's soft sculpture, which we will examine later in this chapter.

SCULPTURAL FORM IN THE HUMAN FIGURE

Plate 22 *The Introduction of the Cult of Cybele at Rome* by Andrea Mantegna, 1505–6

When you first look at this painting you are struck by the powerful feeling of form, by the way the figures seem to come out from the surface like pieces of sculpture. In fact, they do resemble stone in their monochromatic colouring, which is called *grisaille* and was developed in the Renaissance precisely for the purpose of creating the effect of painted sculpture. Mantegna was born in Padua and learned to love sculpture in the studio of the artist Francesco Squarcione, who was also an archaeologist. The city was a centre for the study of the classical past because of its university and its history as a Roman town. It is thought that Mantegna would have known the sources for the story he depicted from the histories of Livy and Valerius Maximus and the poetry of Ovid.

The story concerns the cult of the goddess Cybele, who represented Mother Earth. She was worshipped in the form of a sacred round stone which you can see being carried in on the left of the picture. Her followers were noted for their frenzy, indicated by the dramatic gesture of the kneeling woman in the centre. She probably represents the Roman matron Claudia Quinta, who proved herself innocent of adultery by saving the ship which was carrying the goddess when it ran aground in the river Tiber.

The form of the figures as a group is conveyed by tones that move from dark to light across the picture. In the original painting the colour in the background is warm and variegated like the veins in marble and has the effect of throwing the frieze forward; it is allowed to filter through into the draperies of some of the figures, particularly Claudia Quinta and the person facing her to the left. The angles and positions of the other people are important for creating a rhythm that encourages the eye to move across the surface from side to side and backwards and forwards. The edges of the picture are clearly defined, establishing the limitations of depth and showing us the effect of relief. We, as the spectators, should be looking up at the picture, because it was originally designed to go round the edges of the ceiling of a room. This is most clearly indicated by the perspective in the steps on the right-hand side.

The grisaille technique lends itself to the painting of form even more clearly in the rendering of individual figures. If you look at the

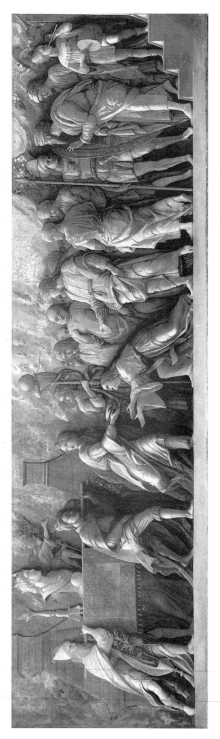

Plate 22 Andrea Mantegna, The Introduction of the Cult of Cybele at Rome, 1505–6. Distemper on linen, 73.5 × 268 cm. The National Gallery, London.

highlight on Claudia Quinta's left thigh in the foreground, you will see that the light is falling directly on the front of it and that this is precisely defined. It then moves round into a middle tone to the side and then behind there is a really dark shadow defining the shape of her back and throwing her forward. You then notice that the shadow goes down behind her foot and is extended behind the feet of the figure to the right. At the top, behind Claudia's head, the same shadow spreads into the area between the two figures behind her. There is another dark shadow behind her right knee, which also helps us to see her figure as solid. The darkest tones describe the furthest background, the medium tones the middle ground and the lightest the foreground, so you always know where you are in the limited depth of the frieze.

The use of the tones allows for this sculptural effect in another way, too, in the sense that Mantegna is able to describe the edges of objects. This is particularly true in relation to the drapery. If you turn your eye to the two figures behind Claudia, you can see how the lightest tones reveal the folds on the sleeve of the right arm of the man with the bald head. Standing to the right of him is Scipio, considered to be the worthiest man in Rome and the fittest to receive the goddess. The edges of the folds on the front of his costume are similarly sharply defined. But, having said that, the most extraordinary thing about this image is the way the materials appear to be made of stone and yet at the same time to be soft and flowing, like soft cotton lawn or even silk chiffon.

This brings us to the most important point of all. As we look at this painting, we see in it the re-creation of a relief, like those on the sides of Roman sarcophagi, and we sense the sculptural form. But, at the same time, we feel the people as real flesh and blood – we can almost hear the ebb and flow of their conversation. The picture may be recording the arrival of an obscure cult recorded in Roman history, but the gestures are those of real people. The uniting of art and life is vital in good painting. Mantegna was certainly an academic and an intellectual in his attitude to classical art, but the form of his figures contains a throb of actuality borne of acute observation of the natural world.

FORM ACHIEVED BY CHIAROSCURO AND *SFUMATO*

Plate 23 *The Virgin and Child with Ste Anne* by Leonardo da Vinci, *c.* 1508

Leonardo was responsible for developing the technique of rendering the effect of form in terms of light and shade which is called by the Italian name *chiaroscuro*. He describes it clearly in his *Treatise on Painting* (now published as *Leonardo on Painting*).

> Shadows and lights are the most certain means by which the shape of any body comes to be known, because a colour of equal lightness or darkness will not display any relief but gives the effect of a flat surface which, with all its parts at equal distance, will seem equally distant from the brightness that illuminates it. Objects seen in light and shade will be displayed in greater relief than those which are wholly in light or in shade.
>
> (Leonardo, *Leonardo on Painting*: 88)

Now we have seen this in operation in the painting by Mantegna. But Leonardo developed it further by increasing the tonal range from very dark to very light, which it was possible to do in the medium of oil paint. Glazes are used between the layers of paint so that light is reflected through them. As oil paint takes longer to dry than distemper or tempera, it is possible to create subtler effects. Leonardo also blurred the edges of the areas of shadow, giving them a smoky quality called *sfumato*.

In the *The Virgin and Child with Ste Anne* we can see these techniques working clearly. In the treatment of the Virgin's right arm reaching down to the Christ Child you can see how carefully graded the tones are, with the lightest ones on the surface of the wrist and the upper arm, then becoming darker and darker as they move underneath. In the right shoulder and arm of the Christ Child you can see where the edges of the shadow are softened, so that you feel his rounded, chubby quality. At the same time, this shadow has a shape which precisely reflects the bone and muscle structure of the arm all the way from the shoulder to the hand.

So, the chiaroscuro and *sfumato* are used to express the form of the underlying structure of the human body as well as its surface layout. The shapes between the forms are also crucial for the feeling of three dimensions; look, for example, at the dark area behind the

Plate 23 Leonardo da Vinci, *The Virgin and Child with Ste Anne, c.* 1508. Oil on panel, 168 × 112 cm. The Louvre, Paris.

light profile of the Virgin's head which frames it and at the same time describes the shape of the side of St Anne's body. But there is an element of ambiguity here, because it could also be the Virgin's hair cascading down the side of her head. This element of deception or uncertainty serves to enhance rather than detract from the viewer's experience of three dimensions. You quickly realise that the pattern of light and dark applies, not just to separate parts but to the overall arrangement of the whole group, which is in the form of a pyramid sitting in space. You cannot see what the Virgin is sitting on – Ste Anne's sloping lap would not be able to support the weight of the Virgin – and yet the feeling is one of solidity because of the subtlety with which the forms appear to move backwards and forwards in space.

The *sfumato* is also deceptive, because you soon discover that the edges of the forms vary and some are much sharper than others, for example, the underneath of the Virgin's right leg as far as the buttocks where it starts to blend into the dark drapery of St Anne. You quickly realise that, where the edges are soft, the eye is encouraged to travel round and this creates movement in the forms of the figures themselves. The sharpness of the outer edge of the group on the left-hand side contrasts with the softness on the right. So, the forms are seen in sharper focus on the left and come forward only to recede on the right because the edges are more blurred. This effect is particularly obvious in the face of St Anne, where the nose, eyebrows and chin are described firmly, but the sides of the mouth and cheeks are softened to give a feeling of mobility. It helps to create her expression and to give the feeling that she and the whole group are alive and made of real flesh and blood, even though they are idealised in terms of their beauty and the way they are sitting.

This experience of form is greatly enhanced by the use of aerial perspective in the blue imaginary landscape background; the edges of the rocks are softened to give the effect of distance and the tones get paler as they recede. The background colours are cool whilst those in the foreground are warm and tend to come forward, increasing the effect of space and the amount of room in which the forms of the figures can sit. The darkness of the tree on the right is also very important, with its dark shadow thrusting forward. If you try covering that section of the picture with your hand, you will see that the three-dimensional effect of the group is much reduced. This is because that dark patch holds the position of the group of figures and the landscape background in relationship to one

another, increasing the effect of depth and therefore the solidity of the pyramid. In this way, the background enhances the feeling of form in the foreground.

Artists of the High Renaissance in early sixteenth-century Italy were fascinated by the idea of the pyramidal composition of a group of two or three figures arranged in a harmonious geometrical shape. Raphael experimented with this composition in a whole series of paintings of the Virgin and Child at this time, but Leonardo renders the pyramidal shape here as well as any painter of the period. The most remarkable aspect of this work is that his understanding of form is so profound that we find the whole experience of the picture believable, even though we know it is idealised.

FORM MADE TANGIBLE

Plate 24 *Flowers in a Basket* by Gustave Courbet, 1862–3

The overwhelming effect of this painting, as with all Courbet's best works, is that you feel you could put your hand out and touch the flower heads; they have a globular quality which makes you want to handle them. What is more, you can sense the contrast between the forms of the different flowers and leaves, between the roses that are fully out in the foreground and the ones more in bud to the right; higher up there is the more pointed form of the white tulip and to the lower left the tiny star-like petals of the lilac. In the background you sense the spiky shiny character of the holly, the smooth razor-like shape of the iris leaves and the softer more rounded foliage of the oak.

This tactile quality is achieved, not so much by detailed drawing and description of the exact character of every leaf and petal but more by the use of the brush and the palette knife. For instance, if you look at the roses in the foreground you can see that the petals are not described in detail, but the form in which they grow is well understood, so Courbet creates the effect of their velvety softness and fragility by the shapes of the areas of colour and tone and by an extraordinary degree of simplification and a sensual delight in their tactile qualities. In other words, the artist understands the forms so well that he knows what to leave out in order to convey a deeper understanding, not of the superficial surface qualities of the rose but of its essential form. The same is true of the wicker basket in which the flowers and foliage are sitting. We understand its roundness and

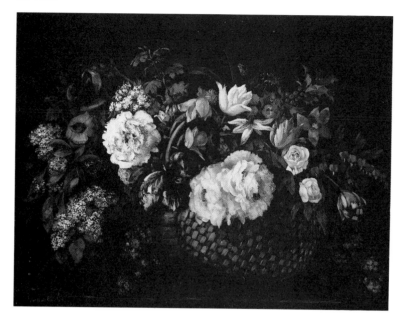

Plate 24 Gustave Courbet, *Flowers in a Basket*, 1862–3. Oil on canvas, 74 × 100 cm. Glasgow Museums; Art Gallery and Museum, Kelvingrove

its roughness by the wedge-like shape of the brushstrokes and the way the tonal qualities in them vary from light to dark.

The dark background is important for projecting the lighter and brighter areas forward but, such is the subtlety of the management of tone and colour, that you feel the ins and outs of the three-dimensional shape of the whole bouquet, as well as the forms of the individual leaves and flowers. The whites are the lightest and come furthest forward, and the near-blacks are the darkest and recede the most; the colours form the section in the medium range. In fact, when you see the actual painting, you will notice that Courbet uses very few colours, namely, red, yellow, green and brown, but there is a wide variation within each one. This is most easily seen where the colours are allowed to invade the white so that it becomes a colour as well as being used simply as the lightest tone; the cow parsley at the top left is yellowish, the rose in front of it is tinged with mauve, as is the lilac to the left, and the roses in the foreground have a pinkish blush. This combination of tone and colour helps you to understand the forms and to know where you are in relation

to each one. This is further added to by the use of the palette knife and the brush; the strokes nearest the eye are the thickest, with the ones furthest away being the smoothest and flattest. If you compare the strokes on the roses in the foreground with those on the leaves at the back, you will see this contrast clearly.

In this way, Courbet makes you much more aware, not only of the tactile qualities of the objects themselves but also of the paint surface. All his pictures have this feeling of sensual tangibility, whether describing petals, human skin, rock or a snow-covered landscape. This, I think, is what we mean when we talk about an artist's individual vision; this is the way that Courbet saw the world and so this is what comes over in his paintings more than anything else. He himself was aware of this. In his *Realist Manifesto* published in 1855 he refers to 'the independent sentiment of my own individuality'. It is what he meant when he said his art was 'real' and 'concrete', and why he felt he could not paint an angel, because it could not be seen and experienced like the objects which surround us (Holt, *A Documentary History of Art*: vol. 3, 348, 352).

THE DISINTEGRATION OF FORM

Plate 25 *High Wind* (known as *The Gust of Wind*) by Auguste Renoir, *c.* 1872

Impressionism, of which this painting is an example, was primarily about the painting of light and atmosphere at a particular moment in time. We now know that this sort of so-called '*plein-air*' painting was not as spontaneous as it might appear, because the artists often worked much more in the studio rather than entirely outside, as was previously thought. However, the first aim still was to capture the fleeting effects of light with colour. This involved a fluid and sketchy technique which eliminated detail in favour of an overall effect. It meant that the form and structure of the picture was of secondary importance compared to the need for the effect of spontaneity.

In this painting by Renoir of windy conditions, the forms appear to disintegrate before our eyes and the three-dimensional qualities of trees, bushes and grass are disturbed and flattened off. The light and the wind appear to dissolve the forms, and this is indicated by the broken feathery brushwork and the lack of clear distinguishing outlines. You are not sure how the division between the hills works or what goes on behind them in the background, but you quickly

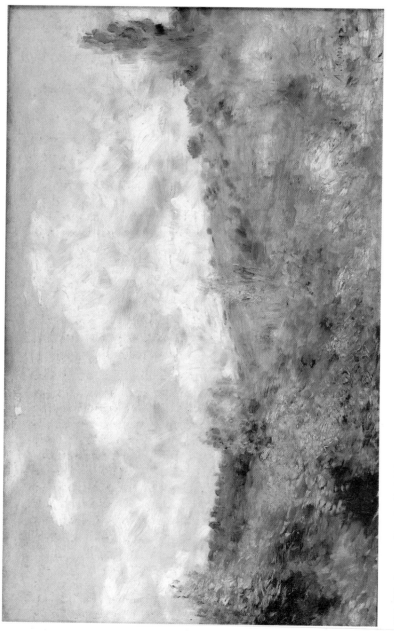

Plate 25 Auguste Renoir, *High Wind* (known as *The Gust of Wind*), c. 1872. Oil on canvas, 52 × 82 cm. The Syndics of the Fitzwilliam Museum, Cambridge.

realise that the artist is most interested in conveying atmosphere, not just the atmosphere created by scudding clouds and wind blowing through grass but by the idea of the quick passing glance. So the composition is cut off at the sides, as if you had just turned to look at this stretch of landscape as you were walking by. Everything on the surface is broken up into brushstrokes of varying sizes and shapes. They are thicker in the foreground than the background, so that those in the front tend to come towards you, but what you sense much more than the forms is the texture. The tactile quality is in the feeling of the grass around your legs, the wind blowing and flapping and the clouds scudding across the sky. In fact, everything is so broken up that you are hardly even sure of where the form and structure of the picture is meant to be. Everything has been so dissolved that you are only aware of an effect. You are only aware of what you might see as you are walking past. The forms seem to disintegrate before your eyes as all detail is eliminated in favour of an impression.

THE REBUILDING OF FORM

Plates 26, 27 and colour plate 7 *Une Baignade, Asnières* **and related studies,** *Bathers at Asnières* **by Georges Seurat, 1883–4**

Seurat, like the other Post-Impressionists, was concerned about the disintegration of form in pure Impressionist painting, and he developed a technique known as Pointillism or Divisionism or Neo-Impressionism, in which the brushstrokes and colours became regularised over the whole surface so that the structure and form of the composition could be made clear. For this painting he made a whole series of sketches in which he used a pure impressionist technique. In the *Final Compositional Study* (plate 26) we can see that, as in the Renoir, the light is dissolving the forms, the outlines are blurred and the whole effect is transient. In the finished picture (colour plate 6), the composition is broadly the same but, because the brushstrokes are more regular, the forms are clearer and more defined.

If you compare the back of the main figure in both pictures you can see how, in the study, the light seems to invade the line of his back so that it appears to become part of the water in the background, making the relationship between the two ambiguous. In the final picture, however, the brushstrokes are regularised so that it is

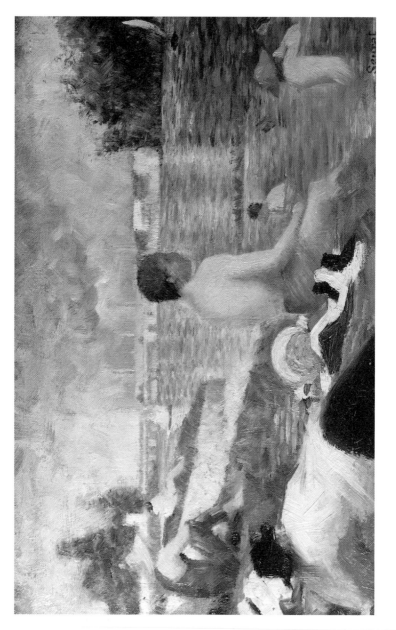

Plate 26 Georges-Pierre Seurat *Final study for the 'Bathers at Asnières' (Une Baignade, Asnières),* final composition study, c. 1883. Oil on wood, 15.8 × 25.1 cm. The Art Institute of Chicago.

quite clear where the water ends and the outline of his back begins. The same is true of the profile of his face and the line of the shadows beneath his chin and under his right armpit. We feel that we know where the form is in space and we sense its three-dimensional qualities. Similar comparisons can be made between the figures in the water in the two pictures. The figure in the water nearest the main one has been turned from a profile in the study to a three-quarters view, so that you sense the body turning away from you much more clearly; the piece of green duckweed in the water has been moved forward so that it crosses immediately behind his head and you sense the solidity of the body in relation to that flat horizontal line of green. In the same way, the figure on the bottom right-hand side raises his arms and is turned more towards us, so that we are more clearly aware of the form of his body. The same is true of the figures on the left. The figure at the back is clearly distinguishable, instead of being little more than a white blob, as in the sketch. The figure with his arms resting on his knees is much more clearly defined, as is the man lying on the grass with his dog in front of us on the left.

Gradually, you start to realise that the forms are defined as much by the spaces surrounding them as by their own shapes. If you look closely at the figure on the left in the middle, you will see how carefully and precisely delineated is the triangle made by the upper part of his legs, his torso and his upper arms; similarly, the triangle made by the shadow from his feet to his buttocks and the underneath parts of his legs. Also, the space defined by his profile, his forearm, the brim of his hat and the line of the back of the man behind him. Then you see how little detail there is and how the texture is rudimentary. In fact, by this kind of simplification, Seurat defines the relationship between form and space very clearly. Unless we look at the form with the space surrounding it, we are not likely to be able to define either very certainly.

Seurat had learned a great deal about the relationship between space and form through his study of the Old Masters and through his drawings, for which he developed a highly original technique. He used a waxy, slightly greasy conté crayon on rough paper which conveyed the effect of light falling on the forms. If you look at the drawing he did for the figure to the left in the background (*Boy with a Straw Hat Seated on the Grass*), you can see how the spaces between the forms are used to define them; and it is the contrast between the tones which creates the effect of recession and the feeling of form in the body. Notice how the area around the dark

Plate 27 Georges Pierre Seurat, *Study for Bathers at Asnières (Une Baignade, Asnières): Seated Boy with Straw Hat c.* 1883–4. Conté crayon 24 × 30 cm. Yale University Art Gallery.

profile is slightly paler, how the space from the top of the back of the hat to the base of the spine is lighter and appears to join up with the section in front of the profile, between the thighs and the torso, and behind the knees. In this way you *feel* the form of the body in space.

From this deep understanding of tone grew a knowledge of colour, and when you look at the same figure in the painting you can see how the relationship between light and dark is identical, except that his singlet is mauve and the grass behind is green, with the spur of white creating the effect of a continuous background. So, by tidying up and systematising his brushstrokes, Seurat was able to control the forms and stop them disintegrating; he still creates the effect of light, although it is no longer the light of a particular time of day. The picture has taken on a quality of timelessness very different from the effects of Impressionism and much more akin to the paintings of artists like Piero della Francesca, Poussin and Puvis de Chavannes, which he loved and admired and which he had studied as a student.

FORM CREATED WITH COLOUR

Colour plate 7 *Portrait with a Green Stripe* by Henri Matisse, 1905

Here, Matisse is doing a similar thing to Leonardo, but he is doing it with colour and using a much more intense colour range than you would actually see. Matisse believed in the power of colour to create form without reference to so-called 'naturalistic' colour. Indeed, he believed in the power of colour as the expressive mainspring of all the elements of picture making. In this he was heir to important developments in the use of colour in the nineteenth century (see Chapter 5). He experimented with this most blatantly in his Fauve paintings of the early twentieth century, of which this portrait is one. He refined the expressive use of colour throughout the rest of his life as an artist. In some of his paper cut-outs of the 1950s he continues to explore the power of colour in a deceptively simple but very sophisticated way.

In this painting, we are invited to feel the form of the head by means of colour. At first it appears quite outrageous: the hair is navy blue, the left side of the face is yellow and the right side is purplish pink; the background is turquoise on one side and purple and red on the other. But, when we look more carefully, we start to see that the colours are actually working to express the form in a remarkable way. The colours on the left are warmer, so the left-hand side of the face and neck comes towards us, as does the background. On the right-hand side, the cool pinks of face and neck tend to recede, and this effect is accentuated by the cool turquoise behind and the dark shadow which runs from just above the right shoulder to the ear. This is all helped by the fact that the figure is placed slightly at an angle to the picture plane with her head turning to face us and the V neck of her dress is carefully angled to reflect this.

In a way, this all seems too easy and one is almost tempted to dismiss it as too simplified. But soon you start to realise that the subtleties far outweigh the simplifications. First of all, there is a deep understanding of the structure of the head. The green stripe of the title describes the width of the forehead narrowing to the tip of the nose. One side of it is outlined with a cool bluish-mauve shadow, creating recession, especially down the side of the nose. The brush-strokes describe carefully the direction of the planes, especially on the right where they are rougher. The texture of these brushstrokes

is also important, being smooth on the left and rough on the right, helping the left side of the face into sharper focus than the right, which appears more blurred. The dark stroke under the centre of the chin creates the shadow which is always there where the lower part of the face juts out from the neck. The green stripe spreads into the socket of her right eye and the quizzical angle of her right eyebrow complements the flatter shape of the one on the other side, giving vitality and expression to the face. Above the forehead, the shape of the hairline exactly describes the form of the forehead jutting forward and the temples receding.

But at this point we start to see that Matisse goes further than just using the colour to express the form of the head. In the hair are red highlights, particularly on the right-hand side, making the hair appear to come forward on the wrong side, so you begin to realise that, not only is he explaining form by colour, he is also making it move backwards and forwards in relation to the surface of the picture as well as in relationship to the solidity of the head. The bent red brushstroke on the right-hand side of the hairline is the most obvious example of this, as it comes forward and so accentuates the recession on the right side of the face. This means that you start to understand the form in relation to the picture's surface. On the left-hand side, the blue of the hair is cooler and so seems to recede and complement the lower part of the face on the left, which comes forward. And, moreover, the purple section of the background behind it is cooler, and that tends to carry the eye back as well. So, the direction which the two sides of the hair move in is in opposition to the two sides of the face; the hair comes forward where the face moves back on the right-hand side and on the left the hair recedes and the face comes forward, so expressing the form.

Depth is also created by the use of black behind the shoulder on the left and on the neckline on the right. The use of pale blue is important, too, around the jawline and the mouth for suggesting recession above the upper lip and beside the lower cheeks on the left and right. The turquoise acts as a recessive colour in the background on the right, as has been said, but it is used also on and under her right eyebrow and in the corner of her right eye. The colours echo one another all over the picture, reminding you at the same time that it is a flat surface you are looking at. The whole portrait is expressed in a fluid and directly expressive way which makes it look raw, easy and even slapdash, but in fact the picture represents an extremely subtle and sophisticated exposé of the processes of painting with colour.

THE CLOSING OF THE GAP BETWEEN PAINTING AND SCULPTURE IN THE TWENTIETH CENTURY

Plates 28 and 29 *The Ecstasy of St Teresa* **(general view and detail) by Gian Lorenzo Bernini, 1647–52**

The idea of painting and sculpture moving closer together is not new. For instance, it can be seen in the seventeenth century in the work of Bernini, who practised as painter, sculptor and architect. In his creation of *The Ecstasy of St Teresa* (1647–52) in the Cornaro Chapel in Rome, he uses tone and colour as a painter would to make a composition out of a sumptuous variety of different coloured marbles and bronze. The light shining on the white marble of St Teresa and the angel is used to dissolve the forms as much as to lend a feeling of solidity. The group appears to defy gravity as it sits, suspended on clouds, within the framework of the arch surrounding it. Above this there is a ceiling decoration of *The Glory of the Angels*, where the forms spill over the window frame so that you are not sure which is painting and which is architecture, which is really three-dimensional and which is not. This deliberate ambiguity in the way we are expected to perceive form and space, known as illusionism, was especially prevalent in seventeenth-century Baroque ceiling decorations; Andrea Pozzo's famous and influential one in the church of St Ignazio in Rome, which we looked at in Chapter 2, is a good example.

In the twentieth century, illusionism has been explored more in relation to manipulating the boundaries between painting and sculpture. In the work of artists like Bridget Riley, for instance, the canvas appears to erupt before our eyes and yet is in fact flat. The idea that sculpture is supposed to be hard and three-dimensional has been questioned by Claes Oldenburg in developing his concept of soft sculpture in such materials as linen and kapok. In this section we shall also look at the blurring of the distinction between painting and sculpture in the collages and constructions of Kurt Schwitters and Andy Goldsworthy.

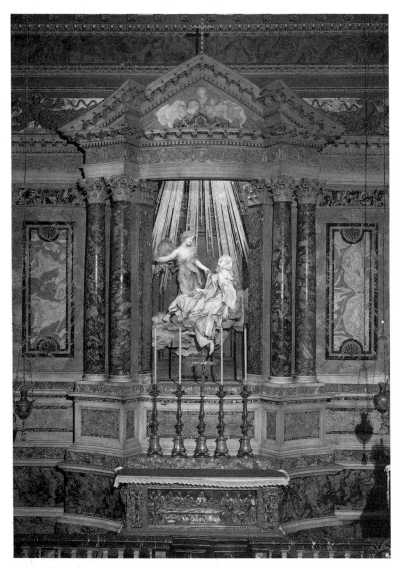

Plate 28 Gianlorenzo Bernini, *The Ecstasy of St Teresa* (general view), 1647–52. Different-coloured marbles and bronze. The Cornaro Chapel, Sta Maria della Vittoria, Rome

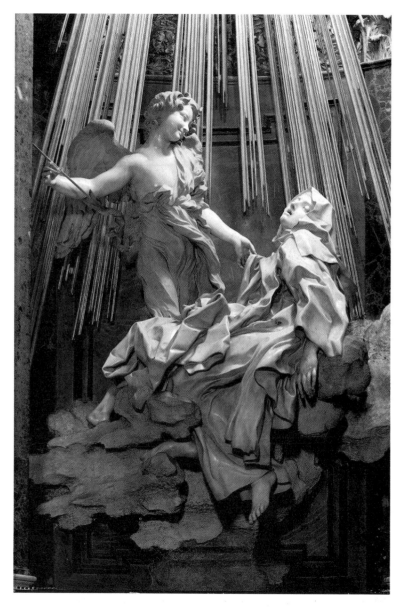

Plate 29 Gianlorenzo Bernini, *The Ecstasy of St Teresa*, detail of plate 28.

Plate 30 *Die Heilige Nacht von Antonio Allegri gen Correggio,* **worked through by Kurt Schwitters (***The Holy Night by Antonio Allegri known as Correggio***), 1947**

Here, Schwitters uses the rubbish left over from modern living – newspaper, waste paper, the sticker from a registered post envelope, the paper and string from a parcel – and, as his centre-piece, a reproduction of a painting by Correggio. These so-called *Merz* works were literally paintings or constructions made out of anything that might otherwise have been thrown away. For this reason Schwitters is associated with the anarchic attitudes of Dada, which arose in Zurich and New York around 1915/16. Schwitters himself described *Merz* like this:

> The word Merz denotes essentially the combination, for artistic purposes, of all conceivable materials, and, technically, the principle of the equal evaluation of the individual materials. . . . A perambulator wheel, wire-netting, string and cotton wool are factors having equal rights with paint.
>
> (Schwitters Catalogue, Tate Gallery: 13)

But what is interesting about many of them, like this one, is the order and beauty of the tonal arrangement and the way it is used to create the form. The dark shadow surrounding the Madonna and Child creates recession, as do the dark areas around the sides of the picture. You could say that this relates it to the Jackson Pollock painting examined in the chapter on space, but there the arrangement is translucent and the scale of the picture is much greater. Here, however, the scraps of paper contribute to a denser effect, creating form rather than space, although the forms do rise off the page into the spectator's area. Then, there are a whole series of greys, greens, russet reds and buff colours which form the middle range of tones. The whites are the lightest and the nearest to us. But, not only do the forms come out towards us, they also appear to recede. In so doing, they challenge the whole idea of the flatness of the surface of the picture.

Plate 31 *Cataract 3* **by Bridget Riley, 1967**

Bridget Riley here creates the illusion that the canvas itself is shaped in a three-dimensional way in the form of waves moving across diagonally. The effect is created by carefully graded lines of complementary colours in greenish-blue and orangish-red which vary

Plate 30 Kurt Schwitters, *Die Heilige Nacht von Antonio Allegri gen Correggio*, worked through by Kurt Schwitters (*The Holy Night by Antonio Allegri known as Correggio*), 1947. Collage 52.9 × 38.8 cm. Private collection, Lugano, Switzerland

Plate 31 Bridget Riley, *Cataract 3*, 1967. PVA on canvas, 223.5 × 222 cm.
British Council Collection, Karsten Schubert Gallery, London.

in thickness, the thin ones creating recession and the thick ones
coming towards us. Gradually, at the top and bottom of the picture,
the colours coalesce to form a bluish-grey and so the optical effect is
more recessive. You can see this happening even though the reproduction is in black and white. As you move backwards and forwards
in front of the picture the lines appear to move; they create a rippling
effect like waves on the surface of a patch of water or the furrows in
a ploughed field. In fact, of course, Riley rejects the need for subject-
matter or detail and the technique is uniform and anonymous.
She does not want anything extraneous to interfere with the effect of
the canvas appearing to erupt and move rhythmically over its whole
expanse.

Plate 32 *Soft Typewriter, 'Ghost' version* **by Claes Oldenburg, 1963**

The work of Claes Oldenburg also plays around with our visual expectations, in the sense that, traditionally, sculpture has always used hard substances as a means of expression, and in a creation like *Soft Typewriter* he is using soft ones. He explores what he called 'dynamic flaccidity', which is the fluidity created by pliable materials rather than the firmness and solidity associated with traditional sculpture. As such, like Bridget Riley's paintings with their erupting surfaces, this sculpture challenges our idea of what sculpture can be. It asks us to reconsider what the sensation of form is really about, whether it needs to be about an immutable kind of solidity or whether it can move and change before our eyes.

For this purpose, Oldenburg does not choose a traditional subject like the human figure but a familiar item from modern life – the typewriter. He invites us to look at it in a new way, as an expression of fluid form. In doing this, he eliminates the detail, like the lettering on the keys or the intricate structure of the roller, and allows us to explore its shapes without unnecessary descriptive reminders of what the original object consists of. He is asking us to consider its form in

Plate 32 Claes Oldenburg, *Soft Typewriter, 'Ghost' Version*, 1963. Canvas filled with kapok, painted with acrylic on wooden base, 9 × 27½ × 28⅜ in. Museum für Moderne Kunst, Frankfurt

a new guise, and in this way he persuades us to concentrate on that alone.

Plate 33 *Sycamore Leaves Stitched Together with Stalks and Hung from a Tree: Pollok Park Glasgow 31st October 1986* **by Andy Goldsworthy**

Andy Goldsworthy makes a more radical departure from the categories of painting and sculpture in relation to the exploration of form. He works with the actual products of nature to make creations which are ephemeral and solid at the same time. He takes leaves or blades of grass, or even pieces of ice, and works them into forms which explore all the elements of painting or sculpture in a three-dimensional way, but which, from their very nature, will disintegrate within a few hours and so can only be recorded in photographs.

Goldsworthy makes his works at places all over the world at different seasons of the year. On 31 October 1986 he made this oblong structure of *Sycamore Leaves Stitched Together with Stalks and Hung from a Tree.* The leaves are blended together in a series of tones and colours ranging from nearly black through russet red and orange to palest creamy yellow. The colours show up strongly because the light is illuminating the leaves from behind, and the whole ensemble contrasts in a complementary way with the green background. And then, from the other side, because the light is shining onto the leaves' surface, the emphasis is laid on their texture and form.

Owing to the transient nature of his materials, this work can only exist for us in photographs. Such works are neither paintings nor sculptures, but creations which can only be experienced at second hand, in reproduction. So, in this sense, one has a feeling that the whole work of art has become an illusion rather than being merely ambiguous, as in the work of Schwitters, Riley or Oldenburg. By emphasising this illusory quality, Goldsworthy enables us to feel the fragile and impermanent characteristics of natural forms. We experience the art of landscape in a new way which is both aesthetic and appropriate to the concerns of the late twentieth century.

CONCLUSION

With the exception of some of the examples in the last section, most of this chapter has been about the rendering of three-dimensional

Plate 33 Andy Goldsworthy, *Sycamore Leaves Stitched Together with Stalks and Hung from a Tree: Pollok Park Glasgow 31st October 1986*

forms on a flat surface. In itself, this concept of form is a contra-dictory one, but that in a way is what makes it so exciting. Form is still considered an important aspect of the study of the human fig-ure in the life class, and of the ability to draw and paint well. Like space, it is connected with wanting to communicate the experience of seeing the physical world and conveying insights into how we apprehend it. In its concern with structure and how objects are put together, form gives works of art a vital sense of conviction which can enhance the spectator's visual experience of reality.

Chapter 4

Tone

INTRODUCTION

Tone is the use of the contrast between light and shade in a painting, which is sometimes referred to by the Italian term chiaroscuro. As we have seen in other chapters, it can be an aid to composition (e.g., Vermeer), to the creation of space (e.g., Jackson Pollock) and to communicating a sense of form (e.g., Leonardo). But, like the other elements, it can also become the main basis of the picture. In connection with the expressive possibilities of light, the use of tone was especially prevalent in the work of such artists in the seventeenth century as Caravaggio, Rembrandt and Velazquez, and sections of the Italian, Dutch and Spanish schools to which they belonged.

Sometimes it can be said that certain periods express a particular kind of sensibility. Subtlety in the use of tone came to the fore especially strongly in the seventeenth century. In the fifteenth and early sixteenth centuries in Italy there was a preoccupation with the rendering of space and form, due to the rediscovery of perspective and the study of classical sculpture. In the nineteenth century the interest in colour became dominant because of the increasing scientific understanding of it. In the twentieth century many of the traditional roles of the painter have been taken over by photography, television, advertising and the cinema, leading artists to turn away from traditional subject-matter.

To speculate on the reasons for periods of heightened perception in this way could become complicated and could lead to meaningless generalisations. However, it can be said that the seventeenth-century interest in the use of light and shade was affected by preoccupations originating in the later sixteenth century connected with the

development of Mannerism, the Counter-Reformation and a new kind of artistic theory, (see also chapter 2).

Plate 34 *Burial of the Count Orgaz* by El Greco, 1586

This painting of 1586 contains an artificial and expressive use of light. The Count Orgaz had been a benefactor to the church of St Tomé in Toledo and was supposed to have been buried by St Stephen and St Augustine, whom you can see in the foreground of this picture, watched by the dignitaries of the town as his soul is carried up to heaven in the upper half of the picture.

The figures, instead of receding into a deep space, are set against a dark background which is very close to the surface of the picture, giving it an unreal and icon-like atmosphere. El Greco had been brought up in the medieval Byzantine tradition of his native Crete and then had visited Venice, where he was influenced by Tintoretto, amongst others. In this picture you can see the strong contrasts of light and dark for dramatic effect found in Tintoretto (Chapter 2) combined with a composition which works in a direct and frontal way. The combination of these two characteristics make an effect which is at once spiritual and imaginative. El Greco's preference for artificial light is illustrated very clearly in the famous story told by another painter, Giulio Clovio. He says that, when he went to visit El Greco on a summer's day, he found him sitting in a room with the curtains drawn because he said he found the darkness more conducive to thought than the light of day, which disturbed his inner light.

This interest in imaginative expression is reflected in the artistic theories of sixteenth-century writers like Lomazzo and Zuccaro, and is picked up most interestingly in the ideas about art coming from the Counter-Reformation in the recommendations of the Council of Trent. These stressed the need for clarity, realism and spectator involvement as an emotional stimulus to piety. Emphasis was placed on the need to make spiritual experience real and direct. This connects, in turn, with the beliefs of the leaders of the new religious orders like those of St Philip Neri, St Charles Borromeo and St Ignatius Loyola. In his book of *Spiritual Exercises*, for instance, St Ignatius suggests that his Jesuit followers should picture in their minds the horrors of Hell and the sufferings and passion of Christ (Wittkower, *Art and Architecture in Italy: 1600–1750*: 24).

Plate 34 El Greco, *Burial of the Count Orgaz*, 1586. Oil on canvas, 15 ft 8½ in × 11 ft 9¼ in. Church of St Tomé, Toledo.

TONE USED TO CREATE DRAMA

Plate 35 *The Supper at Emmaeus* by Michelangelo Merisi da Caravaggio, *c.* 1600

The religious patrons of an artist like Caravaggio in Rome at the turn of the seventeenth century are known to have been familiar with this philosophy and we find much of it reflected in his work. Ultimately, of course, it was expressed in its most developed form in the style known as the Baroque, in the sculpture, buildings and ceiling decorations of artists like Bernini, Borromini, Pietro da Cortona and Andrea del Pozzo. But in Caravaggio it can be seen very clearly, particularly in relationship to his use of light.

In his painting of *The Supper at Emmaeus* of 1600 Caravaggio uses the tonal contrast to create the atmosphere. Certain areas are lit up starkly and the rest cast into varying degrees of penumbrous shade, in order to emphasise the drama of the narrative. The story, as told in St Luke's Gospel, is that, after the resurrection of Jesus two disciples were walking on the road to Emmaeus near Jerusalem; they were joined by a third traveller, a stranger to them both. At Emmaeus they persuaded him to stay with them at an inn. As He sat down with them at table He blessed the bread and then broke it and offered it to them. The two disciples immediately recognised the risen Christ and then He vanished from their sight.

Caravaggio chooses the moment of recognition, with Christ blessing the bread and wine and the two disciples registering their surprise. The attitudes and gestures of the figures are important here: the man on the left starting from his chair, the one on the right with both arms outstretched, and the stunned expression on the face of the innkeeper at the back. But light and shade are used to increase the dramatic effect, rather like spotlighting in the theatre. The lightest parts start with the tablecloth and then move round in an ellipse from the hole in the sleeve of the figure on the left, to the rolled up shirt sleeve on the upper arm of the innkeeper, to the innkeeper's hat, to the left side of Christ's face, the light fabric on his left arm, the shell on the breast of the figure on the right and the napkin round his waist. Also relatively pale in tone are the hand of the man in the chair on the left and the fabric he is sitting on, the side of his face, part of the innkeeper's arm and face, Christ's face, hands and tunic, and those of the disciple on the right, and the food and drink on the table.

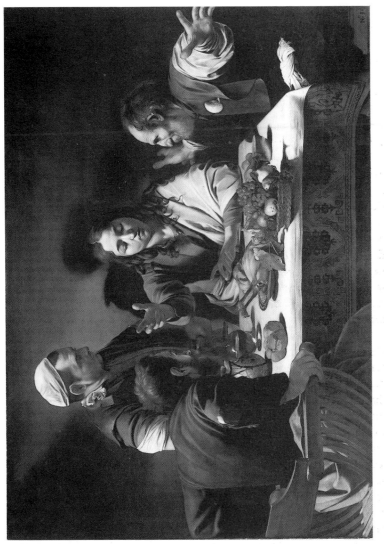

Plate 35 Michelangelo Merisi da Caravaggio, *The Supper at Emmaeus*, c. 1600. Oil on canvas, 141 × 196.2 cm. The National Gallery, London.

The rest of the composition is shrouded in varying degrees of darkness, with deep shadows cast by the objects on the table and by the shoulder and head of the innkeeper on the wall in the background. This shadow, in particular, is very important, because its darkness contrasts with the overall lightness of Christ's figure and throws him forward so that he is the first thing the spectator notices. This reminds us that it is not just the light areas or the dark separately, but the contrast between the two which is important for controlling the atmosphere and making us feel the drama of the story. When we look more closely at this we see that the pattern between light and dark moves round the picture, allowing our eyes to concentrate on the figure of Christ, as the disciples and the innkeeper are doing in the painting.

In fact, so great is our involvement that we are made to feel that we are being invited to sit at the empty space in front of the line of the tablecloth in the foreground. This feeling is increased by the dramatic foreshortening in the outstretched arms of the figure in the right foreground and by the angle of the chair and the elbow of the figure on the left. So subtly balanced are the tonal values here that they lead you in, directly over the food and towards Christ and the gesture of blessing he is making, immediately connecting you to the heart of the story at the point of revelation. This gives the picture a tremendous feeling of immediacy and actuality. Here are a group of ordinary people in their working clothes sitting down to eat a meal in what is apparently a simple everyday situation, and this serves to give the spiritual message greater power.

But then you slowly start to realise that what is sometimes called Caravaggio's 'realism' is in fact not very real at all, and this is to do with the way the light is used. It shines down from high on the left and picks out those areas that the artist wants you to look at, casting the rest of the picture into deep shade. You are given no clues in the background as to what kind of a room they are in; the darkness there only serves to throw the whole composition forward, so much so that the chair and the elbow of the man on the left, the basket of fruit near the centre and the hand of the man on the right appear to project beyond the surface of the painting. It is theatrical light, artificial light, heavenly light which only reveals what the spiritual dimension of the story requires you to see. So stark and clear are the contrasts that the whole painting takes on a kind of hallucinatory or visionary quality where the parts that are lit are seen with great clarity in contrast to the deliberate mystery of the darkness surrounding them.

TONE AND THE EXPRESSION OF EMOTION

Plates 36, 37 and 38 *The Jewish Bride, c.* 1668, *Saskia Asleep in Bed, c.* 1635 and *Woman at the Bath with a Hat beside Her,* 1658 **by Rembrandt van Rijn**

Later in the same century, in his painting of *The Jewish Bride* of about 1668, Rembrandt uses the same kind of painting language as Caravaggio, but for creating a different effect. This is an intimately emotional rather than a theatrically dramatic picture, and is justly regarded as one of the greatest expressions in the visual arts of the love between a man and a woman. There is some doubt about what the subject represents, as the title *The Jewish Bride* or *The Jewish Marriage* was given to it in the nineteenth century. It could be from the Old Testament story of Isaac and Rebecca, where he embraces her while being spied on by Aimelech. However, although Rembrandt uses Old Testament stories in his religious paintings, the message of this picture is much more universal than narrative because of the profound emotional atmosphere he communicates.

Like Caravaggio, Rembrandt uses a dark background with the figures picked out in light which comes from the top left, and in the original painting there is even a similar range of colours in the use of red and gold. But the way that Rembrandt manipulates these tones is very different. There is no foreground, as there is in the Caravaggio, so our eyes move straight to the light parts of the half-length figures and are drawn to the two faces which are in the area of greatest emotional importance. The dark background, instead of staying back, comes towards us and moves around the figures, eating away at their edges and embracing them like a soft blanket, so that we are allowed to concentrate on the relationship between the two people in the central section of the picture. This is helped further by the fact that the most important parts of the couple are highlighted, their foreheads, their noses and their cheekbones on the left and right, then parts of their necks and sleeves, their two hands touching, the woman's right hand below and the man's left hand on her shoulder above. The intimacy created by this arrangement of pale tones is intensified by Rembrandt's use of *impasto*, particularly in the man's sleeve. Impasto is where the palette knife is used to pile on the paint so that the surface of the picture becomes raised. Used for the highlights, as Rembrandt does here, it also increases the feeling of solid form.

Plate 36 Rembrandt van Rijn, *The Jewish Bride*, c. 1668. Oil on canvas, 121.5 × 166.5 cm. Rijksmuseum, Amsterdam

Within this pattern of light, between the heads and shoulders is a very dark and sharply defined shape which draws the eye into the middle. As it is the most definite area and the point of greatest contrast, it holds the whole picture together and is augmented by a series of well-defined dark shadows underneath their arms, particularly where they cross. Otherwise, the edges of Rembrandt's tones are blurred, creating an effect of movement, uncertainty and change which sets us wondering about who they are and the tender emotions they are expressing. The painting of the costume is very beautiful, but essentially there are no surroundings to distract the eye from the relationship between these two people. In the way that he uses the contrast between light and dark Rembrandt encourages us to focus on the nature of love and affection between a man and a woman.

The colour in the two paintings by Caravaggio and Rembrandt is similar, in the sense that it largely consists of red and gold and is used for tonal enrichment in the medium range. But, unlike Caravaggio, Rembrandt set great store by drawing and print-making, and his mastery of tone can be seen even more clearly in that part of his work where even a limited range of colour is not a distraction.

In the drawing of his first wife, *Saskia Asleep in Bed*, of about 1635 Rembrandt has used a pen and a brush and a kind of ink called *bistre*, which was made from boiling soot and water. The light is directed across from the left, shining on the pillow and the bed-clothes and on her right hand, but most of all across the lower part of her face. Here is the most sharply defined contrast, surrounded by certain strongly emphasised dark patches around the face and in certain key areas further down, particularly under her right elbow. The brushed-in section behind comes towards the body and helps to convey the feeling of weight and relaxation associated with the human form when it is asleep.

Rembrandt was also a master of etching (for a description of this technique see Chapter 8), and in *The Woman at the Bath with a Hat beside Her* of 1658 you can see the increased definition, precision and simplification necessary in a print.

In this etching you can see clearly the kinds of lines made by the etcher's needle on the woman's body and how they become denser and closer in the background, just as they would in a drawing, but the effect of light and dark is created by the amount of ink in the different sections of the plate. All the tones on the face and body

Plate 37 Rembrandt van Rijn, *Saskia Asleep in Bed*, c. 1635. Drawing: pen, brush and bistre, 30.7 × 20.3 cm. Ashmolean Museum, Oxford.

Plate 38 Rembrandt van Rijn, *Woman at the Bath with a Hat beside Her*, 1658. Etching, 15.6 × 12.9 cm. The British Museum, London.

and in parts of the background have soft edges, creating the effect of life and movement. The dark areas behind move forward over her left arm and around the head, throwing the figure towards us and creating an atmosphere of intimacy and reverie. The use of a precise printing technique requires great technical discipline and control, and so you can see even more clearly here Rembrandt's supreme understanding of how to organise tone.

TONE AND THE REALISATION OF FORM AND SPACE

Plate 39 *Portrait of Pablo de Valladolid* by Diego Velazquez, *c.* 1632

Rembrandt's great contemporary, the Spanish artist Diego Velazquez, uses tone in yet another way. In his portrait of the actor Pablo de Valladolid from about 1632 the sitter is painted wearing a black costume which stands out starkly against a lighter background. So, instead of the figure looming as an area of light out of a dark background, the reverse is true and the figure himself becomes the shadow. It has the effect of creating the feeling that this thespian is surrounded with air, and the tones are manipulated to increase the physical presence of the man in space. Yet there is no space in the sense of a visible background or even of where the wall joins the floor; instead space is indicated by the darkening of the corners, the diagonal shadows cast by Pablo's legs and feet, and the fact that he is standing slightly at an angle, gesticulating into depth with his right hand.

Furthermore, the figure is defined clearly round the outside, almost like a silhouette, and there is none of the contrast between sharp and blurred edges that you find in Rembrandt or Leonardo. Yet the sensation conveyed is one of overwhelming realism based on the principle that we do not see everything in the same amount of detail, hence the contrast between the crisp focus on the figure and the softness of the background. Moreover, there are variable levels of detail on the costume rendered in subtle degrees of black: towards the top left of the figure we see decoration and on the bottom right we are made aware of more elaborate folds and his flamboyant garter. Also, his pale ruff sets off the strong light and dark contrasts in his face, and the light cuff enhances the pattern of tone in the fingers of his left hand. So, as well as there being the

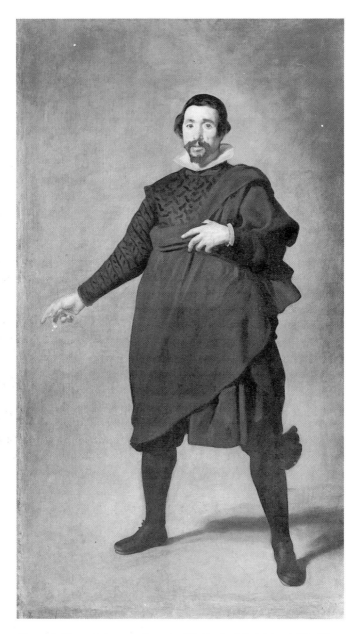

Plate 39 Diego Velazquez, *Portrait of Pablo de Valladolid, c.* 1632. Oil on canvas, 209 × 125 cm. Prado Museum, Madrid.

main contrast between the figure and the plain setting we also see him and his costume more sharply in some areas than others.

All these aspects combine to create a feeling of immediacy and spontaneity, but in fact we know no more about what is behind the actor than we do in either of the paintings by Rembrandt or Caravaggio. In *The Supper at Emmaeus* the background is blocked off and in *The Jewish Bride* it comes towards us and embraces the couple; in the case of Velazquez we see Pablo standing in space, a space that seems to go beyond the frame and to invite us to speculate about it. So subtle is the modulation of the tone between the areas of flesh and the background (particularly in his gesticulating right hand) that we are made to feel that the man belongs there and is part of it, whilst in the other two paintings the figures are illuminated and separated from the darkness as a light is cast upon them.

The extraordinary tonal qualities in Velazquez's painting were recognised by the nineteenth-century artist Edouard Manet when he saw it during his visit to Madrid in 1865. In a letter to his friend, the artist Henri Fantin-Latour he wrote:

> The most astonishing item among his splendid work, and perhaps the most astonishing ever painted, is the picture listed in the catalogue as 'Portrait of a famous actor in the reign of Philip IV' (Pabillos de Valladolid, a court jester). The background disappears; it is simply air that surrounds the man, dressed all in black and alive.
>
> (Friedenthal, *Letters of the Great Artists*: vol. 2, 118)

Here, Manet pinpoints the fact that the quality of the painting here is nothing short of miraculous and ultimately inexplicable in words.

TONE USED TO CREATE ATMOSPHERE

Plate 40 *The Witches' Sabbath* by Francisco de Goya y Lucientes, *c*. 1819–23

Although the expressive use of light was prevalent amongst artists of the seventeenth century, as we have seen, it would be quite wrong to imply that there have not been masters of tone in other periods. Nearly 200 years after Velazquez, another Spanish artist, Francisco de Goya, used tonal contrast to explore extremes of emotion in his so-called 'Black Painting' of *The Witches Sabbath*. It

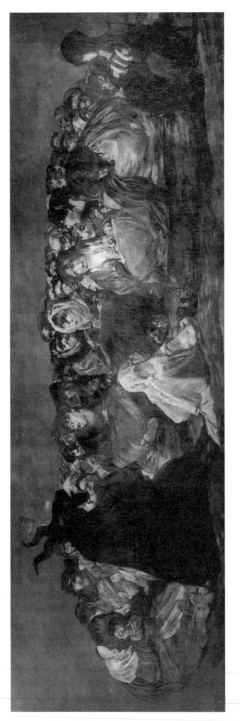

Plate 40 Francisco de Goya y Lucientes, *The Witches' Sabbath*, c. 1819–23. Oil on canvas, 140 × 438 cm. Prado Museum, Madrid.

is part of a series of pictures which Goya did on the walls of his house between 1819 and 1823. By the time he came to paint it he was an old man in his seventies. He had lived through extraordinary dramatic and tragic events both in his own life and in the outside world. He had started out as a court painter in the second half of the eighteenth century, shared in the idealism of the Enlightenment, welcomed the coming of Bonaparte, observed the horrors of the Spanish Peninsular war and seen the conservative reaction in the restoration government of King Ferdinand VII. He had also experienced at least three bouts of serious illness, one of which left him stone deaf in 1792.

By 1819–23, when this series of paintings was done, Goya was clearly expressing a mood of despair and disillusionment. They are called the 'Black Paintings' because Goya used a black background and then superimposed the medium and light tones on top. So, the darkest areas of *The Witches' Sabbath* are where he leaves the black to show through, as in the horrific horned figure of the devil in the foreground. In his understanding of how to use extremes of dark and light Goya was heir to a long tradition in Spanish painting going back to the work of seventeenth-century artists like Ribera (1591–1652), a contemporary of Velazquez. Ribera had started work in Naples where there were followers of Caravaggio known as the Caravaggisti. Painters like these, and Ribera, were given the name Tenebristi because of their use of tenebrous dark backgrounds with the light used to pick out the areas they wanted you to see. We have already noticed this process at work in Caravaggio and Rembrandt.

Goya's understanding of this Spanish tradition was augmented by an interest in Rembrandt, some of whose prints he owned, but he himself always maintained that he learned most from Velazquez and from the study of nature. This combination of sharp and blurred focus between the foreground and the background is similar to Velazquez but the impact of the painting is Goya's own. The shapes are very simplified but remain powerfully three-dimensional. They are also monochromatic, in the sense that there is virtually no colour. These qualities, together with the tonal expression, had been developed by Goya through his mastery of etching. He learned the technique when he was asked by the King of Spain to make prints of the paintings by Velazquez in the royal collection in 1778. And, indeed, it is the realism combined with the knowledge of the expressive possibilities of tone which make this painting of devil worship so powerful.

In spite of the simplification in his treatment of the figures, Goya makes us believe they exist and so the fantasy element becomes convincing. This combination of realism and expression can best be seen in the group on the right, with the woman sitting on a chair next to an enormous screaming figure leaning forward with two staring ones immediately behind. If we look carefully at the screaming figure we can see the brushstrokes of the middle tones of its skirt dragged over the dark background. Then the black of its shawl and the back of its head are emphasised by the extraordinary shape of its screaming face picked out in another area of medium tone. The lightest part of the whole monstrous image is the white of its eye, which is then picked up in the whites of the eyes of the figure next to it and the shawl of the one to the left. The whites of the eyes and the patches of pale fabric picked out in the audience help to unify the composition and draw it together with the pale draped figure in the foreground. But the most startling use of the palest tones is where the light patches of drapery are used to outline the fearful shape of the devil himself, so that we are left in no doubt as to the object of the people's frenzied gaze. This makes the emotional reality of what is going on totally and horrifyingly convincing. The monochromatic character of the late 'Black Paintings' is accounted for to some extent by the influence of his graphic work (see Chapter 8), but of course the need to express his mood of disillusionment and despair came from the circumstances of Goya's own life and the tragic period he had lived through.

TONE AND THE RECONSTRUCTION OF FORM

Plate 41 *Bottle and Fishes* by Georges Braque, *c.* 1910–12

The tonal qualities in this picture are used to reconstruct the forms as if they were in front of the picture plane rather than behind it. The bottle mentioned in the title is recognisable at the top on the left and there are two fishes' heads nearer the centre of the composition. Otherwise, the objects are not identifiable and the forms are broken up into broadly geometrical shapes, with their facets placed at different angles to one another. We have seen Cézanne and Picasso using similar methods in relation to space in Chapter 2. Like the Picasso portrait, Braque's painting is an early Cubist picture. Both artists were experimenting with new ways of expressing the

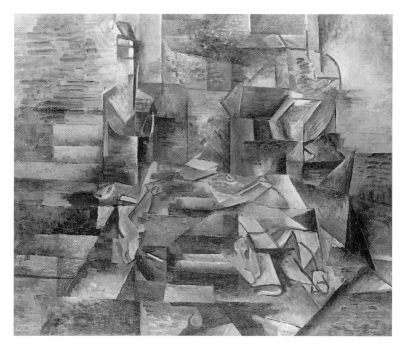

Plate 41 Georges Braque, *Bottle and Fishes*, c. 1910–12. Oil on canvas, 61.6 × 74.9 in. The Tate Gallery, London.

interrelationship between form and space in painting. We have looked at this in several contexts but it is the way that Braque breaks down the structure of the forms and then uses the tones to rebuild them which I want to explore here.

If you begin by looking for the picture plane, you will see that there is what looks like a horizon line immediately behind the still life on the right and on the left it is higher up and slightly further forward. The edges of the objects on both sides are clearly defined tonally against the background and you perceive them as being in front of it. If you look at the oblong patch in the centre, there is an apparent modicum of perspective with the possibility of a vanishing point, but the effect of that focus is blocked off. The section below this area appears further forward. Then, at the bottom of the picture, the eye seems to accept the existence of another picture plane, so you are no longer sure where the surface of the picture is supposed to be.

There is considerable ambiguity here because you are not sure what the still life is sitting on, what its background is or where it is

in space. There is no single light source; instead you can see light coming from the right and left and from behind, as well as in front. This enables the artist to use subtle gradations of tone to express solidity and recession wherever it suits him. The forms are made to resemble glass cubes or fragments, translucent in some places and opaque in others. You could say that this effect corresponds to the reflections on the bottle and the shiny scaly surface of the fishes' skin.

There is no question of using a simplified contrast between dark and light here, because the medium tones are vital for our understanding of the three-dimensional nature of the forms. Braque deliberately abandons colour, except in a residual sense, in order to concentrate on the perception of solidity without any visual or decorative distractions. Tone was most often the means of doing this in the past, and Braque continues to use tone but in a new way. Still life is a traditional subject, too, but here we have to struggle to make sense of it. Tone is manipulated subtly to make us think about the rendering of three dimensions on a flat surface rather than just looking at it and accepting its ordered construction.

CONCLUSION

Plates 42, 43 and 44 *Portrait of Mrs Mary Robinson* (*Perdita*) by Thomas Gainsborough, 1781 and *The Haywain*, 1821 and related sketch, 1820–21 by John Constable

The artist's decisions about tonal contrasts are most important in the preparation and design of pictures. The cartoon drawings of the Renaissance are an example of tone being explored very carefully before transferring a design to the wall, panel or canvas. This is evident in Leonardo's cartoon of the *The Virgin and Child with Ste Anne*, although he did not use it for the later version of that subject discussed in Chapter 3. Concentrating on the main areas of light and dark in a composition can enable the artist to eliminate detail and extract the main lines of the overall arrangement. The notion of half-closing your eyes in order to see a picture or a possible subject in terms of its basic structure can have the same effect. The eighteenth-century painter, Thomas Gainsborough, developed an interesting method of doing this by reducing the light in his studio. His friend and contemporary Ozias Humphrey recorded how he used this reduction in light when painting a portrait.

Plate 42 Thomas Gainsborough, Portrait of *Mrs Mary Robinson* (*Perdita*), 1781. Oil on canvas, 228.6 × 153.0 cm. The Wallace Collection, London.

These pictures (as well as his Landskips) were often wrought by Candle Light, and generally with great force, and likeness. But his Painting Room even by Day (a kind of darkened Twilight) had scarcely any light; and our young Friend has seen him, whilst his Subjects have been sitting to him, when neither they or their pictures were scarcely discernible. . . . Having previously determined and marked with chalk upon what part of the Canvasses the faces were to be painted they were so placed upon the Eisel (for this purpose the canvas was not yet attached to its stretcher, but remained loose, secured by small cords) as to be close to the Subject he was painting, which gave him an opportunity (as he commonly painted standing) of comparing the Dimensions and Effect of the Copy, with the original both near and at a distance; and by this method (with incessant study and exertion) he acquired the power of giving the Masses, and general Forms of his models with the utmost exactness. Having thus settled the Ground Work of his Portraits, he let in (of necessity) more light, for the finishing of them; but his correct preparation was of the last Importance, and enabled him to secure the proportions of his Features as well as the general Contours of Objects with uncommon Truth.

(quoted in Gainsborough Catalogue, Tate Gallery: 28)

So, by working in a kind of half-light, Gainsborough could see the main areas of tone without being distracted. He then increased the light to bring up more detail as he wanted it. In his *Portrait of Mrs Mary Robinson (Perdita)*, of 1781 you can see how the placing of the main tonal contrast behind her head helps to throw her forward and how the softening of detail enables us to see the relationship between the tones more clearly; it helps to unify the composition and makes the more intricate sections on the dress and face more pertinent.

Another area of preparation where tonal exploration is important is in the oil sketch. There are many different types, and we have already seen some examples in connection with Géricault's *The Charging Chasseur* in Chapter 1 or Corot's landscape in Chapter 2. In the academies of art from the seventeenth century onwards, studies like this were regarded as an essential part of the process of graduating from a drawing through to a finished picture. Painting with more fluidity and on a small scale offered an opportunity to experiment and develop pictorial ideas. Oil sketches were also

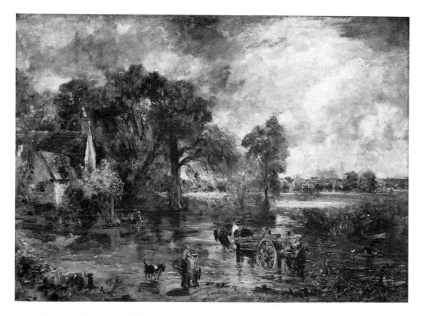

Plate 43 John Constable, *Full-sized Sketch for The Haywain*, 1820–21. Oil on canvas, 130.2 × 185.4 cm. Victoria and Albert Museum, London.

Plate 44 John Constable, *The Haywain*, 1821. Oil on canvas, 130.2 × 185.4 cm. The National Gallery, London.

instrumental in the working up of a landscape painting, particularly when they started to be done outside in front of the subject.

This point is perhaps best demonstrated in John Constable's landscape oil sketching method. It was a laborious task, because before he started work on a final painting he would work out his composition in broad tonal terms on a canvas of exactly the same size. This, in turn, would be based on a number of small oil sketches made out of doors. The full-scale sketch for *The Haywain* of 1820–1 shows Constable exploring the blocks of light, dark and medium tones and their distribution across the surface of the picture. Browns, greens, ochres and whites are present all over it but in subdued form, so that they do not interrupt the overall effect. The finished painting shows the same tonal range but it is more varied. If you compare the background to the right in both pictures you can see that Constable has softened the tonal contrast in the sky and in the grass and sharpened the relationship between the trees and their background. He has clarified the tonal relationships without losing the unity achieved in the sketch. He wanted to capture what he called 'the chiaroscuro of nature' whilst still making a finely tuned painting which worked in pictorial terms.

Later in the nineteenth century the advent of photography and the influence of the Japanese print had a significant effect on the use of light and dark in painting. They showed how it was possible to eliminate the middle range of tones and still create a convincing and realistic impression particularly in relation to contemporary and everyday urban subject-matter. You can see this in Degas' *The Orchestra at the Opera* in Chapter 1 or in Manet's *The Bar at the Folies Bergère* in Chapter 6.

The use of tone is fundamental in giving both structure and atmosphere; perhaps its most important attribute is the way that it can shift and alter the expressive emphasis of a painting. This chapter has concentrated on this kind of expression. Later on in the book we will discover in more detail how powerfully tone can be when used in drawings, watercolours and the graphic arts.

Chapter 5

Colour

INTRODUCTION

The language that we use when discussing colour in relation to painting is often confusing, partly because much of it is imprecise – this is an area where exact definition is difficult. However, there are some points which need to be understood. First of all, there is the idea of the primary and complementary colours as the constituents of white light revealed through the prism or in a rainbow. This was proved by Sir Isaac Newton in his book *Opticks*, published in 1704, although it was thought that colours were contained in white light as far back as Aristotle in the fourth century BC. There are seven prismatic colours: red, yellow and blue are the primaries, and green, orange, indigo and violet are the complementaries, which appear opposite one another on the colour circle (see colour plate 8).

All colours contrast with one another, but the strongest contrasts are seen between the primaries and complementaries. When we talk about contrast in colours we do not mean the same thing as the contrast between light and dark in relation to tones. With colour it is the degree of brightness which is important. Hue refers to the intrinsic colour and whether it is saturated or not, and that means whether or not it has reached its maximum level of brightness. Colour can also be translucent, so that you can see through it as in, say, blue smoke, or it can be solid and opaque as in red brick. We also use words like tint or shade which refer to paleness or darkness, and this is where discussion of colour does relate to tone. There is also the intensity of colour, which has more to do with the relationship between colours and the way they influence one another.

Legend has it that Titian believed the test of a good colourist was whether he could make Venetian Red appear like Vermilion. This brings us to the point about whether colours always affect one

another or whether each has its own intrinsic and immutable qualities. The phenomenon which Titian is supposed to have referred to is the way one colour influences another so that its appearance changes. This principle, often referred to as intensity, means that levels of brightness in a colour are controlled more by what you put next to it than by its intrinsic hue. This had been known by artists for a long time, certainly as far back as the Renaissance. There were also theories about colour in the time of the ancient Greeks; recent research has shown that there were philosophies and beliefs attached to colour and what it could do all the way through Western art from classical times onwards.

However, most artists and art historians would agree that it was in the nineteenth century that colour developed furthest in relation to painting. Particularly influential was the work of Michel Eugène Chevreul who published his *Principles of Harmony and Contrast of Colours* in 1839. He was a chemist who was asked by the Gobelin tapestry factory in the 1820s to investigate the quality of coloured dyes. He discovered that it was not only the intrinsic colour that was important but how it related to other colours. He discovered the principle of contrast, through which colours enhance one another, and the principle of the after-image, where each colour is influenced by its complementary. When you look at a red, for instance, and stare at it for some time and then look away, the colour you see next will be influenced by green, the complementary of that red. You can try this for yourself by looking at a square of paper in a primary colour for a little while and then shifting your gaze to a sheet of plain white paper. If you wait for a few seconds you should then see a square of the complementary colour come up on the white background.

Colour plates 9, 10 and 11 *Odalisque and Slave* **by Jean-Auguste-Dominique Ingres, 1842,** *The Women of Algiers in their Apartment* **by Eugène Delacroix, 1834 and** *The Riviera* **by Pierre Bonnard, 1923**

The issue about whether colour is intrinsic or changeable can be demonstrated very clearly in the work of two nineteenth-century painters, Ingres and Delacroix. In the pictures I have chosen, both artists are using a similar range of primary and complementary colours. The main theme in both pictures is red and green, with orange, violet, blue and gold added. At first glance, the Ingres looks the lighter and brighter of the two, with its area of colour sharply

defined throughout the picture. The Delacroix, on the other hand, shows one colour influenced by another, so that it becomes part of the composition.

Ingres believed that drawing is the 'probity of art', that therein lies art's truth and centre; for him colour was an adornment of his line. But Delacroix referred to this kind of colour as 'illumination', by which he meant that each colour is separated and divided from its neighbour. In the Ingres, if you look carefully at the nude figure, you will see that the line of the body is defined against the gold of her hair, the blue drapery, the blue of the bed cover and the soft orange of the maidservant's skirt. You can also see how the bed cover changes from lighter blue on the right to a darker blue on the left. The green is taken through the maidservant's jacket, the black attendant's tunic and the water and the foliage of the trees in the background. Similarly, the reds can be followed through from the centre of the fan in the foreground, the maid-servant's cuffs and hat, the red pillars and curtains, and the edges of the sleeves and the waistband of the black servant. There is virtually no red in the background except for a pinkish tinge in the niche and along the edge of the ornamental pond. This encourages the back-ground to recede and allows the main interest in the foreground to be contained and concentrated upon. The white is important too, not just as a light tone but as a colour in the odalisque's body, her pillow and chemise, and in the sleeves, mandolin and turban of the maidservant.

It is hard to see where the light is coming from because it appears to emanate from several directions; from high up in front behind the viewer for the nude and her maidservant, from the left for the box at the end of the bed. There is also an unaccountable shadow in front of the railings. Essentially, the edges of the objects are very clearly defined in order to enhance and clarify the line they make. We have looked at colour used to create composition, space and form and as an adjunct to tone. But here it is used at a maximum level of brightness to help with definition, as in a medieval manu-script. We know that Ingres was fascinated by Italian Primitive painting and by medieval art, and these interests are shown most clearly in his attitude to colour as illumination.

Ingres was also interested in Persian miniatures, as can be clearly seen in the background to this picture, but he never went to the East. Delacroix, on the other hand, spent six months in Morocco in 1832. He visited a harem and the first point about his picture of

The Women of Algiers in Their Apartment is its warm, languid and sensual atmosphere, which feels authentic. This is largely achieved by means of the colour. Like the Ingres, the scheme is based on red and green with violet, yellow, orange and blue. But here all are used in much greater variety of tint and shade and are made to influence one another in very subtle ways which are often not immediately obvious.

If you allow your eye to move slowly round the harem you will see that practically every colour is tinged by red or green. If you start with the red and green pattern on the cushion in the bottom left-hand corner and move to the right, you will see that the trousers of the woman who is leaning on it are of a greenish-gold; the fabric over her thighs has a reddish tint and the material in her jacket is an orangey red, with a more greenish-gold braiding. There is a blue shade in the lining of her jacket which is complementary to the gold immediately below it. The overall warmth in the upper part of her body is contrasted with the green in the wall behind. Your eye then travels to the strongly contrasting red and green in the doors at the back; it is then pulled forward, over the red and green cushion in the centre, onto the carpet and the striped fabric over the right knee of the woman in the centre. She also wears green in her waistcoat and red in her watch chain and the scarf around her neck, but the tints are different and so create variety.

In the concubine on the right, the red becomes pink in her skimpy waistcoat and the green a strong emerald in her trousers. This colour appears again as a streak in the strong red of the turban of the black maidservant; her skirt is a rich greenish-blue with a light red stripe; the violet of her bodice creates just enough surprise, with the golden tint in the short sleeves and waist area of her underblouse. Her turning motion and the surprise in these colours turns the eye back into the main body of the picture. There are no clearly defined edges here as there are in the Ingres painting; instead, the colour is used to relate all parts together in one continuous whole.

The light is extremely important, as it streams in from the top left-hand side of the picture and reveals the colours so that you can almost smell the perfume and feel the heat in this dusky interior. We know that Delacroix based this composition on a number of watercolours of Moroccan interiors in which he made a special study of the colours and noted them down. Watercolour has considerable advantages in the creation of luminosity because the white paper can show through the translucent paint medium, as we shall see in chapter 7.

So, in these two pictures of Eastern subjects, Ingres is painting intrinsic or local colours in as pure a way as possible, where the influence of light is reduced to a minimum. Delacroix, though, is more concerned with the way the eye sees colours as influenced by one another and by the light in a particular context. An extension of Delacroix's attitude to colour can be found in the work of Pierre Bonnard. Bonnard uses colour with great flexibility in a painting like *The Riviera* of 1923. When you first look at this picture you feel the atmosphere of heat radiating from every aspect of the land-scape. But you quickly realise that this sensation is not conveyed by realistic or descriptive portrayal but by the colour itself. Bonnard uses colour in all its forms and enables us to explore more fully the terms discussed at the beginning of this chapter.

The brightest area is in the yellow bushes in the left foreground, and the hues are essentially blue, orange, yellow and violet, with a certain amount of green and red as well. The green in the fore-ground is particularly important because it is a saturated colour and acts as an anchor to the whole composition, as does the other little bit of green at the bottom on the left and the orangey red on the right about half-way up. There are translucent passages in the centre foreground where there is an area of white flecked with blue and orange. There is translucency, too, in the middle of the large blue section on the left-hand side. There are opaque patches all over the picture, particularly in the middle and far distance, where the variations in texture are not made so obvious because the view is further away and therefore hazy. But in the foreground the textures would be more obvious, so the brushwork and colour are more varied to indicate the character of the different surfaces. There are also several densely shaded places moving across from left to right and rising to the dark green cypress tree on the upper right-hand side. The palest tints are in some white patches in the foreground, the white bush on the right and the flecks of white amongst the blue trees on the left-hand side.

However, these different types of colour are not isolated but are mixed by Bonnard with great precision. So the bright yellow in the foreground also has green and white added to it to throw it into greater relief. The saturated green is shaded in part and the orange has some red with it to increase the contrast with the green trees; this enhances the relationship with the lightest white. Here is where the quality of the brushwork becomes extremely important. It renders texture and modulates the colour to indicate light falling

on different surfaces and so suggests the bosquiness of the various plant forms. Bonnard is not concerned that we should identify the different plants, trees and flowers in a botanical sense but wants us to feel their characteristics and how they appear in the atmosphere of heat and light. When you stand close to the picture the web of brushstrokes appears like a tapestry, but when you stand away they all fall into place and become visually comprehensible.

This technique of subtle juxtaposition of colour enables Bonnard to achieve the special intensity and shimmering effect which is the outstanding quality of this picture. The trees on the left are composed of a myriad of blues and mauves, as are the bushes in the foreground, which are full of different yellows. But the really telling touches are not what you notice at first. If you look at the apparently dark green tree on the right, you will see there is a lot of blue in it and that it is edged with orange to intensify its relationship with the blues in the background; its base is dark blue to intensify the effect of the saturated orange below. The orange around the edges of that group of blue trees on the left is then picked up in the centre of them to bring the whole area alive. You would never actually see the trees like that in life, but the arrangement corresponds with the visual sensation of the image. Bonnard uses colour in all its guises to re-create the atmosphere he had experienced.

This is where it becomes important to understand Bonnard's method of work. He was not interested in realism in a naturalistic or descriptive sense but more in terms of recording an impression of a moment. In this sense, then, he could be called an Impressionist, but here the similarity ends, because he actually worked in a very traditional way. He would record his experience immediately in a pencil sketch and then work the painting up entirely in the studio from memory. He did not even make small oil sketches on the spot. It was only when the colours and textures corresponded with his memory of a particular visual sensation that he was prepared to say the picture was complete. This approach also gives the painting as a whole a special poetic and visionary quality so that, not only are the colours intense but also the spectator's whole experience of the picture.

In this introductory section we have looked at some aspects of the way colours can be made to work together. In previous chapters we have seen colour used in relation to composition (Turner, *Interior at Petworth*), space (Cézanne, *Still Life with Apples and Oranges*) and form (Matisse, *Portrait with a Green Stripe*). Now we should go on and look at colour and the expression of emotion.

THE USE OF COLOUR TO EXPRESS EMOTION

Colour plates 12 and 13 *Bedroom at Arles*, 1888 and *The Sick-ward of the Hospital at Arles*, 1889 by Vincent Van Gogh

The use of colour for the expression of emotion has a long history but, like the aspects of colour we have so far discussed, it really came to the fore in the nineteenth century. As early as 1810 the German poet Goethe published a theory about primaries and comple-mentaries and their emotional connotations. It was based on the idea that cool colours in the blue and violet range convey sadness and those in the warm section like red, orange and yellow are more optimistic. This theory was known to Turner, and certainly Delacroix believed that colour could be used to arouse feeling in the spectator. Van Gogh's understanding of colour and emotion came via Chevreul's principles and the work of Delacroix and the Impressionists. In a famous quotation from one of his letters to the artist Emile Bernard he wrote:

> My God, yes, if you take some sand in your hand, if you look at it closely, and also water, and also air, they are all colourless looked at in this way. *There is no blue without yellow and without orange* and if you put in blue, then you must put in yellow and orange too mustn't you?
>
> (Holt, *A Documentary History of Art*, vol. 3, 481)

This principle is clearly demonstrated in the familiar painting of Van Gogh's bedroom, where the relationship of blue and yellow through to orange is dominant. Blue is used in the walls, the doors, the jug and ewer, the reflection in the mirror and the coats hang-ing on the walls at the back. Orange, gold and yellow appear in the bed and bedding and the picture frames, too, as well as the chairs and the table. The towel on the left is tinted with green and has a red line on it. The window frame is dark green complemented by the red coverlet on the bed, and the subtle green and pink contrast in the floor. The atmosphere and feeling emanating from the picture through these colour combinations produces an emotional response which is happy and optimistic.

But the really interesting point about Van Gogh is that he can manipulate a similar range of colours to create a very different emotional sensation. In *The Sick-ward of the Hospital at Arles* he

uses blue and gold to express an atmosphere of melancholy and
claustrophobia by the exact shades and tints of those colours and
the way he puts them together. The reds and greens are there in the
ends of the beds and their coverlets, but in a much more subdued
form than in the painting of his bedroom. The dominant colours
are a much colder series of blues, sometimes verging on violet as in
the figure in the left foreground, and the yellows and oranges are
not as bright as in *Bedroom at Arles.*

This comparison demonstrates very clearly how well Van Gogh
understood the power of colour to express different moods. He was
not the first artist to use it in this way, but his grasp of its possi-
bilities is very precise. In a letter to his brother Theo, written in
December 1889 from the hospital at St Remy, he put it very
succinctly. After discussing the colour contrasts in two of his
pictures in some detail he wrote:

> I am telling you about these two canvases especially about the
> first one, to remind you that one can try to give an impression
> of anguish without aiming straight at the Garden of Gethsemane;
> that it is not necessary to portray the characters of the Sermon
> on the Mount in order to produce a consoling and gentle motif.
> (Van Gogh, *The Complete Letters*: vol. 3, 522)

Although this passage might seem to imply that Van Gogh could
do without the subject altogether, this was very far from the case.
He maintained that he needed to be painting in front of nature all
the time. This was one of the main reasons why he and his con-
temporary, Paul Gauguin, quarrelled about the use of colour and
other aspects of painting, as we shall see in the next section.

COLOUR AND THE POWER OF SUGGESTION

Colour plate 14 *Nevermore* by Paul Gauguin, 1897

Gauguin arrived at his attitude to colour through association with
the Symbolist movement which was prevalent in France in the
1880s and 1890s. Symbolists believed, above all, in the power of
suggestion, in the creation of a dream-like atmosphere where
realism was denied in favour of using the picture to evoke a poetic
and imaginary world. Much of the theory was derived from French
literature of the nineteenth century, going back as far as Baude-
laire's poems of 1857, *Les Fleurs du Mal*, in one of which he wrote

about the idea of 'correspondances' or 'affinities' whereby natural forms may be used to suggest ideas beyond mere likeness.

> Nature's a fane where living pillars stand,
> Whence words confusedly reach man below;
> He wanders there through woods of symbols, and
> They gaze at him with looks he seems to know.
>
> (Baudelaire, *Les Fleurs du Mal*: 10)

The most important mouthpiece for Symbolist theory in Gauguin's time was another French poet, Stéphane Mallarmé who said: 'To suggest that is the dream. That is the perfect use of mystery that constitutes symbol' (quoted in *Impressionist and Post-Impressionist Masterpieces: the Courtauld Collection* 40). And Gauguin himself famously told a young artist friend, Paul Serusier, in 1888, to paint a landscape while dreaming before it. When you hear this you can understand why Gauguin and Van Gogh quarrelled. As far as Van Gogh was concerned, this was the stuff of abstraction; he told Emile Bernard:

> As you know, once or twice while Gauguin was in Arles, I gave myself free rein with abstractions . . . and at the time abstraction seemed to me a charming path. But it is enchanted ground old man and one soon finds oneself up against a brick wall.
>
> (Van Gogh, *The Complete Letters*: vol. 3, 524)

So, certainly there was a difference of attitude between the two artists, and this comes out quite clearly in their work. In his painting of *Nevermore* Gauguin uses colour in a harmonious way, creating an atmosphere of melancholy by making a bluish tone the basis of the whole picture. In the background, for instance, there is a great deal of blue which underlies the browns and purples, and even the red has a bluish tint. These tints are also found in the costumes of the women in the background, in the pattern on the bedhead and in the sheet and coverlet on the bed. Even the greenish shadows on the girl's body have an underlying bluish tint which is complementary to the golden colours on her skin.

In order to prevent these colours from becoming monotonous, Gauguin gives a provocative note of excitement to the picture by the use of the bright saturated acid yellow in the pillow and the warm red behind the girl's feet. You can see how this latter colour particularly sings against the greenish cloth behind, and how the

yellow is made sharper by the decorations on its surface being picked out in blue. Gauguin had very clear ideas about his use of colour which he expressed in his *Intimate Journals*, which he wrote when he was living in Tahiti. In particular, you will see that he is keen to create harmony rather than contrast, and to use indigo, which is a kind of blue, as the basis of the colour arrangement of the whole picture.

> Always use colours of the same origin. Indigo makes the best base; it turns yellow when it is treated with spirit of nitre and red in vinegar. The druggists always have it. Keep to these three colours; with patience you will then know how to compose all the shades. . . . seek for harmony and not contrast, for what accords, not for what clashes.
>
> (Gaugin, *Intimate Journals*: 31)

So, in Gauguin's picture, the colours are more blended than they would be in a Van Gogh with their basis in blue. The paint all over the picture is thinner and flatter, with less agitated brushwork. In the background Gauguin's colour has a more translucent quality and in the foreground it is more opaque. In the end, you begin to see that the golden brown of the woman's body is in complementary contrast to all the purplish and blue shades in the rest of the picture. She is painted in tints and shades of gold through to ochre with blue, which give her a dark and burnished solidity.

In choosing the subject of the reclining female nude, Gauguin was joining a long tradition in European painting going back to Giorgione in early sixteenth-century Venice. You can also see similarities between the pose in Gauguin's picture and in Ingres' *Odalisque and Slave*, which we looked at earlier in this chapter. But the remarkable use of colour adds greatly to the suggestive and symbolic air of mystery surrounding Gauguin's new style of Venus figure.

THE POWER OF COLOUR TO DISTURB THE EMOTIONS

Colour plate 15 *Girl with a Cat (Fränzi)* by Ernst Ludwig Kirchner, 1910

In paintings such as this where expressive colour is uppermost, there seems to be an almost deliberate denial of rational organisation of

form and space to make way for a jarring visual impact. In this painting, Kirchner goes further than Van Gogh in the attempt to create a claustrophobic atmosphere. The background is tipped forwards so that the girl appears to be sitting on a slope, almost sliding out of the bottom of the picture. The figure is simplified down into a series of flat shapes emphasised by black outline and the cat is like a paper cut-out or punctuation mark in the background. The converging lines of the corner of the room meet high up in the picture behind the girl's head.

Strong primary and complementary colours are used in sharply tinted shades of yellow, blue and orange on the girl herself, and red and green in the fruit and tablecloth in the right-hand section of the background. The red that she is sitting on is thick and opaque like a pool of blood, an impression which is added to by the charcoal grey and black surrounding it. These acid colours, the contrasts and the closed space, convey an uncomfortable restless atmosphere in which the eye is not allowed to be still. Even the position in which the girl is sitting looks tense and uncomfortable. But it is the use of the colours to create dissonance rather than harmony which does most to convey the highly charged feeling in this picture.

Kirchner belonged to the first phase of the German Expressionist movement called Dië Bruckë (The Bridge), which was founded in 1905, at the same time as Fauvism in France. The German Expressionists looked back to the medieval tradition, particularly woodcut making, and the art of Africa, in order to find the means to appeal directly and strongly to the feelings of the spectator. At this time, primitive art and its preoccupation with spiritual communication, was regarded as an alternative to the European Renaissance tradition by many artists. They recognised in it the power to stir the emotions of the spectator without recourse to naturalism.

THE POWER OF COLOUR TO EXPRESS EMOTION WITHOUT A FIGURATIVE SUBJECT

Colour plate 16 *The Fugue* by Wassily Kandinsky, 1914

Kandinsky believed in using colour for emotional expression. In particular he was interested in the direct effect of colour on the spectator and its connection with the experience of music. In his book, published in 1910, he talks about it in very vivid terms:

The sound of colours is so definite that it would be hard to find anyone who would express bright yellow with base notes or dark lake with the treble. . . . Generally speaking, colour directly influences the soul. Colour is the keyboard, the eyes are the hammers, the soul is the piano with many strings. The artist is the hand that plays, touching one key or another purposively, to cause vibrations in the soul.

(Kandinsky, *Concerning the Spiritual in Art*: 45)

In this painting, Kandinsky uses a musical term as the title, and of course the picture is abstract in the sense that it is without a figurative subject. If you take the term 'fugue' to mean a theme taken up by a single voice or instrument which is then followed and embroidered on by different voices or instruments, then you can see how this works in terms of colour. The dominant theme is yellow – yellow in many variations of opacity and translucence, brightness and dullness, saturation and intensity. The next most significant colour is blue, not in just one manifestation but many, going from a greenish tint right through to rich cobalt and ultramarine. These are, broadly speaking, complementary to the yellow, as the more obviously green areas are to the reds which are next in importance. And then, in much smaller quantities, there are mauves and violets and, in addition, black and white.

The black is a key area for creating recession, while the white lies on the surface. The shapes do not appear to resemble anything in particular, but are generally organic or biological rather than geometrical. Some are seen in sharp focus and some more blurred; this makes them appear to float in some places and scintillate or vibrate in others, as if constantly changing like patterns in a kaleidoscope. This feeling of movement is greatly helped by the spectator's viewpoint, which alters between the bottom and the top of the picture. In the lower part you are looking from above and in the upper half you see from below. You could regard the black and white section as a bridge crossing from one side to the other of the picture; many of Kandinsky's paintings did originate from mountain landscapes and there is another one from this same year named *Improvization Gorge*.

But in many ways the references to natural appearances do not help, because the artist made it quite clear that he wanted us to experience the colours for their own sake. The famous story of how he returned to his studio one evening as it was getting dark and saw

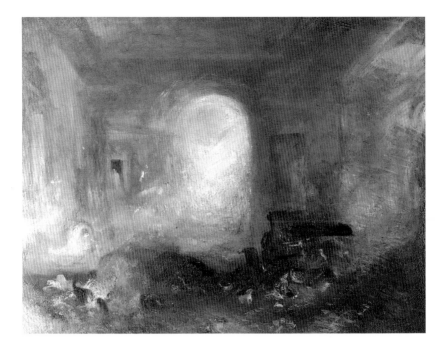

Plate 1 J.M.W. Turner, *Interior at Petworth*, 1830–7. Oil on canvas, 35¾ × 49 in. Trustees of the Tate Gallery, London.

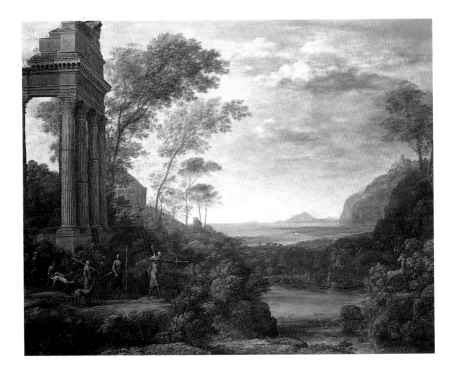

▲ *Plate 3* Claude Lorraine, *Ascanius Shooting the Stag of Sylvia*, 1682. Oil on canvas, 120 × 150 cm. Ashmolean Museum, Oxford.

◄ *Plate 2* Peter Paul Rubens, *The Rainbow Landscape*: 1636. Oil on panel, 136.5 × 236.5 cm. Wallace Collection, London.

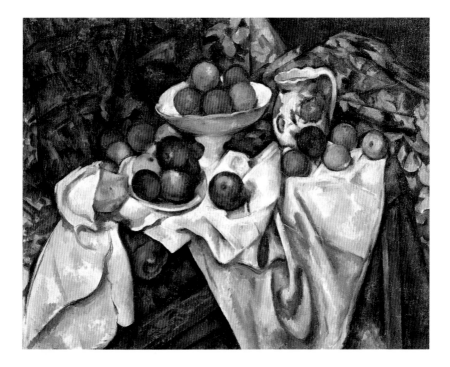

Plate 4 Paul Cézanne, *Still Life with Apples and Oranges*, c. 1895–1900. Oil on canvas, 74 × 93 cm. Musée d'Orsay, Paris.

Plate 5 Titian, *Portrait of a Man* (sometimes called *The Man with a Sleeve*), *c.* 1512. Oil on canvas, 81.2 × 66.3 cm. National Gallery, London.

Seurat

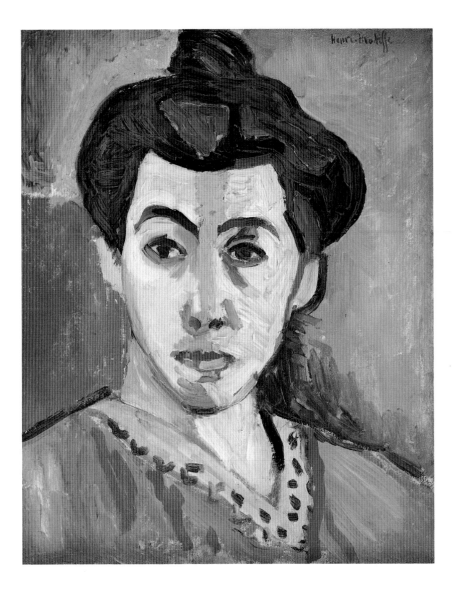

▲ *Plate* 7 Henri Matisse, *Portrait with a Green Stripe*, 1905. Oil on canvas,
40 × 32 cm. Royal Museum of Fine Arts, Copenhagen.

◄ *Plate* 6 Georges Seurat, *Bathers at Asnières* (*Une Baignade, Asnières*), 1884.
Oil on canvas, 200 × 300 cm. National Gallery, London.

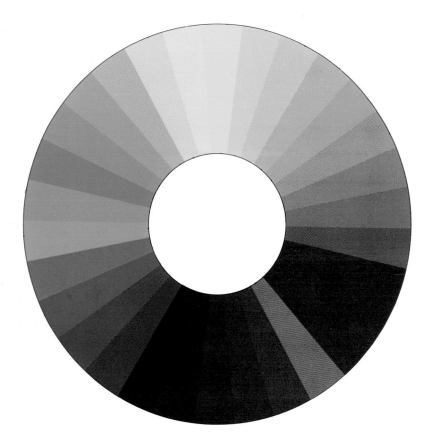

Plate 8 Reproduction of a Colour Wheel Diagram. From *The Oxford Companion to Art* ed. Harold Osborne: Oxford University Press.

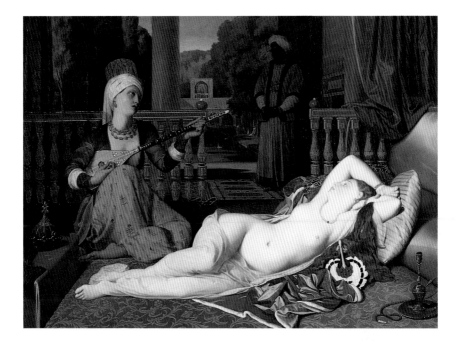

Plate 9 Jean-Auguste-Dominique Ingres, *Odalisque and Slave*, 1842. Oil on canvas, 76 × 105.4 cm. Walters Art Gallery, Baltimore.

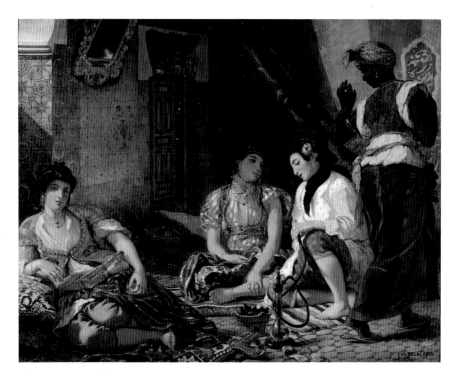

Plate 10 Eugène Delacroix, *The Women of Algiers in their Apartment*, 1834. Oil on canvas, 70⅛ × 90⅛ in. The Louvre, Paris.

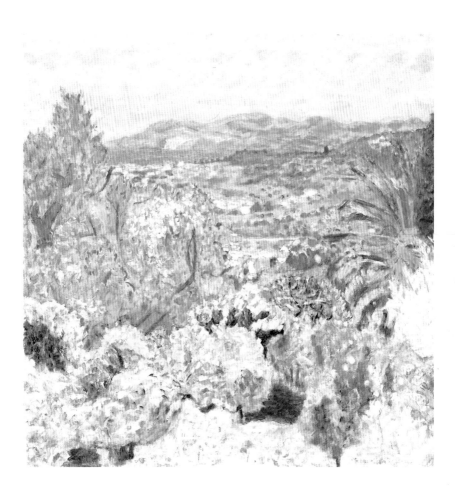

Plate 11 Pierre Bonnard, *The Riviera*, 1923. Oil on canvas, 79 × 76 cm. The Phillips Collection, Washington.

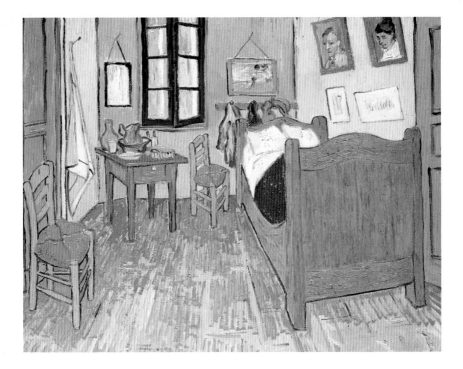

Plate 12 Vincent Van Gogh, *Bedroom at Arles*, 1888. Oil on canvas,
57.5 × 74 cm. Musée d'Orsay, Paris.

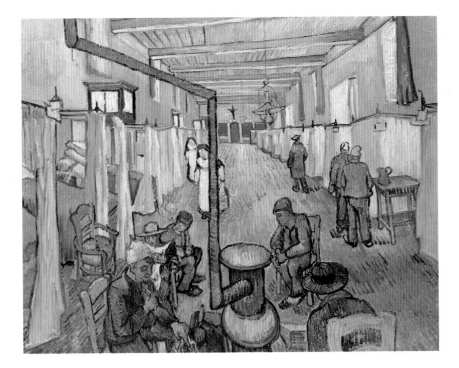

Plate 13 Vincent Van Gogh, *The Sick-ward of the Hospital at Arles*, 1889. Oil on canvas, 29⅛ × 36¼ in. Oskar Reinhardt collection, Winterthur.

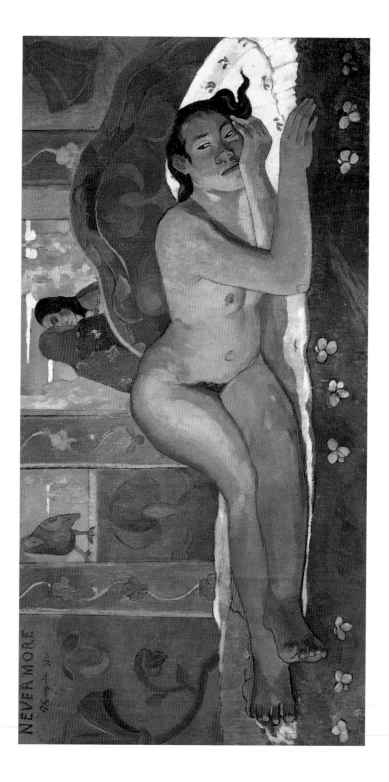

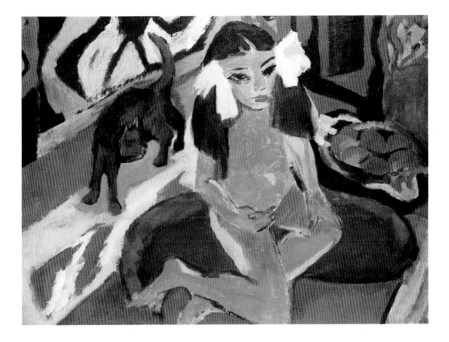

▲ *Plate 15* Ernst Ludwig Kirchner, *Girl with a Cat (Fränzi)*, 1910. Oil on canvas, 88.5 × 119 cm. Private Collection.

◄ *Plate 14* Paul Gauguin, *Nevermore*, 1897. Oil on canvas, 60 × 116 cm. Courtauld Collection, London.

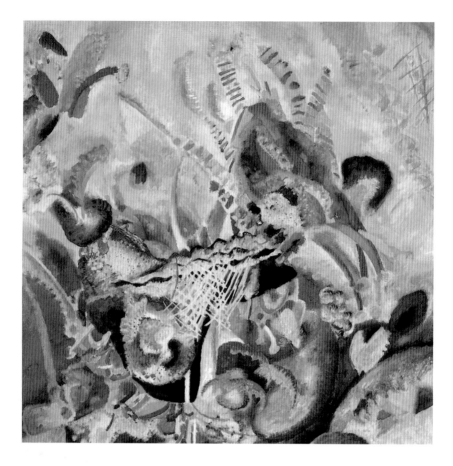

Plate 16 Wassilly Kandinsky, *The Fugue*, 1914. Oil on canvas, 130 × 132 cm. The Solomon R. Guggenheim Museum, New York.

▶ Plate 17 Mark Rothko, *Light Red over Black*, 1957. Oil on canvas, 232.7 × 152.7 cm. Trustees of the Tate Gallery, London.

Plate 18 John Constable, *The Trunk of an Elm Tree*, 1820. Oil on paper, 30.6 × 24.8 cm. Victoria and Albert Museum, London.

Plate 19 John Constable, *The Trunk of an Elm Tree*, detail of plate 18.

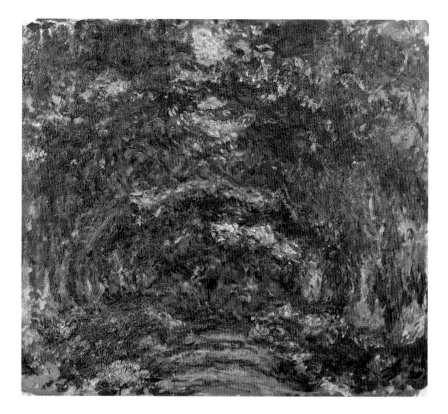

Plate 20 Claude Monet, *Rose Trellises at Giverny*, c. 1922. Oil on canvas, 89 × 100 cm. Musée Marmottan, Paris.

▲ *Plate 22* Bruce Naumann, *Green Light Corridor*, 1970–1. Wall Board and Fluorescent light. 304.8 × 30.5 cm. The Solomon R. Guggenheim Museum, New York, The Panza Collection.

◄ *Plate 21* Howard Hodgkin, *Interior at Oakwood Court*, 1978. Oil on panel, 81.3 × 137.6 cm. Whitworth Art Gallery, Manchester.

▲ *Plate 24* Henri de Toulouse-Lautrec, *The Englishman at the Moulin Rouge*, 1892. Lithograph, limited edition of 100 impressions 37 × 47 cm. Bibliothèque National, Paris.

◄ *Plate 23* Thomas Girtin, *The White House at Chelsea*, c. 1800. Watercolour, 29.8 × 51.4 cm. Trustees of the Tate Gallery, London.

Plate 25 Edouardo Paolozzi, *Moonstrips Empire News*, 1967. Limited edition of 100 prints, 38 × 25.5 cm. Michael D. Abrams Collection.

one of his pictures upside down is relevant here. He wondered who had painted it. He always said that this experience was one of the things that convinced him that subject-matter in painting was unimportant and that what is crucial is to appeal directly to the feelings of the viewer. It is, indeed, hard to say what this picture of *The Fugue* is about or whether it needs its musical title. But the colour relationships in it are so subtle, luminous and glowing that they do in themselves communicate a sensation of joy, excitement and well-being. The artist has orchestrated his colours to play in harmony as if they were instruments performing in concert.

COLOUR AND SCALE

Colour plate 17 *Light Red over Black* by Mark Rothko, 1957

Like Jackson Pollock (see Chapter 2), Rothko belonged to the American Abstract Expressionist movement. Like Kandinsky, he believed in the emotional power of colour and the ability of painting to do without a figurative subject. As with other Abstract Expressionists, all his pictures are very large, on a scale considerably greater than life size. When you stand in front of them it is possible to feel surrounded and enveloped by the colour. At first they often appear to be about nothing at all, but given time you gradually find yourself becoming involved.

After viewing this painting for a few minutes, the black rectangles appear to float on the surface of the red colour field and slowly you start to see the lower one move in front of the upper one. And the orange near the top of the picture seems to slide behind the central square and then in front of it, so its position is not certain. The way that Rothko achieves this is not at all obvious at first glance, but it certainly has something to do with the blurred edges of the dark shapes which are more sharply defined in some places than in others.

In the first chapter, we saw how Turner used this method to create a feeling of atmosphere, movement and the possibility of ephemeral imagery. It is a technique that painters have known about and used, certainly since the time of Rembrandt and Velazquez in the seventeenth century (see Chapter 4). Another point to notice is that Rothko makes the black much denser in the central rectangle than in the lower one; this has the effect of making the central rectangle recede and the lower one, which is more

translucent, appear to float in front of it. At the same time, the vertical and horizontal axes give the whole picture a certain classical and architectural stability, creating a calm and contemplative atmosphere. Certainly, Rothko's attitude to his work was spiritual and he always denied that the colour relationships were important for their own sake.

In this extract from a conversation Rothko had with Selden Rodman, he shows his concern with spirituality:

> The people who weep before my pictures are having the same religious experience I had when I painted them. And if you as you say you are moved only by their colour relationships, then you miss the point.
>
> (Rodman, *Conversations with Artists*: 93)

He also set great store by the interaction between the picture and the viewer. We, as the spectators, are being asked to see more in Rothko's picture than is obviously there. In a letter to his friend Katherine Kuh, Rothko wrote:

> If I must place my trust somewhere, I would invest it in the psyche of sensitive observers who are free of the conventions of understanding. I would have no apprehensions about the use they would make of the pictures for the needs of their own spirit. For if there is both need and spirit, there is bound to be a real transaction.
>
> (quoted in Rothko Catalogue, Tate Gallery: 58)

From these quotations it is evident that Rothko had an almost mystical or religious sense of what colour in painting could communicate. Here is an example of a case where we might need to reserve judgement until we are standing in front of the original picture. Then it can be seen that the size of this picture and its colour give it a very special quality. We can consider for ourselves whether it can be looked at as the twentieth-century equivalent of an altarpiece.

COLOUR AND THE EXPRESSION OF TEXTURE

Colour plates 18, 19 and 20 *The Trunk of an Elm Tree* (full view and detail) by John Constable, 1820 and *Rose Trellises at Giverny* by Claude Monet, *c.* 1922

The late paintings by Monet of his garden at Giverny, particularly the 'Lily Paintings' at the Musée de l'Orangerie in Paris, which are enormous, have been acknowledged by American Abstract Expressionist painters as a source for their ideas. But, Monet's paintings of the garden itself also have a lot to do with the expression of texture by means of a tremendous variety of different marks as well as contrasting primary and complementary colours. The manipulation of the brush is very important here for creating the impression of surface detail. To illustrate clearly what I mean, I know of no better example than John Constable's picture of *The Trunk of an Elm Tree* (colour plates 18 and 19) where he uses the colour and brushwork to express rather than describe the texture. When you stand away from this painting it looks like a very detailed and almost photographic rendering of the trunk of an elm tree. When you get close to it and look at it in detail you see that it is achieved entirely by the juxtaposition of strokes of light and dark and the subdued complementaries of pink and green. In other words, Constable is using this method to suggest the impression of detail and texture, creating a visual correspondence between the painted surface and observed reality.

Now, as we have seen, by the late nineteenth century much more was known about how colours work together and influence one another, and Monet, in *Rose Trellises at Giverny* (colour plate 20), uses primaries and complementaries in a much freer way than Constable. By piling the colours one on top of the other separately, Monet makes them react to one another so that they appear to shimmer and sparkle. There is a visual reference to perspective in the ochre and orange foreground, but essentially any sense of distance is carried by the recessive blues and purples, which dominate in the central section of the picture, and the reds at either side, which come forward. The light areas seem to correspond to sunlight filtering through the foliage and flowers. The thick impasto technique plays an important role here. The paint has been built up until it stands off the surface of the picture and is made to suggest the

rich appearance of texture created when light penetrates fitfully through a dense thicket. Unlike the paintings which are non-figurative, the artist here wants you to be aware of the subject so that your imagination is stimulated to sense the atmosphere of what it must be like to stand in a tunnel of roses. You are aware all the time that you are looking at paint on canvas because the surface is so opaque. But such is the variety of marks and so complex is the colour that, at the same time, you can almost smell the roses and hear the rustle of a breeze amongst the plants and their blossoms.

Colour plate 21 *Interior at Oakwood Court* by Howard Hodgkin, 1978

There are still artists working today who would say that the example of late nineteenth-century painting with colour is important to them. Howard Hodgkin's *Interior at Oakwood Court* of 1978 is an example. Here the rich primary and complementary colours and brushwork are used to express texture, atmosphere and mood. More radical, however, is the use by some artists of actual coloured light in order to create an environment which the spectator can enter. These are not paintings on canvas but installations that involve the body as well as the eyes of the onlooker.

THE USE OF COLOURED LIGHT FOR EXPRESSION

Colour plate 22 *Green Light Corridor* by Bruce Naumann, 1970–1

Bruce Naumann's *Green Light Corridor* invites you to walk into it and experience for yourself the effect of white light in a green and yellow surrounding. The neon lighting is ordered and composed. You are encouraged to feel the narrowness of the passage in contrast with the wide green and yellow space around it. This is expressed by the intense white light in the corridor, which is quite different from the soft and inviting atmosphere outside. You can see that some areas are brighter, like the white section, whereas some are dull and opaque, like the framework and the large cube behind, and others are nearly saturated, like the yellow in the background, or translucent and reflective, like the floor of the corridor.

You can say that Naumann is using geometrical shapes with firm outlines against a background which is more blurred, or that he is varying the softness and hardness of the edges of the objects as we found in the work of Kandinsky and Rothko. But this is neither a painting nor a sculpture in the traditional sense. The artist is using a medium of the twentieth century to express the bland and unexciting atmosphere of neon lighting which is so much part of our culture.

CONCLUSION

Artists of the Romantic movement in the early nineteenth century would have agreed with Rothko that painting is about the expression of emotion, but of course the visual language he uses compared to, say, that of Delacroix or Turner, is different because he belongs to the twentieth century. The idea of chronology, of painting developing in a historical way, can appear to deny the idea that artists at different periods can be involved with similar preoccupations but carrying them out in the visual language of their own time. For instance, it is possible to say that, in their use of colour to express texture, Constable, Monet or Howard Hodgkin have something in common with Titian and his painting of the fabric in the *Portrait of a Man* (Chapter 3 and colour plate section).

In this chapter we have explored a number of different approaches to colour, ending with what appears to be a complete departure from the traditions of Western European painting. But it is worth considering that, in his manipulation of light, Naumann could be seen as the heir to such painters at Tintoretto and Caravaggio in the sixteenth and seventeenth centuries, as well as to abstract colourists like Kandinsky and Rothko. It might be argued that this work is quite different because he is not using paint on canvas. However, I think one can still see that he is interested in expression with light and colour but within a twentieth-century context.

Chapter 6

Subject-matter

INTRODUCTION

There will always be an argument about how necessary it is to know the subject and background of a picture before you can appreciate it. Up to a point, a good picture will always speak for itself in purely descriptive terms. But it seems to me that paintings of all periods, including our own, need some interpretation of their subjects as well as the other more purely visual elements, if we are to get to know them in a deeper way. They are not intended to be instantaneous in the sense that much twentieth-century imagery, particularly in advertising, is designed to be. Knowledge of the historical and cultural context, the subject-matter, where the picture was originally placed and its function can greatly enhance our comprehension, helping us to peel away the layers of meaning that lie beneath the surface.

In preceding chapters we have been looking at the pictorial side of picture making. As we have seen, the subject, or indeed the lack of it, is an integral part of the painting's construction. Now we should go on and ask ourselves more about this aspect. We need to explore a selection of major types of subject and the contribution each can make to the way a picture communicates.

The first and most obvious kind is what are loosely referred to as 'narrative subjects', where the picture tells a story. They include, for example, religious, mythological, historical and literary scenes as well as scenes from everyday life. Other categories are those which have more to do with image making, where the content lies in the visual impact of the painting itself rather than the story it is telling. This applies to a picture which is painted to convey a particular message, as in some kind of propaganda or protest, for instance. There are also images in which there is a deliberate kind of ambiguity, where

the spectator is not sure how to react. In these cases you have to try to discover what is going on and then come to your own conclusions. Abstract painting and the whole concept of doing without the subject becomes an issue here, and we shall look at that more closely. Then there is the philosophy of painting as poetry, where the picture is created for contemplative enjoyment rather than specific meaning.

Nowadays we are not so used to looking for stories or messages in paintings. To a large extent, these roles have been taken over by photography, the cinema, video and television. But, particularly when looking at painting of the past, it is necessary to take the content seriously because it would have been important to the artist, to his or her patron and the spectators of the time, most of whom would have known what it was about. Most pictures with apparently complicated subjects become much more accessible once you know a little more about them. Conversely, they can appear easy to understand because the subject seems simple, and then grow more complex when you become more familiar with them, and this can bring into question the notion that twentieth-century art is more difficult to understand than the art of the past. Lastly, looking at various types of subject-matter offers another angle from which to approach paintings of different periods.

RELIGIOUS SUBJECTS

Plate 45 *The Descent from the Cross* by Rogier van der Weyden, c. 1435

In the first half of the fifteenth century and for hundreds of years before and after that, the majority of paintings were religious. Most of us would recognise the subject of this picture as being connected with Christ's crucifixion but, because we come from a largely secular society, we might not be aware of the details of the story. We also go to see it in an art gallery rather than as an altarpiece in the church for which it was intended.

The contemporary spectator, however, would not only have seen it in an ecclesiastical setting but would have been familiar with the accounts in the Gospels which agree on the whole about what happened, how the body was taken down from the cross and who was there. They would have known that the man behind Jesus was Nicodemus, a Pharisee and member of the Council of Jews in

Plate 45 Rogier van der Weyden, *The Descent from the Cross*, c. 1435. Oil on panel, 86½ × 103 in. Prado Museum, Madrid.

Jerusalem, who came secretly to be taught by Jesus. The man in the foreground with the brocaded costume was Joseph of Arimathea, who provided the tomb and whose manservant stands behind him with a phial of myrrh for anointing the body. The four women were all called Mary. Mary the Virgin, in blue, is fainting in the foreground and being supported by the Apostle St John; Mary Magdalene, the reformed prostitute, is on the extreme right; and in the background on the left are the two Marys from Gallilee who were mothers of other disciples.

The figures are set against a gold background in a box-like space which admits of no escape for any of the people confronted by the reality of their Lord's death. The skull in the foreground refers to the place where crucifixions happened, called Golgotha and known as the place of the skull. The bones are thought to represent the remains of Adam, who was expelled from the Garden of Eden and was supposed to have died in the same location. Nowadays we are moved by this picture because of its emotional power. This is achieved by the positioning of the figures and their gestures, attitudes and body language expressing grief. The artist has re-created the story in such a way that he convinces us of the emotional reality involved.

The world in which this painting was made has gone, but the image still speaks to us of a society in which religious faith was more important than such secular considerations as nationality. In this sense, the picture can be considered, not just as a marvellous evocation of *The Descent from the Cross* but as an imaginative and powerful historical document from a culture which we sometimes find remote.

MYTHOLOGICAL SUBJECTS

Plate 46 *Primavera, The Allegory of Spring* by Sandro Botticelli, *c.* 1482

One way of deciding how important the subject is to our total appreciation of a picture is to look at one where we are not entirely sure what the subject was intended to be. In fact, thousands if not millions of words have been written about this painting and the general opinion seems to be that unless a new document turns up we will probably never know for certain. But there is now a general consensus of opinion about the set of ideas with which it was connected. This picture also allows us to explore the complexity and

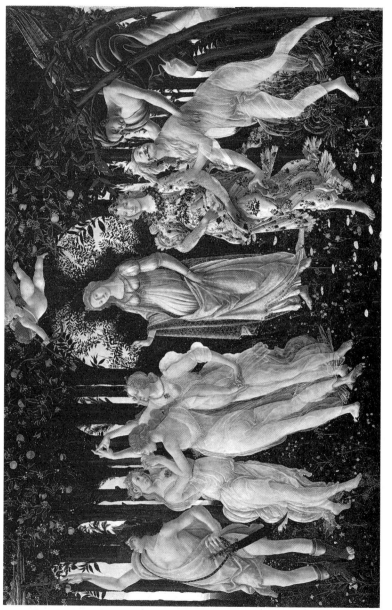

Plate 46 'Sandro Botticelli, *Primavera, The Allegory of Spring,* c. 1482. Tempera on panel, 6 ft 8 in. × 10 ft 4 in. Uffizi Gallery, Florence.

layers of meaning that paintings of the past were supposed to communicate. It deals with a mythological and allegorical subject derived from classical literature. It is called mythological because of its sources and referred to as an allegory because it presents the idea of Spring in terms of a story.

The visual language Botticelli uses is, on the face of it, comparatively simple because of the grace, flow and sheer beauty of the elongated figures and the detailed way in which they and their background are painted. If you look at it only in the pictorial terms of its line and rhythm, it is still very satisfying. Although the figures are elongated, they are very precisely drawn and painted. The superficial subject-matter of Spring is created in an idealised and imaginative way which corresponds in a general sense with everyone's idea of a hopeful time of year. But of course there is much more to it than that. Botticelli would not just have been given a subject and told to paint it; his picture would also have had an iconographical programme of meaning. By iconography we do not just mean the subject and how it appears, but the contemporary philosophy and beliefs behind it. So, first of all, we have the look of the picture and its title of 'Spring'. Then there is the basic story which, in this case, concerns Venus and her garden where eternal Spring reigns. We certainly enter a dreamworld. Zephyrus, the west wind, comes in on the right pursuing Chloris, the Greek goddess of flowers. Ravished by him, she turns into the goddess Flora, and flowers flow out of her mouth. In the centre there is Venus, with Cupid above her shooting his arrow at her emanations of beauty, the Three Graces. To the left there is the god Mercury blowing away any storm clouds as these are not allowed in Venus's garden; even the flowers have been identified and there are 42 varieties, all known to bloom in Tuscany in the Spring.

So, Botticelli creates a Pagan paradise using a number of sources from classical literature, including the poets Ovid and Horace. But what is really interesting about the painting is that it is thought, for example by E.H. Gombrich in his essay on Botticelli in *Symbolic Images*, to have a Christian angle as well. The Venus figure has a halo created by the semi-circular gap in the orange bushes behind, and this is thought to make reference to the Virgin Mary as the goddess of marriage. Now here is where the patrons and the circumstances of the commission become very important; in fact, they must be considered as a crucial part of the creative force behind the picture. Botticelli was almost certainly part of the Medici family circle. We

can assume this because he had painted the portraits of Cosimo dei Medici and Lorenzo the Magnificent in a picture of the Adoration of the Magi in the early 1470s. The Primavera was painted for Lorenzo's cousin Pierfrancesco dei Medici, who married in 1478. He lived at Villa di Castello, a country house near Florence, where the picture was placed outside his nuptial chamber.

The Medici had surrounded themselves with a circle of Humanist intellectuals like Marsilio Ficino, Angelo Poliziano and Pico della Mirandola, and they became members of what was known as the Medici's Platonic Academy. They believed in the philosophy of Neo-Platonism. Plato had propounded the theory of the ideal world which we can never see but must aspire to. But the Neo-Platonists added a mystical element to this so that it was not just a belief in the ideal but a mystical search for a more spiritual version of it. They also concerned themselves with *Humanitas* or Humanism, which did not just mean a man-centred universe but one in which there was a programme of virtue and civilised living. In this was united admiration for classical antiquity along with the Christian faith. Marsilio Ficino was tutor and guide to the young Pierfrancesco dei Medici and in a famous letter of 1478, when his pupil would have been 14 or 15, he wrote advising him to look to Venus as the symbol of *Humanitas*:

> For Humanity (*Humanitas*) herself is a nymph of excellent comeliness born of heaven and more than others beloved by God all highest. Her soul and mind are Love and Charity, her eyes Dignity and Magnanimity, the hands Liberality and Magnificence, the feet Comeliness and Modesty. The whole, then, is Temperance and Honesty, Charm and Splendour. Oh, what exquisite beauty! How beautiful to behold. . . . If you were to unite with her in wedlock and claim her as yours she would make all your years sweet and make you the father of fine children.
>
> (Gombrich, 'Botticelli's Mythologies' in *Symbolic Images*: 42)

So, the classical goddess of love is regarded here not just as sensual and beautiful but as a symbol of moral rectitude closer to the ideal of the Virgin Mary. Altogether, this is a very plausible explanation and serves to show, if nothing else, that mythological subjects like this were provided for an educated elite and were only comprehensible to those 'in the know'. In the twentieth century we think that modern art is more difficult than the art of the past; but the so-called avant-garde viewer of today is equivalent to the elite educated spectators of previous eras.

Ultimately, Botticelli's picture must remain a mystery, partly because we may never discover what he himself thought about it. But he carries out the whole conception in such a convincing way that we, as onlookers, can still marvel at his dreamworld and believe in it. Knowing more about the subject and how to interpret it allows us to gain insight into the complex philosophical background of the Renaissance. We can contemplate the relationship between the secular and spiritual world in Botticelli's time and in our own. Like peeling away the skins of an onion, we can understand that we were intended to enjoy the meaning of this picture on several levels.

HISTORICAL SUBJECTS

Plate 47 *The Death of Germanicus* by Nicolas Poussin, 1626–8

This type of picture is called a history painting because it takes as its subject an episode from the classical past. The Roman historian Tacitus tells how Germanicus was a Roman general who was victorious in the German provinces of the Roman Empire and was nicknamed after them. He was the adopted son of the Emperor Tiberius who eventually became jealous of his success and had him secretly poisoned. The story then goes on to tell how Germanicus's soldiers vowed to avenge his death.

Poussin shows Germanicus on his deathbed with various expressions of grief among the people surrounding him. They are set against a background of grand and severe classical architecture which rises above them in a monumental way and helps to set the sombre mood of the picture. The use of gesture and body language is very eloquent, just as it was in van der Weyden's *The Descent from the Cross*, which we looked at earlier. But this is a secular subject which, at first, may appear rather forbidding. However, as soon as we look into it we can see how carefully Poussin has painted Germanicus to make him look really ill. The feelings of sorrow are subtly varied from the intensity of the wife to the firm determination of the steadfast soldiers. It is a story of heroism, honour and loyalty in the face of betrayal. The figures are idealised; they are made more perfect than they might have been in terms of looks, proportion, attitude and gesture. By these means it was thought that the viewer's mind and morale could be lifted to consideration of courageous deeds and noble motivation.

The idea that art could somehow be improving to the mind and attitude of the spectator lay at the heart of what is called the

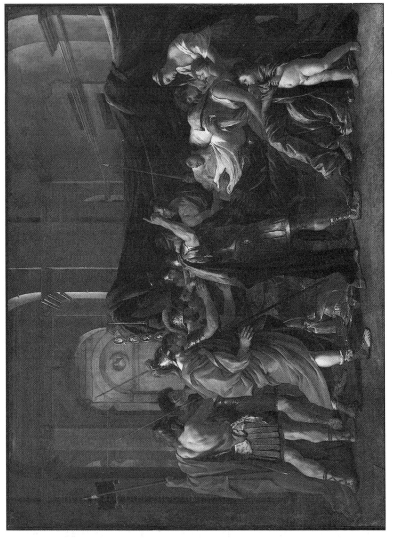

Plate 47 Nicolas Poussin, *The Death of Germanicus*, 1626–8. Oil on canvas, 148 × 198 cm. The Minneapolis Institute of Arts.

academic theory of art. The academies of art were places where students could go to learn rather than being apprenticed in an artist's studio. Technically, the training laid emphasis on drawing from engravings and plaster casts or sculpture. Then there was drawing from the life model, and only after that could the student move to painting and the use of colour. The historical development of this kind of art education is long and complicated and need not concern us here. But what is relevant in this chapter is that, by the time the academies were established, from the mid-seventeenth century onwards, they developed firm ideas about subject-matter.

Subjects suitable for painting were arranged in a hierarchy of superiority. History painting, together with religious and mytho-logical subjects, were considered the highest, with portraits, landscape, still life and genre painting lower down the scale. The first three were thought to be superior because they were morally uplifting. History painting, in particular, was supposed to be about heroism and especially heroic death, preferably in classical times.

Poussin's picture of *The Death of Germanicus* is thought to be the first of its kind and seems to have been his own invention. Although it is not typical of much of his work, it was very influential on the whole development of the genre of history painting. In Poussin's theoretical writings, too, lies much of the basis for this kind of art, painted in what he called 'the grand manner'.

> The grand manner consists of four elements: subject or theme, concept, structure and style. The first requirement, fundamental to all the others, is that the subject and the narrative be grandiose such as battles, heroic actions and religious themes. . . . Thus the painter not only must possess the art of selecting his subject, but judgement in comprehending it, and must choose that which is by nature capable of every adornment and of perfection. Those who choose base subjects find refuge in them because of the feebleness of their talent. Artists should thus scorn the sordidness and baseness of subjects far from every artistry that might be used therein.
>
> (quoted in Holt, *Documentary History of Art*: vol. 2, 144)

In this passage Poussin suggests that by choosing grand and historical subjects, the artist sets his mind on higher things. The theory sounds all right and certainly the academic training was rigorous and thorough. Unfortunately, though, these high ideals tended to give rise to much painting that was dour and difficult.

As we shall see in the next section, it was the high value placed on remote classical history subjects that the English painter Hogarth objected to, rather than their moral content. He wanted to find a way to communicate this kind of message more directly.

SCENES OF EVERYDAY LIFE WITH A MORAL

Plate 48 *Marriage à la Mode I: The Marriage Contract* by William Hogarth, 1743

Hogarth certainly wanted his pictures to be looked at as narratives, almost to be read like a book or experienced as a play. He was profoundly influenced by the theatre, and the most innovative part of his work was what he called his 'comical moral history paintings'. He did them in series with scenes following on from one another. They were given titles like *The Harlot's Progress* (1729), *The Rake's Progress* (1733) or *Marriage à la Mode* (1743) and were intended to satirise the customs and moods of the day and their conse-quences. They were designed to be turned into engravings for publication and accompanied by a commentary in which we see what happens to the characters.

The *Marriage à la Mode* series describes the customs and results of an arranged marriage organised for economic and snobbish reasons. In the first episode we see Lord Squander getting ready to sign the contract. Here is a descriptive summary in modern English of Hogarth's commentary, which appeared on the bottom of the engravings.

A marriage of economic convenience is being arranged at the house of the groom's father, Lord Squander. The dowry, a good if costly investment for the miserly alderman who scrutinises the settlement, will replenish the funds of the gouty Earl who points out his pedigree and ignores the clerk who calls his attention to the unpaid mortgage.

The plight of their children is reflected in the chained dogs. Viscount Squanderfield gazes into a glass while his prospective wife receives the attention of Councillor Silvertongue, the lawyer in the settlement.

Besides exhibiting the Earl's poor taste, the Old Master copies on the walls – scenes of violence, murder and martyrdom – intimate the consequences of the match, while the source of his financial straits, and ultimately of the marriage itself, can be

Plate 48 William Hogarth, *Marriage à la Mode I: The Marriage Contract*, 1743. Oil on canvas, 69.9 × 90.8 cm. The National Galllery, London.

seen through the open window. It is a half finished building, a blundering example of the Palladian style, introduced in this form by Burlington and Kent.

(Hogarth Catalogue, Tate Gallery: 62)

From this, we understand not just what the participants are doing and who they are, but what the pictures on the walls signify (rather difficult to see in a small reproduction), why the Palladian villa is unfinished and that there is an unpaid mortgage. Hogarth piles on the details in order to enable the spectator to seek them out like a detective, or perhaps to make the effect more like the theatre, where scenery, props and costumes are made to reflect the characters and their lives. The commentary does the job of the dialogue in a play. In his aesthetic theory called *The Analysis of Beauty*, which was published in 1753, Hogarth talks about paintings in which the eye is invited to go on a voyage of discovery:

This love of pursuit, merely as pursuit, is implanted in our natures, and design'd, no doubt, for necessary and useful purposes. . . . It is a pleasing labour of the mind to solve the most difficult problems; allegories and riddles, trifling as they are, afford the mind amusement: and with what delight does it follow the well-connected thread of a play, or a novel which ever increases as the plot thickens, and ends most pleased, when that is most distinctly unravell'd?

(quoted in Holt, *Documentary History of Art*: vol. 2, 270)

He then goes on to discuss what he calls 'intricacy . . . that leads the eye a wanton kind of chase and from the pleasure that gives the mind, entitles it to the name of beautiful'. So, the mind was as important as the eye in the appreciation of his pictures. Hogarth was a contemporary of the writer Henry Fielding. They both had very definite ideas about this sort of painting. In the Preface to the *Marriage à la Mode* series Hogarth refers the reader to the introduction to Fielding's novel *Joseph Andrews*. There Fielding writes about the serious moral purpose underlying the comical history paintings. He says that Hogarth's characters appear to think rather than being mere caricatures:

It has been thought a vast Commendation of a Painter, to say that his Figures *seem to breathe*; but surely it is a much greater and nobler applause, *that they appear to think*.

(quoted in Hogarth Catalogue, Tate Gallery: 60)

Hogarth was reacting against the idea of history painting being buried in subjects from classical times. He tried to create a new genre which would appeal to a wider section of the community than just the educated elite. The engravings sold well; they brought him an income and enabled him to achieve his aim. Above all, he wanted his work to be relevant to the present rather than the past and to continue to have a moral content. Hogarth's paintings still speak to us vividly today and can sometimes make us laugh, once we understand that they need to be 'read' as well as looked at.

LITERARY SUBJECT-MATTER

Plate 49 *Mariana* by Sir John Everett Millais, 1851

There is a sense in which all narrative painting is literary because it tells a story and is often derived from literature. You can say that religious subjects come from the Bible, mythological ones from classical literature, and Hogarth's work, as we have seen, was inspired by the theatre and connected with the novel. Even Poussin's history painting was derived from the story told in the Roman history of Tacitus. However, the term 'literary' in relation to subject-matter can also be used in a more direct way when it applies to a specific book or poem. In the nineteenth century it was used in this way by artists like the Pre-Raphaelites. Millais's painting of *Mariana* refers directly to a passage in a poem of that name by the Victorian poet Alfred Lord Tennyson:

> She only said, 'My life is dreary,
> He cometh not', she said:
> She said, I am aweary, aweary,
> I would that I were dead!'
>
> (Tennyson, *Selected Works*: 4)

Mariana in the poem is based on a character in Shakespeare's play *Measure for Measure*. She is deserted by her lover Angelo when she loses her dowry in a shipwreck. Here we see her pining for his return, in a room in the moated grange in which she was confined for five years. In the play she and her lover are reunited, but neither Tennyson nor Millais give us any inkling of this. As in the work of Hogarth, information is conveyed by detail. The altar with the communion lamp and the Early Italian altarpiece refers to the fact that in the play Mariana prays to the Virgin Mary. It is also a reference to the

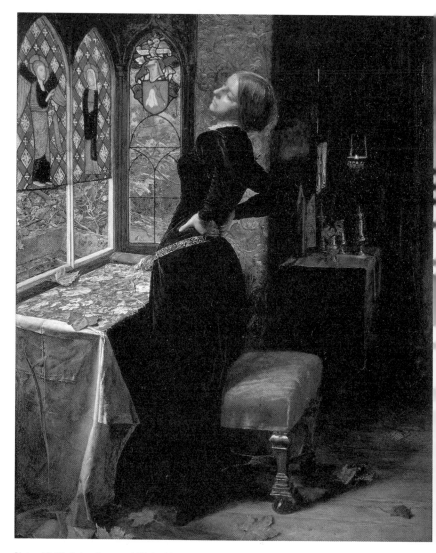

Plate 49 Sir John Everett Millais, *Mariana in the Moated Grange* (*Shakespeare*), 1851. Oil on panel, 59.7 × 49.5 cm. The Makins Collection, The Bridgeman Art Library, London.

Pre-Raphaelite painters' enthusiasm for Italian art before 1500 or 'pre-Raphael'. The Pre-Raphaelite painters were part of the revival of interest in medieval art which had been fuelled by the writings of John Ruskin. He was a supporter of the Pre-Raphaelites and believed in descriptive detail as a conveyor of truth and realism. In this picture, much of the setting is based on places in Oxford where the Pre-Raphaelite Brotherhood originated. The stained-glass windows were copied from Merton College chapel and the velvet for Mariana's dress was bought in a local shop. The view from the window was painted in the garden of Thomas Combe, printer to the university and patron of the Pre-Raphaelites. This sort of painting is a kind of book illustration and, indeed, it was turned into a wood engraving for that purpose in 1857.

The idea of accuracy and truth in art delivered through descriptive detail was very important to the Pre-Raphaelites. This brings us to another very interesting area surrounding the whole question of realism in painting. By this I do not mean the philosophical problem of what is reality or even the subject of perception and how we see, but the fact is that artists since the Renaissance living at different periods have been making reference to the world around us in their pictures. More abstract interpretations in the twentieth century often have their basis in visual reality, and of course medieval art refers to the natural world, even if it does not interpret it in a naturalistic way. So, what we might consider asking ourselves is not so much whether pictures portray the real world but why they look as they do and in what different ways they are convincing. They are always a product of their period and its visual language, even though we can still appreciate them today.

THE SIGNIFICANCE OF THE INTENDED SETTING FOR A PICTURE AND THE ROLE OF RESTORATION

Plates 50, 51 and 52 *The Madonna Enthroned* by Masaccio, 1426, *Virgin and Child with St George and St Anthony Abbot* by Antonio Pisanello, *c.* 1450 and *Portrait of the Doge Leonardo Loredan* by Giovanni Bellini, *c.* 1501–5

In our discussion of different kinds of narrative subject-matter we have seen that the visual appearance of paintings is connected with the historical background of ideas from which they came. This

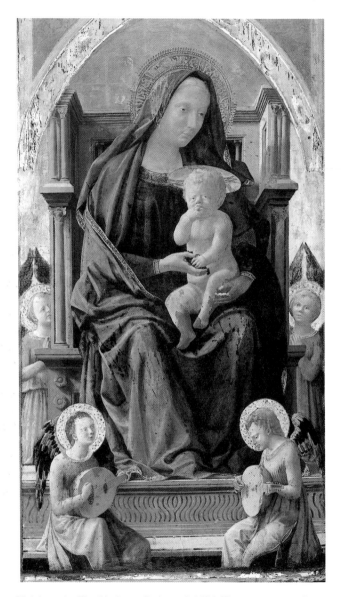

Plate 50 Masaccio, *The Madonna Enthroned*, 1426. Tempera on panel,
135.3 × 73 cm. The National Gallery, London.

is interesting in another historical sense, too. When we go into a museum we are not always aware of exactly what it is we are looking at. When you stand in front of *The Madonna Enthroned* of 1426 by Masaccio in the National Gallery in London, for example, you admire it as a single picture. Even though it is set against a flat gold background, the sense of the physical existence of the mother and child is very real and convincing. But we are not looking at this picture as it was intended to be seen, because it was originally part of an altarpiece, a multi-panelled structure known as a polyptich (see Figure 4). The other panels are in museums all over the world and are unlikely ever to be brought together; even if they were, some of them are lost and there is disagreement amongst scholars about how they would have been arranged. So, what we see now in the gallery is necessarily incomplete. We need to be aware of this fact in order to look at the picture in a more informed way.

Then there is the question of restoration and how much that can alter the intended appearance of a picture. Also in the National Gallery there is a small and exquisite panel by Pisanello, another fifteenth-century Italian artist, of *Virgin and Child with St George and St Anthony Abbot*. The costume of St George was almost completely repainted in the nineteenth century. So, although we can admire the beautiful surface decoration of the picture, we are not looking at a work which is completely by Pisanello's hand, even though it is the only signed painting by him – you can see his name 'Pisanus Pinxit', amongst plants in the foreground. This kind of question also applies to the frame which is nineteenth century. Sometimes, even if the frame is contemporary in terms of date, it may not have been intended for that picture. Bellini's *Portrait of the Doge Loredan* in the same gallery is a case in point. It is framed in what was probably originally a tabernacle frame for a religious painting and therefore it is correct in terms of date only. This question of frames applies to paintings of any period, because they can be changed easily by the patron or subsequent owners. Frames can alter the appearance and effect of a picture and are another factor in the question of its original context and how it appears to us now.

Figure 3a Reconstruction of the surviving fragments of the Pisa polyptych (after C. Gardner von Teufel)
Source: J. Dunkerton, S. Foster, D. Gordon and N. Penny, *Giotto to Dürer* (Yale University Press and The National Gallery, 1991). Reproduced with permission.

Figure 3b Reconstruction of the surviving fragments of the Pisa polyptych by Masaccio by John Sherman
Source: J. Dunkerton, S. Foster, D. Gordon and N. Penny, *Giotto to Dürer* (Yale University Press and The National Gallery, 1991). Reproduced with permission.

Plate 51 Antonio Pisanello, *Virgin and Child with St George and St Anthony Abbot,* c. 1450. Tempera on panel, 47 × 29 cm. The National Gallery, London.

Plate 52 Giovanni Bellini, *Portrait of the Doge Leonardo Loredan*, c. 1501–5. Oil with some tempera on panel 61.5 × 45 cm. The National Gallery, London.

SUBJECT-MATTER AND IMAGE MAKING: CLARITY AND AMBIGUITY IN COMMUNICATING A MESSAGE

The creation of strong and powerful images where visual impact is more important than the telling of a story is another aspect of subject-matter. This kind of picture often includes an element of propaganda, which means the need to convey a partisan or selective point of view. This can be the idealisation of a likeness, as in a royal portrait, or the making of a hero, as in political propaganda painting. The visualisation of political, social or moral protest is also important and can be seen, for instance, in German art after the First World War. In this section we will consider the work of Rigaud, David, Dix, Manet, Ernst and Warhol in these terms.

Plate 53 *Portrait of King Louis XIV* by Hyacinthe Rigaud, 1701

From the sixteenth century onwards the royal portrait became much more than a mere likeness. Here, the spectator is made to look up at the king from below. He is standing on a dais, so he appears taller and more imposing than he probably was. He is presented in a swaggering position, showing off his silk-stockinged leg and with his foot pointing forwards, his left hand on his hip and his right holding a cane. This effect is augmented by the extraordinary amount of detail in his costume: the ermine, the fleur-de-lys, the sword, the elaborate heeled shoes and the frilled lace on his sleeves and cravat. Then there is his throne, his crown and the large curtain and pillar in the background, making us see that his surroundings are equally grand. He is first and foremost an image of kingship and power. In his looks he is idealised. The likeness is there so that he can be recognised, but we certainly do not see him 'warts and all'!

Plate 54 *The Death of Marat* by Jacques-Louis David, 1793

David's famous image presents Marat as a hero and martyr of the French Revolution after he had been murdered in his bath by Charlotte Corday. The episode is turned into a heroic death scene like the history paintings of classical heroes. At this stage in his career David believed totally in the Revolution and in the possibility of communicating its message through contemporary rather than

Plate 53 Hyacinthe Rigaud, *Portrait of King Louis XIV*, 1701. Oil on canvas, 277 × 184 cm. The Louvre, Paris.

Plate 54 Jacques-Louis David, *The Death of Marat*, 1793. Oil on canvas, 63¾ × 49⅛ in. Musées Royaux des Beaux Arts, Brussels.

ancient subject-matter. In fact, of course, we know that Marat was a scurrilous journalist who spent his time assassinating the characters of those whom Robespierre wished to send to the guillotine. He suffered from an irritating skin condition which he had contracted while hiding in the sewers, and sitting in a bath was the only way he could alleviate it. We also know that in reality this murder would have been extremely messy. But David has sanitised it and does not show us anything except the bare essentials like the knife, his pen and inkwell and the letter in his hand. The knife wound and the blood are tidied up for the benefit of the idealised image David wishes us to see. Marat sits in the bath with just enough blood staining the sheets and the water he is sitting in to indicate what has happened. We feel the weight of his right arm and the lolling angle of his head and we know he is dead. By steering a course between accurate reportage and idealisation David convinces us that Marat was a hero and martyr for his country, even though we know otherwise from the historical background. In this sense, it is a fine example of political propaganda painting.

Plate 55 *Skat Players* by Otto Dix, 1920

Here we see an almost unbearable picture of grotesquely wounded soldiers playing cards together. They are sitting in a café with the daily papers on sticks behind them and a hat stand to the right. The minutely detailed way the picture is painted helps greatly to convey the horror, in the sense that the spectator is forced by macabre curiosity to closely inspect the arrangement of the objects in order. For instance, the pipe coming out of the ear of the man on the left ends in an ear trumpet which is resting on the table. Then you find yourself looking for limbs and you notice that the man on the right has two prostheses for his left hand and a whole mechanical right arm. The man in the centre has no arms or hands at all and has to use his mouth to hold the cards. The legs are equally awful, in that the figure on the right has none at all, the one in the middle has two peg legs and the man on the left has one and uses his surviving foot as a hand. By looking for the details and finding out what they mean, you are gradually led to a fuller understanding of the subject and its message.

This kind of minute treatment of the real world was known as Verism. The movement to which Dix belonged was called the New Objectivity or Neo-realism, in which copying of surface detail would

Plate 55 Otto Dix, *Skat Players*, 1920. Oil on canvas with collage, 110 × 87 cm. Private collection on loan to the Galerie der Stadt, Stuttgart.

enable the artist to make the spectator aware of an important inner truth about human beings and the horrors they are capable of inflicting on one another. Dix has produced a memorable and enduring image of man's inhumanity to man. He based this painting and others on photographs of the human cost of war which were being published in Germany at this period. But the effect is more horrific than a photograph because of the caricatural elements. Dix makes it more poignant still by juxtaposing these maimed figures with the idea of enjoyment and the playing of a game.

The visualisation in all these pictures is very clear. We know what the artist wants us to see and how he wishes us to think. But there are other kinds of images where the information we are given is deliberately ambiguous. The message here is that things are not always as they seem, that appearances can be deceptive. The spectator is made to feel uncertain and is asked to question and to try to find out what is going on. We will go on to explore ambiguity in a number of contexts: in a social sense in Manet's *The Bar at the Folies Bergère*, in relation to fantasy in Ernst's *The Elephant Celebes* and in the serial image with Warhol's multiple portrait of Marilyn Monroe, *Twenty-five Colored Marilyns*.

Plate 56 *The Bar at the Folies Bergère* by Edouard Manet, 1881–2

This is a painting of a modern urban subject from the latter part of the nineteenth century. The idea that subjects should be contemporary was the result of a long development but was expressed most cogently by the poet and critic Charles Baudelaire. In the title work of his book entitled *The Painter of Modern Life and Other Essays*, which was originally published in 1863, he advocated modernity particularly in relation to the city scene. Manet and his contemporaries were familiar with this view. Nightclubs like the *Folies Bergère* or the *Moulin Rouge* were a new and developing phenomenon in Paris at that period.

When you first look at Manet's picture you believe you are seeing a beautiful barmaid serving customers with drinks, and on one level this is certainly true. You assume that the girl is reflected in the mirror to the right serving the man in the top hat and that the people behind her are also reflections, as are the bottles on the marble shelf.

Then, quite quickly, you realise that all is not quite as it seems. The back view of the girl to the right is in the wrong place to be a

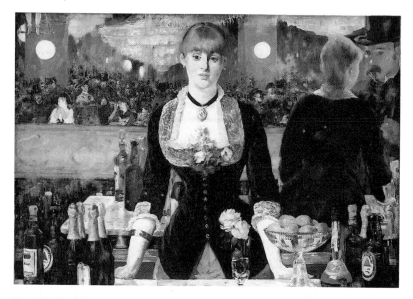

Plate 56 Edouard Manet, *The Bar at the Folies Bergère*, 1881–2. Oil on canvas, 96 × 130 cm. Courtauld Institute Galleries.

reflection of the one in the foreground, and the bottles behind are not the same as those in front. So then you start to wonder whether the buff horizontal section is the frame of the mirror rather than the gilt line under the marble slab. This would mean it is only reflecting the crowd in the background. But then, if that is the case, why is that gold line running in front of the girl behind and where is the lower part of her body?

If the girl in the centre is not serving the male customer, who or what is she looking at? If the whole of the background is meant to be a reflection, why is there more recession on the left than on the right? Then you look back at the face of the barmaid and consider whether you, as the spectator, are meant to be her customer. Then you see that she is not looking at anything. She appears distracted, caught in a moment of reverie and isolated by her thoughts from those around her.

Manet has created an interior which appears to be logical but which, in fact, is not. This encourages disorientation and uncertainty in the mind of the onlooker; it stimulates questions about who and where the girl is which cannot entirely be answered because of the position she is in. She starts to appear isolated, lost

and unable to communicate directly, perhaps prompting thoughts about the alienation of modern urban life. The result is a fascinating and beautiful image which is also marvellously ambivalent. It explores brilliantly the idea that appearances can be deceptive and poses the question of whether we can ever see things as they really are.

Plate 57 *The Elephant Celebes* by Max Ernst, 1921

This is an imagined or fantastic image, but it is also deliberately ambiguous because it seems to have a number of possible meanings. At first, you think you know what it is and then your visual assumptions are rapidly made to change. If you have noticed the title, you will immediately think that it must have something to do with elephants. So you look for the configurations of an elephant: the trunk, the small eye, the feet and the greyish-green colour. But there is a hard metallic quality about the surface. The head could resemble an army helmet and the trunk some kind of pipe ending in a bull's head with characteristics of a gas mask. The picture was painted in 1921. It is surprising how many people see a bellicose connection with memories of the First World War. In fact, Ernst is supposed to have based the painting on a picture he found in an English anthropology journal of a Sudanese clay grain vessel. He transposes this image into something more like a cauldron with an exhaust pipe on its lower left-hand side and smoke apparently rising from high up on its right.

It looks powerful and aggressive, mainly because of its size in relation to its surroundings. It dominates the horizon and there is nothing to indicate where it is. We wonder whether there is a shore line in the background, what seems initially to resemble a cloudy sky has fishes swimming in it on the top left-hand side. This feeling of spatial disorientation is augmented by the presence of the decapitated woman and the curious semi-human phallic structure behind her on the right. Then what are the objects coming out of the lid of this diabolical container? Catalogue descriptions of the painting say that they are artist's materials, but whatever they are they are not what you expect to see coming out of the head of an elephant or the top of a cauldron.

Ernst was influenced by the metaphysical paintings of Giorgio de Chirico in which spatial disorientation plays a large part. He was also interested in the use of collage which, as we have seen in the

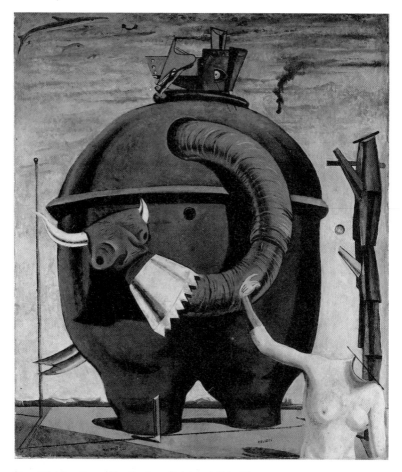

Plate 57 Max Ernst, *The Elephant Celebes*, 1921. Oil on canvas,
125.4 × 107.9 cm. The Tate Gallery, London.

work of Rauschenberg (Chapter 1) and Schwitters (Chapter 3), uses
found objects and puts them together in unexpected ways. This
picture is painted in the normal way but uses that same technique
of juxtaposition. More significantly, Ernst was a founder-member of
the Dada and Surrealist movements which took these ideas further.
They were interested in the theories of Freud and his recognition of
the importance of the unconscious mind and dreams.

Amongst the basic tenets of psychoanalysis was the idea of free
association, which releases feelings stored in the unconscious into

the conscious mind of the patient. These factors are all relevant in relation to what Ernst was doing. They give us some insight into the imaginative strength of his work. Ernst succeeds in communicating with us on an irrational level with all the force of a nightmare. This painting, like an image in a dream, can be interpreted in a number of ways, none of which are certain.

Plate 58 *Twenty-five colored Marilyns* by Andy Warhol, 1962

Another area where ambiguity is paramount is in the idea of the serial image. In these portraits of Marilyn Monroe, Andy Warhol explores the idea of multiplicity in relation to likeness. How can we know who the real person is if every picture is different? When you look into each square in this painting you see that there are tiny variations in every one. The changes are in the green eye-shadow or the lipstick or the hair, or in all three. Sometimes it is the tonal quality which changes. But every picture starts with the same basic photographic image. Warhol is exploring not only the minute visual differences, but the way multiplicity can alter our sense of what is real. How do we know which is the true Marilyn Monroe? Her name has become confused with her image both as a film star and in photographs. Is this picture one painting with a number of faces in it, designed to be seen as a total arrangement, or are we supposed to look at each likeness individually?

Warhol was a member of the Pop Art movement of the 1960s, which advocated the return to figurative subjects taken from the contemporary world in reaction to the visual obscurity of abstract painting. Here he is asking us to confront the world of advertising and film and to stop and consider it rather than just accepting it and allowing it to take us over. A painting on a gallery wall requires the spectator to be active, to take part, to look and to think about the implications of what he or she is looking at. Faced with the media, on the other hand, where everything is packaged for us, we are encouraged to accept passively whatever is put in front of us.

At first, you wonder what this picture is about because it seems to resemble so much of what we see around us. But, on reflection, one realises that by deliberately exploring the minutest differences between the pictures Warhol is perhaps asking us to question their veracity. Whatever appears to be blandly regular and superficially a perfect reproduction of a likeness may be masking complexities and ambiguities of meaning which could pass us by. Warhol was trained

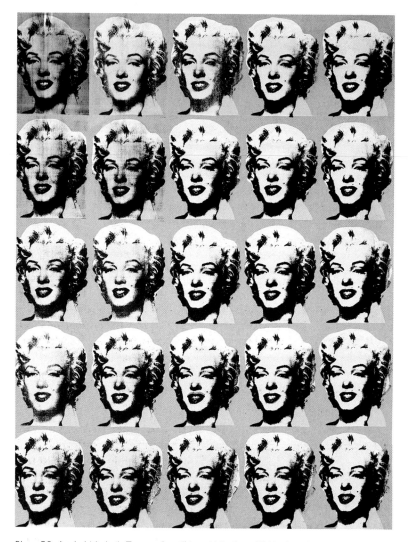

Plate 58 Andy Warhol, *Twenty-five Colored Marilyns*, 1962. Acrylic on canvas, 209 × 169.5 cm. Collection of the Modern Art Museum, Fort Worth, Texas.

as a commercial artist and worked in advertising himself for a number of years. Later in life he also made films. He knew about these worlds from the inside. Although he called his studio 'The Factory' and referred to himself as a machine, I think he communicated with us on a deeper level. He seems to be saying that, if we accept too easily what we see before us, we could lose our capacity to think for ourselves about what may or may not be true.

SUBJECT-MATTER AND THE IDEA OF ABSTRACTION

Plate 59 *Composition* by Piet Mondrian, 1929

Pollock, Kandinsky and Rothko, whom we have already looked at, abandoned figurative subject-matter for various reasons. Mondrian, however, came to believe that figuration was not necessary, largely through his study of landscape. He evolved a complex theory which he named 'Neo-plasticism'. He developed a series of semi-mystical ideas about the fundamental relationship between horizontals and verticals and the underlying geometry of the natural world.

> We find that in nature all relations are dominated by a single primordial relation, which is defined by the opposition of two extremes. Abstract plasticism represents this primordial relation in a precise manner by means of the two positions which form the right angle. This positional relation is the most balanced of all, since it expresses in a perfect harmony the relation between two extremes, and contains all other relations.
>
> (quoted in Chipp, *Theories of Modern Art*: 323)

From about 1917 onwards Mondrian's paintings were reduced to horizontal and vertical lines on a flat white surface with blocks of primary colour strategically placed between. The formal or pictorial relationship between the blacks and the whites, the squares and the rectangles, and the primary colours becomes the subject-matter of the picture. On the left-hand side, the black lines appear to lift off the surface and the upright oblong piece of white seems to move behind them; the central square on the other hand seems to be in front of the horizontals and verticals surrounding it. The horizontal black line in the upper part of the picture is on the Golden Section; it does not quite reach the edge of the canvas on the left whilst all the others do.

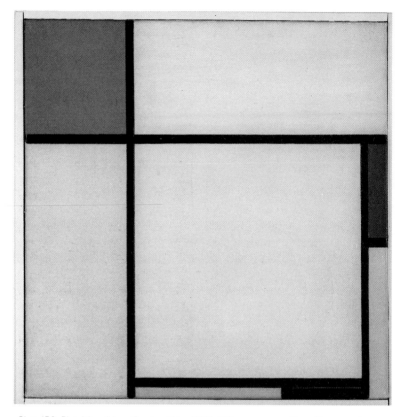

Plate 59 Piet Mondrian, *Composition*, 1929. Oil on canvas, 45 × 45 cm. Solomon R. Guggenheim Foundation, New York,.

We are supposed to look for all these nuances and experience the surface as flatter in some places than in others. In some ways this can be exciting, but it requires a degree of purely visual understanding which is often difficult for the uninitiated observer to cope with. Is this picture as sophisticated in its own way as Botticelli's *Primavera*? This reduction of painting to its most basic visual elements was regarded by some artists like Malevich and Ad Reinhardt as heralding the end of painting in the traditional sense. Certainly, today, there are types of art as we have seen which do not belong to any traditional category like painting or sculpture. There is also the movement known as 'minimalism', which aims to reduce every aspect of a work of art to its minimum.

Most critics and art historians would agree, I think, that the

return to figuration in movements like Pop Art, for instance, makes painting more accessible. A recognisable subject, after all, allows for the formation of a bridge or mutual point of contact between the spectator and what the artist is trying to communicate.

POETICAL SUBJECTS

Plate 60 *The Halt during the Chase* by Antoine Watteau, 1720

In this painting Watteau shows us a group of finely dressed figures in a woodland clearing. On the right is a woman in yellow being helped from her horse by an elegant gentleman. Other members of the party have already dismounted and are sitting on the ground spread out along the foreground of the picture. In the middle distance are a man and a woman with their backs to us. Another man is holding the hands of a woman who is sitting down. The title tells us that they are resting while out hunting. Huntsmen, horses and dogs are all here, but we do not feel that that is what the picture is really about. Instead, we are asked to wonder about it. Who are the people and what are they doing? As most of them are couples, is it about love and dalliance in the woods? We do not know but we feel that it might be.

The atmosphere that Watteau creates leads us to thoughts of pleasure, and yet there is a wistful sensation of transience at the same time. The experience is like music or poetry in the sense that the picture moves us, but we do not know why. We do not see anybody's face completely, except for that of the woman in the centre who looks out at us and appears to invite us to join them. The landscape is idealised and yet we believe in it as if in a dream; the background fades into nothingness so that we are not even sure where the horizon is. We enjoy this picture as a series of suggested meanings. We provide them for ourselves rather than being told by the artist what we ought to think and feel. Watteau is the opposite of his near-contemporary, Hogarth who, as we have seen, wanted his paintings to point out a particular moral.

In his poetic interpretation and his use of the natural world as a kind of Arcadia, Watteau joins a long line of artists with similar pre-occupations – Titian, Rubens, Boucher and Fragonard. In the nine-teenth and early twentieth centuries this tradition was revived by the Impressionists Monet and Renoir, and later by Matisse and Bonnard. There is real continuity here, in that we know that Rubens looked at

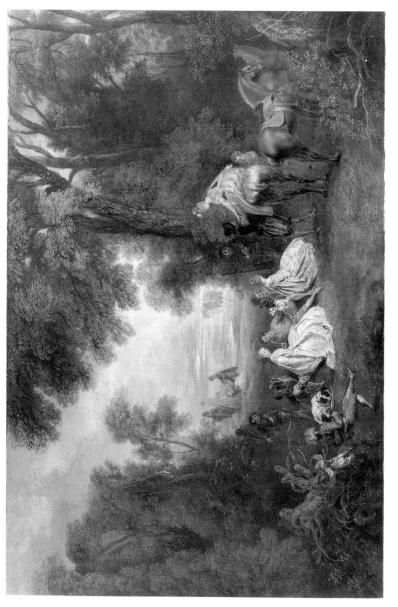

Plate 60 Antoine Watteau, *The Halt during the Chase*, c. 1720. Oil on canvas, 124 × 187 cm. The Wallace Collection, London.

Venetian art, Watteau studied Rubens, and then Boucher and Fragonard were in turn influenced by Watteau. Renoir was trained in this eighteenth-century French Rococo tradition as a painter on china and there was a revival of interest in the Rococo period during the second half of the nineteenth century. In fact, it might be argued that one of the reasons why the Impressionist painters are so popular today is because they present a modern equivalent for a pastoral paradise. They often show us urban middle-class people at leisure in semi-rural or suburban situations where there is no traffic, no congestion and no noise.

SUBJECT-MATTER AND THE IDEA OF PAINTING AS POETRY

Plate 61 *Concert Champêtre* by Giorgione and/or Titian, *c.* 1510

The idea of painting as a kind of poetry where subject and meaning are not specific is believed to have originated with the Venetian artists of the early sixteenth century like Giorgione and Titian. Pictures like the *Concert Champêtre* (thought to be by Giorgione and/or Titian) show figures in a landscape setting for no clearly discernible reason other than enjoyment and aesthetic pleasure; they were actually referred to as 'poesie' as if they were poems. Leonardo's *Treatise on Painting* is also held to be important because of its emphasis on the painter's imaginative powers. The famous passage usually referred to is the one where Leonardo talks about the ability of the artist to conjure up any aspect of the natural world:

> And if he wishes to produce places or deserts, or shady and cool spots in hot weather, he can depict them, and similarly warm places in cold weather. If he seeks valleys, if he wants to disclose great expanses of countryside from the summits of high mountains, and if he wishes to see the horizon of the sea, he is lord of them, or if from low valleys he wishes to see high mountains, or from high mountains to see low valleys and beaches.
>
> (Leonardo, *Leonardo on Painting*: 32)

This is rightly regarded by Gombrich (in *Norm and Form*) and others as an important theoretical source for the development of landscape painting. Landscape came to be highly regarded by many artists and their patrons from the sixteenth century onwards. We

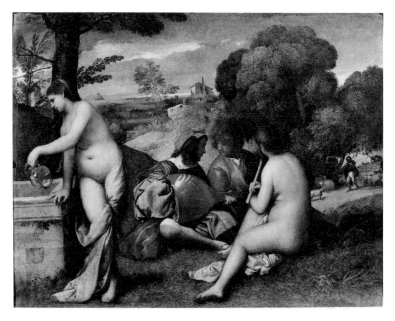

Plate 61 Titian and/or Giorgione: *Concert Champêtre, c.* 1510. Oil on canvas, 105 × 136.5 cm. The Louvre, Paris.

have looked at landscapes in other parts of this book, where pictorial considerations have been uppermost. This is because, along with still life and genre subjects, landscape painting tends not to have a message to communicate. Concern is more with painting for its own sake, creating an atmosphere and allowing the spectator to form his or her own conclusions. This relates closely to the equation we have been discussing between painting and poetry, which was really given respectability during the Renaissance by its association with the pastoral poets of the classical past like Horace, Ovid and Virgil. Horace particularly married painting and poetry in his famous phrase 'ut pictura poesis' – as in painting, so in poetry.

CONCLUSION

In this chapter we have been discussing the subject-matter of pictures and how important this is for different reasons, even when there does not appear to be a meaning behind the chosen image. But, in a way, one of the most interesting aspects of this whole field is the one that we have just been considering. Should a painting

convey a message or exist simply for pleasure and enjoyment? Matisse is famous for saying that painting should be like a good armchair in which to rest after a hard day's work, whilst his contemporary, the German Expressionist painter Kirchner, drew a contrast between this attitude and what he considered to be a more serious kind of expression. He equates it with the difference between the German and Latin temperaments:

> How basically different are German and Latin artistic creation! The Latin attains his form from the object, from the form in nature. The German creates his form out of fantasy, out of his inner vision – and the form of visible nature is a symbol to him. . . . For the Latin beauty lies in appearance, the other seeks it beyond things.
>
> (quoted in Myers, *Expressionism*: 101)

Another artist who made an equally well-known assumption about subject-matter was the late nineteenth-century symbolist painter Maurice Denis. In his definition of what he called 'Neo-traditionalism', he contended that painting is essentially abstract and is concerned with pictorial qualities more than with communicating a message, telling a story, or creating a poetic atmosphere:

> I. Remember that a picture before it is a war horse, a naked woman, or some anecdote, is essentially a flat surface covered with colours arranged in a certain order.
>
> (quoted in Holt, *A Documentary History of Art*: vol. 3, 509)

In the end, of course, there are no right or wrong answers to this discussion. But, having explored some different types of subject-matter and issues connected with them we can see that it is important because it is integral with the whole work of art. It can help us to look at paintings in a context which can be enlightening and can add a further dimension to our visual understanding and enjoyment of them.

Chapter 7

Drawing and its purposes

INTRODUCTION

Drawings can seem more difficult to approach than paintings. This is partly because often they have no colour and because they can seem fragmentary and unfinished. They require keener observation and greater patience on the part of the spectator. Even more than with paintings, the art of looking at drawings lies in knowing what to look for like the flexibility in the use of the drawing instrument and the variety and skill with which the different strokes are made. Sometimes, especially if drawings are very old, the paper may be discoloured and what is called 'foxed' with marks caused by damp and/or fungal growth. This can make them appear less attractive at first. The fact that they are incomplete need not necessarily be a disadvantage, though, because they are by their very nature much more immediate than paintings and so can give us greater insight into the process of making a work of art.

Most artists would agree that drawing is of supreme importance for all sorts of reasons. It is a craft which essentially has to do with the training of the co-ordination of hand and eye through constant practice. It then enables the artist to translate whatever he sees onto the paper, often more quickly and spontaneously than in a painting. Drawing is intimately connected with all kinds of looking and visualisation. We have already explored some aspects of drawing in association with the use of tone. In Chapter 3 we saw how Seurat used tonal drawing techniques to help him with colour and the development of pointillism. Later on, in Chapter 4, we looked at how Rembrandt manipulated tone for emotional expression equally powerfully in his drawings, paintings and prints. However, the purposes of drawing are many and various and cover much more than this. They can, of course, be preparations for paintings or just

studies which an artist has made from observation of something which interested him or her, like jottings on a notepad. This can include trying out possible subjects or arrangements. The use of drawing for more imaginative purposes, that is, to generate ideas and help invention, is regarded as one of its key functions. Making drawn copies from the work of other artists is also useful, because it can help to solve technical and formal problems to do with composition, for example. In the past, copying from engravings of pictures was very important in this context, as we shall see in the next chapter. Sometimes, drawings can be much more like a finished work of art than any of these types, particularly if they are done for a patron as what is called a 'presentation drawing'.

There are also a large number of techniques connected with drawing, for example, those done in charcoal or red or black chalk. White chalk can be used on coloured paper or for highlights on a charcoal or red or black chalk drawing. Graphite, like the lead in pencils, was used from the sixteenth century. Pencils with graphite set in wood came from Cumberland in the late seventeenth century. Variations in the hardness and softness of pencils were developed in France by Nicolas Jaques Conté, who mixed clay with graphite in different proportions. He patented the pencil as we know it from 1795. All these methods replaced metalpoint and silverpoint, which were less flexible and could only be used on specially prepared paper. There are other techniques, where pen and ink and the brush are used, which can extend into watercolour put on as a wash. This can then become virtually a painting when colour is added. The same kind of range applies to pastels, which are pigments bound with gum. They can broaden drawings from something done just in black and white to include the use of a wide variety of opaque colours, when they too become more like paintings.

The idea of completeness or of something that is finished is a concept that we are not nowadays so concerned with because we no longer have such set attitudes. It comes from the belief in drawing as something which is preparatory to a painting; a sketch in other words, which records the artist's development of an idea. In the academic tradition, the theory of what was finished or unfinished became very rigid and depended in painting on working with fine brushes to create a smooth uninterrupted surface (see Poussin in Chapter 6 or Ingres in Chapter 5 for examples of this). In the case of drawing, it meant grading the tones extremely carefully to convey the sculptural qualities of form, particularly in relationship to life

drawing. The observation and interpretation of the human body requires the most complex co-ordination of hand and eye and can act as a very effective discipline. You can see this clearly in the draughtsmanship of an artist like Toulouse-Lautrec (see Chapter 8 and colour plate 24), who had a very strong natural talent and innate caricatural style. His mature work benefited greatly from the control provided by his academic training, giving it a more concrete, solid and convincing quality. Since the end of the nineteenth century, which was the period when Lautrec was working, our thoughts about what constitutes a complete work of art have become much more liberal. Certainly, anything by the hand of a great artist is regarded as worth looking at. An extreme version of this is contained in the stories told about Picasso making drawings on his napkin in cafés and people picking them up as treasured examples of the master's skill.

Drawing did not always play such a multiplicity of roles in such a variety of techniques. Before the late fifteenth century it seems to have been used as a kind of total preparation for a painting or the detailed study of a particular subject, like Pisanello's drawings of birds and animals, for example. Of course, many of the drawings from earlier periods are lost, so we do not have such a complete record as we do from more recent times. But what seems fairly certain is that, until the late fifteenth century, drawing was not used for experimentation in the way that we now understand it. The growth of this attitude seems to have coincided with the use of the more flexible black and red chalk, although it is thought that these techniques were known about much earlier. Most scholars would agree that Leonardo da Vinci was the first to extend the possibilities of drawing and that this was connected with his view of the painter's imaginative powers, which we discussed in Chapter 6. We will begin by looking at one of his drawings.

DRAWING USED TO TRY OUT IDEAS

Plates 62 and 63 *Study for the Head of Leda* **by Leonardo da Vinci, c. 1505–7 and** *Study of a Kneeling Woman in the Expulsion of Heliodorus* **by Raphael (Raffaelo Santi), 1512–13**

Study for the Head of Leda is a preparatory drawing for a lost picture by Leonardo of *Leda and the Swan*. The painting was famous in its day and made more so by both painted and engraved copies. Here,

Plate 62 Leonardo da Vinci, *Study for the Head of Leda*, c. 1505–7. Pen and ink over black chalk, 19.8 × 16.6 cm. The Royal Collection, Windsor Castle.

Leonardo is experimenting with possibilities for the head and especially the hair. The pen and ink lines are not used to outline but to convey the feeling of form. As we saw in Chapter 3, Leonardo invented the technique of chiaroscuro to achieve this sense of form in painting. In drawing, he used a method where the closely spaced lines move across the form and indicate its shape and fullness by the direction in which they are moving. You can see this working on Leda's cheek. Slanting lines spread over the right-hand side of the face and down the neck, closer together in some places than in others. On the lower part of the cheek down to the jawline, they are straighter. On the flat side of the nose you can see the lines are crossed, a technique referred to as cross-hatching. On the neck and the forehead the lines are more curved. If you feel the side of your own face, nose and neck you will notice that Leonardo's inter-pretation corresponds with their planes and underlying structure.

In places, sharper outlines are used to indicate tone, as can be seen on the front edge of the nose, up into the eyebrows, on the left side of the face and across the shoulder. But, if you look care-fully at them, you will see that they are not continuous but thicker and darker in some places than in others. This variation in pressure is very important because it allows the eye to move and rest. By doing this, Leonardo creates an impression of life. But even though his use of the pen is fluid, Leonardo does not leave out anything vital. Notice how the head is turned in relation to the shoulders and how the ligaments in the neck are indicated by a slight change in the shaded lines where the neck joins the body. In this area you can see where the pen and ink lines have been put on top of initial strokes of black chalk, giving a more incisive effect. This is more obvious in the hair on the right of the head, where you can see how the black chalk underneath adds to the feeling of density and pliability. In the top left-hand corner of the sheet Leonardo has sketched some plaiting, so you can get an idea of what the black chalk looks like by itself.

The sense of forms in nature as living and growing is one of the strongest characteristics of Leonardo's drawings. He used drawing to express his interest in many aspects of the visual world, not just the natural but the mechanical and scientific as well. For instance, he studied anatomy intensively, dissecting bodies and drawing internal organs. He also observed the structure of water and rock formations. One of the most interesting aspects of this universality is the way one preoccupation seems to inform another, so that when

you look at the hair in this drawing it also reminds you of waves and currents. This is particularly true of the separate sketches of the hair, where it seems to take on a life of its own. Another remarkable effect is the sense of scale. The dimensions of this sheet are extremely small and yet the feeling conveyed is of a much larger size. This drawing is ostensibly developing ideas for a specific painting, but it also sets up resonances in our minds, giving imaginative insight into aspects of the world beyond this beautiful head of Leda.

One of the outstanding characteristics of Raphael's work is the ease, grace and effortlessness which it communicates. This, I think, is deceptive, in the sense that it can lead us to take for granted the extraordinary qualities of a drawing like *Study of a Kneeling Woman*. It was done for a fresco of *The Expulsion of Heliodorus* in the Pope's apartments in the Vatican, part of the same series as *The School of Athens*, which we considered in Chapter 2. The design of the kneeling figure in this drawing was used with few alterations in the final painting. For this, a more detailed cartoon or finished drawing of the whole composition would have been made for transfer to the wall.

The kneeling woman is made to appear to be moving in a three-dimensional space with the aid of a few lines of darker or lighter black chalk. Again, as in the Leonardo, there are no outlines as such; the key factor is the way the lines are made to move by being broken up and varied according to their lightness or darkness, their thickness or thinness and the angles at which they are set on the page. There is also great precision in the placing of the darkest tones to emphasise recession, around the waist, under the left elbow, at the side and nape of the neck and under the chin. This relates closely to the head and shoulders at the top right, too. Notice also how shading of similar tonal value is drawn behind the feet to throw the forms forward in the sketch in the bottom right-hand corner.

The drapery helps to enhance the turning motion of the woman's body. You see the buttocks beneath the light material and this convinces your eye of the pose of the underlying figure. Weight is added by the darker areas of clothing lower down. There is a visual relationship in terms of tone and pattern between the folds here and those higher up and in the turban.

The strokes of black chalk twist in different directions in the head, over the shoulder and in the lower part of the body until the whole figure appears to be swinging round in space. This sensation is

Plate 63 Raphael (Raffaelo Santi) *Study of a Kneeling Woman in the Expulsion of Heliodorus, c.* 1512–13. Black chalk, 39.5 × 25.9 cm. Ashmolean Museum, Oxford.

augmented by the whole arrangement of the drawing. The sketches on the right encourage a feeling of recession, whilst the space on the left, blank except for the faint drawing of a hand, appears to come forward. This is not a composition in the usual sense of a formal and thought-out design. Nevertheless, Raphael has put the drawings on the page in a layout which is visually satisfying. This is a quality often associated with great draughtsmanship. The interrelationship of form and space is so well understood that the main kneeling figure appears to be surrounded with air.

DRAWING AND SCULPTURAL EXPRESSION

Plate 64 *Christ on the Cross between the Virgin and St John* by **Michelangelo Buonarroti, *c.* 1554**

Michelangelo was a sculptor who also practised painting, architecture and poetry. But he was most interested in what is called 'sculptural expression', conveying first and foremost the feeling of solid forms contained within an outside edge. This is very evident in his late Crucifixion drawings, of which this is an example. By this time in his life Michelangelo was intensely preoccupied with a more spiritual attitude than that evident in his earlier work, such as the figure of Jonah which we saw in the introduction to Chapter 3. This increased emphasis on spirituality came about partly through Michelangelo's experience in Rome during the turbulent Counter-Reformation period of the sixteenth century. He was a member of a religious and mystical group concerned with reforming the Roman Catholic Church from within. One of its leading members was Vittoria Colonna, who became his friend and mentor. It is thought by Michael Hirst (*Michelangelo and his Drawings*) that three of these Crucifixion drawings were done for Colonna, probably as presentation drawings which were more highly finished than this one. But Michelangelo became very preoccupied with this subject in his private work too. Drawings such as this one are contemporary with the sculptures of the Pietà which he was working on at the same time.

In this drawing the forms are clearly marked out by their dark edges. The contrast between these and the light background make the spaces between the figures appear to press in upon them. The bodies do not move out and interact with the space in the way that we saw in Raphael's drawing. Instead, they are contained within

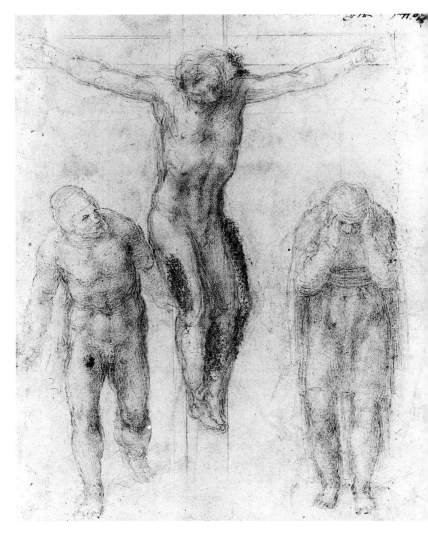

Plate 64 Michelangelo Buonarroti, *Christ on the Cross between the Virgin and St John*, c. 1554. Black chalk with white, 27.5 × 23.4 cm. Ashmolean Museum, Oxford.

their confines and the interior muscle structure is more developed, so we look at the body itself in more detail. We understand the stress and tension expressed in the torso of Christ by the way the stomach is pulled in and the ribcage distended. The tonal variation within the form expresses the configuration of muscles. The dark areas seem to push inwards from either side, leading the eye to concentrate on the shadows below the head as they move downwards, mainly towards the centre of the body. The vertical and horizontal lines of the cross help to emphasise this by the contrast with the awkward angle of the hanging Christ and the pain apparent in the nailed feet. The stretching of the arms to breaking point is expressed through the use of lighter tones in order to enhance the feeling of weight in the body; the hands are less developed so that we should focus on the central section of the composition. The figures of St John on the left and the Virgin on the right also help to define this area. They loom out of the space as solid forms expressive of grief and agony of mind.

When an artist works on the same subject over and over again, emotion can become extremely concentrated. You can see where this drawing has been considerably worked over with obvious changes of mind, as in the bending of Christ's knee. These visible corrections lend expressive vitality to the drawing. Sometimes they are covered over with white paint, adding to the sculptural quality of the legs and body of Christ, for example. The white chalk used for highlighting has oxidised and gone darker, giving the drawing a greyer appearance which makes the drawing seem even more mysterious and profoundly contemplative. The deep feeling Michelangelo communicates here comes over clearly in his sonnets of the same period.

With a vexatious heavy load put down,
O my dear Lord, and from the world set free,
I like a fragile craft turn to You, weary,
From tearful tempest into gentle calm.

The thorns and nails, the left and the right palm,
Your face, benign, humble, and filled with pity,
Pledge that for great repentance there is mercy,
To the sad soul give hope You will redeem.

(Michelangelo, 'Sonnet 288', *Complete Poems and Selected Letters*: 161)

LANDSCAPE DRAWINGS

Plate 65 *View with Trees* by Claude Lorraine, *c.* 1640

Claude Lorraine was primarily a painter of ideal or poetic landscape as we saw in Chapter 2. He became very interested in the theoretical side of landscape composition, too, publishing a number of possible alternatives in his *Liber Veritatis* (*c.* 1636). Initially, the book was produced to guard against forgeries, but it was used by later artists as a source of compositional ideas. Turner was the most famous example of this, producing his own version in the '*Liber Studiorum*'. Also, Claude was supposed to have used what came to be known as the 'Claude glass'. It was like a smoked-glass lens which acted as a filter. When you looked through it it emphasised the tonal relationships in a landscape and reduced detail. You can achieve a similar effect more naturally by half-closing your eyes; this has the effect of reducing unnecessary detail when you want to look for composition and tone.

More importantly from our point of view in this chapter, Claude based his dream-like, atmospheric paintings on hosts of landscape drawings mostly done, like this one, in a mixture of chalk, pen and brown wash. Many of them were sketches for paintings, but others seem to have been observational studies. In particular, he was a master of trees in his ability to convey the solidity of the trunks, the canopy of leaves and branches, and above all the feeling that they are rooted in the ground. The trees in this picture would have been drawn roughly in black chalk, the wash would have been added to get the tonal areas right, and then other sections would have been captured in greater detail with the pen, as can be seen in the foliage on the upper left, in the middle and down on the right-hand side of the picture. This is true of the leaves in the foreground, too, where you can see how they have been drawn in on top of the wash.

The lightest areas all over the picture where the paper is exposed would have been left to start with, and then the darker parts added gradually in varying tones. There is a technical reason for this. An artist begins with the lightest tones and works up to the darkest in layers, waiting for each one to dry before putting on the next. With pen and ink or brush, or indeed watercolour, once the surface gets too dark it is difficult to reverse unless you use opaque white. Then you can lose the fluidity and lightness of effect so essential to this kind of drawing. The edge of the trunk of the tree on the far right

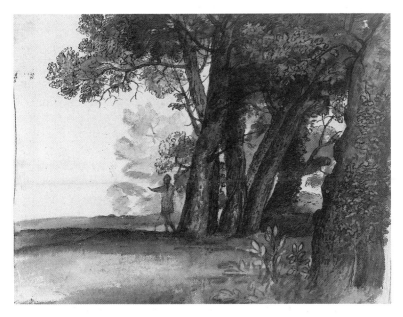

Plate 65 Claude Lorraine, *View with Trees, c.* 1640. Blue paper, chalk, pen and brown wash. The British Museum, London.

in front is sharply defined against the light background and the chiaroscuro effect throws it forward. In the central section there is the barest suggestion of a tree done lightly with the brush, and it is made to recede further because of the darker more detailed foliage of the tree in front, and the indication of a figure. Here again, it is the contrast between the lighter and darker tones which conveys the feeling of form and space. That pale tree is also crucial for defining the light and dark areas to the left of the picture. The simplicity of arrangement there is contrasted with the complexity on the right. All these qualities help to make the drawing convincing.

You may well ask why this is called a drawing in the first place and not a painting. As we shall see in the next section, the use of washes gradually became more sophisticated in the development of watercolour techniques. When colour is used, the division between a drawing and a painting becomes more blurred. Essentially, this is a drawing because it is monochrome and is not as resolved as a fully completed painting would be. This is why it can also be referred to as a sketch. As we discussed in the Introduction to this chapter,

nowadays we do not make the same distinctions between the sketch and the finished picture as would have been the case in Claude's time. In one sense, this drawing can be seen as a complete work because the observation and technical mastery are so acute; but it is nevertheless part of a creative process, a building-block along the road to making a more developed picture.

TOPOGRAPHICAL DRAWINGS AND WATERCOLOURS

Plate 66 and colour plate 23 *Cardiff Castle and the South Gate* **by Paul Sandby, *c.* 1780 and** *The White House at Chelsea* **by Thomas Girtin, *c.* 1800**

The development of the landscape sketch is intimately connected with the expansion of watercolour. Chalk, pen, brush and wash were commonplace techniques, as we have seen. By 'watercolour' we mean full-coloured watercolour in which the ground pigment is bound together with gum which dissolves in water. It differs from other similar techniques, like tempera, because the lightest tones and colours are achieved without white but simply by the addition of more water and exposure of the paper. The technique of water-colour painting had been known about for a long time and was used for landscape as early as the 1490s by Dürer in his watercolours of the Alps. But it is not really until the eighteenth century that water-colour comes into its own. It was used mostly in a type of drawing called Topography, the making of detailed records of particular places and especially of buildings. Paul Sandby's drawing of Cardiff Castle is a good example. The castellations, the stonework, the arrangement of the windows and the shape of the tower and walls are delineated carefully in great detail. The texture of the foliage of the tree on the left is used as a foil to contrast with the castle and the lower buildings on the right help to convey a sense of scale. The man on horseback and the other figures provide interest in the fore-ground, as do the reflections in the water. The watercolour is a monochrome wash for light and shade to enhance the detail of the architectural drawing.

At this period also, watercolour came to be used, particularly in England, as a medium in its own right to express light and atmos-phere rather than the merely physical forms of the landscape. In

Plate 66 Paul Sandby, *Cardiff Castle and South Gate, c.* 1780. Pencil and wash. The National Museum of Wales, Cardiff.

Thomas Girtin's painting *The White House at Chelsea* the emphasis is on its translucence and the way it can be brushed over the paper in a series of thin washes. In some places, like parts of the sky and in the house itself, the white paper is left to show through to represent the lightest tone. On the horizon, the washes are denser and more opaque. In between these extremes are a whole range of medium tones of greater or lesser transparency. But this painting is not just monochrome because Girtin has used the contrast between the complementary colours of blue and gold to give a palpable feeling of vibrancy, light and space. The rendering of atmosphere becomes the main subject of the picture. The fluidity of this medium and its quick-drying properties enable it to be used to convey fleeting effects of weather conditions at a particular time of day. For this reason, watercolours gave a boost to the development of landscape painting in the nineteenth century both in the sphere of colour and in the expansion of possible landscape subjects. This picture is really a type of painting which grew from developments in drawings, like the pen and wash works of Claude, and the Topographical tradition.

LINE DRAWING

Plates 67 and 68 *Portrait of Paganini* by Jean-Auguste-Dominique Ingres, 1819 and *Seated Woman Adjusting her Hair* by Edgar Degas, *c.* 1884

Degas was an admirer of both Ingres' drawings and his paintings. The two artists were interested in using line with great precision. It has been said that Degas derived his 'passionate desire to find the one and only line which delimits a figure' (quoted in Holt, *A Documentary History of Art*: vol. 3, 401) from his love of Ingres. This is a very good definition of line drawing because it expresses the idea that the forms are delineated by lines, with the shading taking second place. However, Ingres' figures, on the whole, are more static, with their poses frozen, as we saw in the *Odalisque and Slave* (Chapter 5), whereas Degas was more preoccupied with the expression of the body in action, which was evident in *The Orchestra at the Opera* (Chapter 1).

Ingres was trained first of all in his home town of Montauban in southern France and then in the studio of Jacques-Louis David. The central tenet of the kind of tutelage he would have received was drawing from the life model. Although David was an inspired teacher who encouraged individuality, he was influenced by the academic theories of art training which emphasised the importance of drawing. Ingres' portrait drawings like this one of Paganini were brought to a high level of perfection and are much more than sketches. Many of them were done as commissions and presented as finished works. We can see clearly why such works are called line drawings.

Taking Ingres' *Portrait of Paganini*, if you look, for instance, at the care with which the fingers of the hand on the right are drawn, your eye is taken by the subtle variation in pressure with which the black chalk has been used. The soft grey of the shading behind it emphasises the delicate yet strong use of line. The same is true of the line at the edge of the sleeve on the left and the patch of shade at the lower end of it. The more you look into this drawing the more precise and accurate it seems, not because of proliferated detail but by the incisive way the artist knows exactly what to include. Ingres loved the work of Raphael, and like his, the drawing looks deceptively simple.

Degas' attitude was more experimental and he spent much time reworking his drawings and allowing his changes of mind to be

Plate 67 Jean-Auguste-Dominique Ingres, *Portrait of Paganini*, 1819. Black chalk, 7⅜ × 8⅜ in. The Louvre, Paris.

incorporated into them. We have seen other examples of this, but in *Seated Woman Adjusting her Hair* it is more exaggerated. First of all, we can see that Degas has drawn in the broad medium tonal areas along the arms and over the back and skirt and then he has rubbed and smudged them. He was a master of the use of pastel, which allows for this but which requires a considerable degree of control because it is so soft. The woman is seen against the light, with the pale paper left to represent that and the tones nearest our eye much darker in consequence. You can see how the right-hand side of the body particularly becomes darker, with the lower part of the back of the turning head virtually black.

The searching way that Degas explores the forms, pushes them around, and leaves his alterations for us to see, makes this drawing very exciting. In the hands and arms you can almost watch the way that he has moved gradually to a more incisive line. Nowhere is this more obvious than on the left-hand side of the back. Once he has found the line he wants he emphasises it. But we feel the movement inherent in the whole picture because Degas leaves the process of his decision-making for us to see. The use of the white chalk on the surface of the skirt and the red pastel in the background serve to throw that section of the drawing towards the spectator and emphasise the weight and solidity of the body at the base of the picture.

Further experimentation has been carried out where Degas has added an extra piece of paper to the upper part of the sheet, so that the composition can be extended and the stretching motion emphasised. Her left hand, the wrist and top of the head appear above where the paper has been glued. You would have thought this was impossible until you see it, but this glue line actually enhances the feeling of movement because the top of the head and her left hand appear to stretch and twist above it; the figure would not appear so alive without it. In one of his notes about his art Degas said:

> No art was ever less spontaneous than mine. What I do is the result of reflection and study of the great masters; of inspiration, spontaneity, temperament – temperament is the word – I know nothing.
>
> (Holt, *A Documentary History of Art*, vol. 3: 401)

This quotation serves to underline the most extraordinary quality of this drawing; it seems so spontaneous and yet it was clearly the result of considerable thought, acute observation and trial and error.

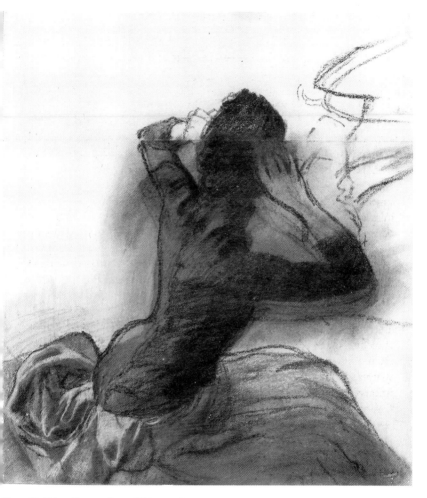

Plate 68 Edgar Degas, *Seated Woman Adjusting her Hair*, c. 1884. Chalk and pastel on paper, 63 × 59.9 cm. Courtauld Institute Galleries.

INDIVIDUAL DRAWING TECHNIQUES IN THE TWENTIETH CENTURY

In the twentieth century, just as in other spheres of artistic activity, drawing has become even more individually expressive than in earlier times. The three artists who I would like to consider now have very personal techniques and attitudes to drawing, even though none of them would rule out some continuity with work of the past.

Plate 69 *Row of Sleepers* by Henry Moore, 1941

Henry Moore is best known as a sculptor. But his drawings of people sleeping in the underground stations and air raid shelters during the London Blitz of the Second World War are complete works of art in themselves. They are the equivalent of presentation drawings. He did them when he was an official war artist from 1940–2.

They are executed in a mixture of media, which makes for a highly individual technique. Black chalk provides the basic layout and tonal contrast, which you can see most clearly in the right-hand corner. Then, the coloured crayon and watercolour are put on, with opaque white on top. Then the pen and ink lines are added to emphasise sections of the forms to give extra definition and to create recession. This emphasis on contour and the solidity of the forms within, gives these sleeping figures a very sculptural quality similar to the drawing we looked at by Michelangelo. You can see this most clearly in the arm of the figure in the foreground, where the inky blacks from the armpit and the elbow down to the wrist create a feeling of mass and solidity. This is enhanced by the thick white highlight. The mother's hand is tucked under the baby's feet and her head rests in a kind of dusky gloaming which is redolent of sleep. The child is related to his mother through the same tonal qualities; but his body, on the other hand, is alert and curious. We are allowed to see one black eye open and looking out at us.

The attitudes of the other figures are very telling in various positions of repose. The same inky darks underneath each of the bodies increase the feeling of weight and slumberous relaxation. Moore talked about how important the life class had been for him. He felt that the years he had spent drawing from the human figure enabled him to achieve the effects he wanted. Many of the artists we have looked at so far in this book would have agreed with him about this, because of the concentration on observation and interpretation it requires. The multiplicity of techniques Moore uses might seem

Plate 69 Henry Moore, *Row of Sleepers*, 1941. Pen and ink, pencil, wax, crayon, watercolour wash, 54.5 × 32 cm. The British Council Collection, London.

unnecessarily complicated or clever, but the layered effect is used so effectively that it gives depth and resonance to the subject. He is able to capture the unique and eerie atmosphere of the shelters and, at the same time, to give the figures a marbled surface resembling stone. They are reminiscent of medieval tomb sculptures or rocks in a landscape, thus creating wider and more profound associations in the mind of the spectator.

Plate 70 *Three Flags* by Jasper Johns, 1959

In the 1950s Jasper Johns did many paintings of the American flag. He is regarded, along with Robert Rauschenberg, whom we looked at in the first chapter, as one of the forerunners of the Pop Art movement. His subjects are always recognisable and based on familiar aspects of the twentieth century. But his drawings are thought by many people to be the most interesting branch of his work. Many of them, like this one, are done *after* he has made the painting and are an attempt to reduce the subject simply to subtle variations in marks and tones. He has said that, for him, the drawing comes after the resolution of an idea achieved in painting. So, they are an opportunity for further investigation of something which has already been explored and brought to a conclusion; it is as though he wants to get rid of the subject in order to have an opportunity to concentrate on the making process.

In the case of *Three Flags*, the painting itself was made from three canvases of graded size piled one on top of the other, moving from larger to smaller. Johns made several drawings of this image, one of which has layers of paper to represent the canvases, and this one, in which they are indicated by rectangles. The work is carried out entirely in pencil on one sheet of paper. He varies the overall tone of each layer so that they appear to lift away from each other in reverse perspective. If you half-close your eyes, which is always helpful when looking for tones, you can see how the darks are present at the straight edges of each rectangle. These lines vary very slightly in thickness and sharpness. You can also see where the square of stars would be in relation to the stripes on the flag. The variety and delicacy of the pencil marks all over the paper is very subtly controlled as well; there is enough repetition in them to hold the surface together and enough variation to keep the eye interested.

The skill and flexibility required to do this with just pencil and paper is superlative. The effect is like the texture and quality of the

Plate 70 Jasper Johns, *Three Flags*, 1959. Graphite pencil on paper, 14½ × 19¾ in. The Victoria and Albert Museum, London.

fine fabric from which flags are made. The pencil marks are connected together in a way that corresponds to but does not imitate the warp and weft of woven textiles. This drawing reminds us in a strangely meditative way that, when stripped of all its emblematic and symbolic meaning, a flag is only a piece of cloth.

Plate 71 *J.Y.M. Seated III* by Frank Auerbach, 1981

Auerbach draws his sitters over and over again on the same sheet of paper. When they are of regular models, like this one of Julia Yardley Mills, they are often referred to by their initials. The paper itself is very thick so that it can resist his continual rubbings and erasures. Auerbach starts by drawing in charcoal and then blurs it with his fingers but also with the rubber. This enables him to get back to the lightest tones when otherwise the drawing might become too murky. It gives him greater flexibility and allows him to make the figure gradually emerge from the background.

Erasers were traditionally never allowed in the studio or life class. This was because they were used to rub out lines which were wrong,

Plate 71 Frank Auerbach, *J.Y.M. Seated III*, 1981. Chalk and charcoal on paper, 77.2 × 57.5 cm. Bolton Museum and Art Gallery.

rather than moving gradually through a correcting process as we have seen most artists do. If you keep rubbing out in this way, it deadens the drawing rather than lending it life, by leaving the lightly drawn lines in. But Auerbach uses the rubber positively to help create the form. You can see this working over the breasts and upper chest; the effect of rubbing back to the whites and pale greys conveys the soft form of the woman's body extremely well. In the upper part of the chair you can see how the back of it started over to the right and how both it and the head have been erased and moved further and further to the left.

The final dark black lines are used not so much to find the incisive edge of the form but as indications of where it might be. The layers of drawing and rubbing beneath appear to shift and change under these strokes, so that a feeling of life and constant mutation are achieved. But there is real definition here, too. You know that the eyes are looking outwards and slightly upwards to the right, that the forearm is resting on the arm of the chair and that the lower part of the body is really sitting down on the seat. The essence of the figure is suggested, giving the feeling of the whole personality of the sitter.

In some ways, Auerbach's technical methods are similar to those we saw in the work of Degas. Auerbach also made a study of Rembrandt, who used tone in drawing and painting primarily as an expressive medium, as we saw in Chapter 4. This drawing of J.Y.M. is, above all, expressive of the whole person, not just at one moment but over a number of sittings which are revealed as a series of many impressions which have been put down one after the other on the same page.

CONCLUSION

As we have seen, there are a large number of different types of drawing. We have looked at a few examples, some of which, at times, come near to paintings, either in their technical effects or in their level of complexity. We have seen that, since the late fifteenth and early sixteenth centuries, drawings have been used for a multiplicity of purposes, not all necessarily connected with preparations for paintings. They offer the artist a chance to experiment, to push visualisation further and to generate ideas.

They can be a rewarding experience for the spectator, too, because they offer the opportunity to come more directly in contact, not only

with the past but with the artist of any period at his or her most inventive. They are mostly private, not only because of the way they were made, but because they have to be kept out of sight to prevent fading from too much exposure to the light. For this reason, although they are exhibited from time to time, we often have to go to the Print Room of a museum in order to see them. When we do this, we experience a much more immediate link between the original works of art and the artists who made them. We can come nearer to witnessing the many layers, the twists and turns and ultimately the mysteries of the creative process.

Looking at prints

INTRODUCTION

The fascination of looking at prints may be hard to understand at first because they can seem unprepossessing and even dull. Like drawings, they often have no colour. They can be very small and extremely detailed, and are usually brought to a high level of finish. They invite close inspection on the part of the onlooker in order to find out what they are about. One good way to do this is to view them through a magnifying glass, because the minutiae may not always be seen with the naked eye. Then you can start to really appreciate the subtlety and skill which goes into the making of a good print.

There are a large number of different graphic techniques but essentially they can be divided into four main types known as intaglio, relief, planar and stencil. In intaglio printing the ink lies in the incisions made in the plate, whereas in relief work it adheres to the raised parts made by cutting the rest away. This is the main technical difference, for instance, between a metal engraving and a woodcut. In planar or planographic prints the ink lies on the surface of the stone or plate as in a lithograph. In the stencil method the design is stamped out of protective sheets and the ink is pressed into the vacant spaces as in screen printing or serigraphy.

One of the main functions of the graphic arts before the advent of photography was for the reproducible recording of various subjects. In the Topographical tradition, for instance, watercolour drawings (see Paul Sandby's *Cardiff Castle and South Gate* in Chapter 7) were often turned into prints. Hogarth (see Chapter 6) deliberately designed his morality paintings to be made into engravings so that they could reach a wider audience and provide him with an income.

Engravings copied from paintings were important in other contexts, too. From about the time of Mantegna in the fifteenth century they were hugely influential on the work of both established artists and students. In the academy schools pupils would spend a great deal of time drawing from engravings in order to learn from the work of past masters. William Blake, who was trained as an engraver, earned his regular income from this kind of print-making.

As we saw in Chapter 4, graphic techniques involve the manipulation of tone, draughtsmanship and craft skill in the use of the print-making tools. We discovered also how drawing, painting and printing can be closely related within one artist's work (see Rembrandt, Chapter 4). Now we will be exploring other aspects of this interactive side of the creative process. Generally speaking, print-making is not used for spontaneously generating ideas in the way that drawing can be, because it always involves much more complicated procedures. It is more disciplined, in the sense that much more has to be worked out in advance. This is because the order in which each stage is achieved is more rigidly controlled by the medium. Indeed, it can provide an opportunity for the artist to understand the intricacies of making and designing in more detail.

A painting, of course, requires considerable preparation but, particularly with oils, much more can be altered and adapted during the process of completing it. In a print you need to work out beforehand where the tones in the lightest, middle and darkest range are going to be. Once the design is set, the room for change is more limited, especially in the intaglio and relief methods, where you can cut too much and ruin a plate. Even more precision is necessary in all types of print-making if you are using several colours. Each one will require printing separately, so accurate knowledge about where it is going to be placed is essential. All graphic processes require considerable skill and craftsmanship. Understanding more about the complexities involved can help us to appreciate the end results even more.

THE EXPLOITATION OF DETAIL: LINE ENGRAVING, WOODCUT AND WOOD ENGRAVING

Plates 72, 73 and 74 *St. Jerome in his Study,* **1514 and** *The Rhinoceros,* **1525 by Albrecht Dürer and** *The Wild Bull* **by Thomas Bewick, 1790**

Line engraving is done by gouging lines on a metal plate with a sharp metal-ended tool called a burin. The round wooden handle is pushed with the palm of the hand and the fingers are used to guide the point while the other hand holds the plate. All the marks made are linear. When the design is ready, ink is put on and rubbed into the lines. Then the plate is wiped very carefully with a cloth so that the ink is left in the lines only; some of them are incised more deeply than others to make variations between lighter and darker tones. The shallower lines will hold less ink and so print paler than the others where more will reside. White areas will appear where the plate has been left untouched. In order to make a print, the paper is applied to the plate under heavy pressure in a press. Line engraving lends itself to fine, small-scale and very detailed work, as we can see here in *St Jerome in his Study* by Dürer, who was one of the first artists to develop graphic work as an art form in its own right. It shows brilliantly the two outstanding qualities of this technique: tonal subtlety and the achievement of texture using only lines.

We see St Jerome busy translating the Bible. He is accompanied by his emblems: the lion he befriended when he was in the desert by removing a thorn from its foot, and his cardinal's hat denoting his importance as one of the founding fathers of the Church. The hour-glass on the back wall and the skull on the windowsill remind us of time running out and our own mortality; the bottle gourd hanging from the ceiling is a reference to a traditional way of carrying water in the desert. Light pours through the windows, falling on the different surfaces in the room and revealing their textures. You can feel the lion's fur and the way that it is smoother on the face and haunches and longer on the mane around his neck. If you look at it with a magnifying glass you can see how the lines move in different directions to follow the way the hair grows.

This linearity is most obvious in the structure of the room, where the lines direct your eye to the different planes. They are horizontal on the flat surfaces like the floor, the side of the window embrasure or the wall at the back. In the ceiling, they move towards one another

Plate 72 Albrecht Dürer, *St Jerome in his Study*, 1514. Line engraving, 24.9 × 19.2 cm. The British Museum Collection, London.

in perspective towards a vanishing point beyond the confines of the room. Surfaces are prevented from appearing boring by the different shapes and textures of the objects that are placed on them, like the cushions and the skull sitting on the windowsill and the reflection of the window pane or the round shape of the cardinal's hat at the back. But the detail is also extraordinary in the sense that you can see every joint and indentation of the wood on the table and the chair. Dürer generates these minutiae so that you want to look into the picture more and more. This is an example of where, if you look long enough, you will need a lens in order to see more exactly what the objects are. On the shelf at the back, for instance, there is a round brush, a string of onions, a pair of scissors and some squares of paper wedged against the wall with string or rope. St Jerome himself sits surrounded by all these objects and our attention drawn to him by the presence of his halo. We can even see his hand holding a pen and the other one resting on the writing slope, with his inkwell by his side.

The palest areas are used to focus our attention on the light in the further window on the left, the crown of the cardinal's hat, the left side of the bottle gourd, St Jerome's halo, head and shoulder, the table top, the pools of light on the floor and parts of the lion's face and front and back paws. These points are related together tonally to draw the eye to the attributes of the saint and also to connect the central section of the composition together. By his tonal manipulation, Dürer makes you see a relationship between normally disparate objects. So you are aware of a satisfying visual unity or pattern of light surrounded by a myriad of subtly varied medium tones. Occasionally, they turn darker to create the effect of cast shadows and the dappling of the light as it shines through the lattice work of the window panes.

Dürer was also a master of the woodcut, a relief technique where the ink adheres to the raised sections of the block. So, in the print of *The Rhinoceros*, the white areas are where the wood has been cut away. Woodcut is not as subtle as metal engraving from the point of view of creating the kind of silvery and shadowy tones which we saw in the print of St Jerome. A woodcut is created by means of gouges made in the wooden block of varying depth using knives with blades of differing size. Woodcutting lends itself more to simplification and directness of expression. It is the earliest of the printing techniques and was used originally to provide simple religious images which were cheap to produce once paper became more readily available from the early fifteenth century.

Plate 73 Albrecht Dürer, *The Rhinoceros*, 1525. Woodcut, 24.8 × 31.7 cm. The British Museum Collection, London.

This print of *The Rhinoceros* was based on sketches and descriptions of the first of these animals to arrive alive in Europe since the third century AD, when there is evidence that the Romans succeeded in importing them. A rhinoceros was presented to the King of Lisbon on 20th May 1515 and then sent on to Pope Leo X in Italy. But the ship which was carrying it foundered off the French coast near Marseilles and it was drowned. Dürer never saw the animal but learned about it from sketches and descriptions. The text at the top of Dürer's print describes the animal in vivid detail, particularly its skin which was said to be thick and scaly. Dürer gives us an imaginative and vivid interpretation of what the skin might have looked like by using an extraordinary variety of purely linear shapes and textures. You can examine these for yourself and explore their variety from the scaly feet to the feathery lines on the tips of the ears. Unlike the print from the metal engraving, you do not need a magnifying glass in order to see what is there. But one cannot help but be amazed by the flexibility in the use of the woodcutting

tools, particularly when you remember that the dark lines are the raised ones, so the drawing is in relief.

The same sort of skill applies to wood engraving except that, unlike the woodcut, it is usually done on the endgrain of the wood rather than along it to make finer lines possible. Boxwood is most commonly used and it is cut with a burin-like tool, but it is still the raised parts which take the ink. Usually the wood engraver inks up his wood first, so that when he cuts into it he can see where the lightest parts are going to be. In that sense, the process is the reverse of metal engraving. One of the greatest masters of this technique was the late-eighteenth-century artist Thomas Bewick. He published a number of well-known illustrated books. This illustration of *The Wild Bull* comes from *The General History of Quadrupeds*, an educational book with text by his colleague Ralph Beilby. Altogether, 400 animals are described in the eighth edition of 1824. The book was first published in 1790.

Plate 74 Thomas Bewick, *The Wild Bull* from *The General History of Quadrupeds* by Thomas Bewick and Ralph Beilby, 1790. The British Library.

In this print of the bull we can see how refined and precise the wood engraving technique can be. Bewick achieves great subtlety by widening and narrowing the relief, so that in the dark areas you can

see that the lines are broader and closer together and in the lighter ones they are thinner and further apart. A good example of this is in the section immediately under the body, where there is plenty of wood left and it is dark; this is contrasted with the grass below it, which is more cut away and therefore lighter. You can see this kind of variation all over the print, enabling Bewick to create an effect of solid dark tones in some places and translucency in others. So, in metal engraving, the tones are created by the varying amounts of ink held inside the lines, but here, as in the woodcut, they are made by the ink lying on top of the different surfaces. Once again, as with Dürer's prints, we can only marvel at the precision and flexibility with which Bewick uses the wood engraver's tools. *The Bull* is not as obsessively detailed as *St Jerome in his Study* nor as simplified and expressive as *The Rhinoceros*. Instead, our eye is held by the accuracy and down-to-earth observation with which the image of *The Wild Bull* has been committed to the block.

THE CREATION OF MYSTERY AND AMBIVALENCE BY MEANS OF TONE

Plate 75 *Carceri d'Invenzione, Plate III* by Giovanni Battista Piranesi, 1761

The strange and threatening atmosphere in this print is created first of all by the use of strong shafts of light and dark cast shadows. Rich and varied contrasts are achieved by the etching technique. Etching is done by covering a copper plate with wax and then drawing into it with an etcher's needle, which uncovers the metal and works like a very finely sharpened pencil. Then the whole plate is plunged into a bath of acid and the areas of metal exposed by the needle are eaten away. You then take the plate out and cover up the areas which you want to remain palest. So the lightest sections in Piranesi's print would be those either that remain covered in wax altogether or where the exposed plate only stayed in the acid a short time; those areas are blotted out with varnish resistant to acid and then the plate is put in the acid again to get it more deeply bitten for the medium tones. This process continues until the plate is most eaten away where the artist wants those deep velvety blacks. Finally, the stopping-out varnish is removed and ink rolled over the plate and carefully wiped. More ink will stay in the deep areas and less in the shallow, thus providing a rich range of light and dark. The

Plate 75 Giovanni Battista Piranesi, *Carceri d'Invenzione, Plate III*, Second Edition, 1761. Etching. British Museum Collection, London.

plate is then pressed onto the paper in an etching press and the ink held in the etched surface of the plate is transferred to the paper reproducing precisely the tonal values as instructed by the etcher's needle and the acid.

In this etching you can see clearly the kinds of lines made by the needle, for instance, on the staircases and balustrades and the bars of the grille. They become softer and more blurred in the background, where Piranesi has used a technique called 'soft ground etching', where tallow was added to the wax to make it more malleable. When the needle is applied, more wax lifts up to create an uneven edge which prints as a softer line. In this second edition of *Carceri d'Invenzione* (the imaginary or invented prisons) Piranesi also shows us how it is possible to augment the effect of a print by subtle additions. In this case, he greatly enhances the atmosphere compared to the first series by the increased contrast in light and shade, particularly in the foreground. This design comes from a sequence of quite large prints which are best seen as pictures on a wall rather than being viewed in a book. Piranesi made his name with his series on the buildings and ruins of Rome. He had been trained as an architect in Venice and was also familiar with the theatrical side of eighteenth-century Venetian life. He was friendly with the Bibiena family who were the most famous theatrical designers of the day.

Quite quickly you realise that everything about this print is illogical, but it takes a little while to realise why. It invites you first of all to believe that it is real because so much of it appears to be solid. The cylindrical structure in the centre draws your eye to begin with because it contains the strongest contrasts between light and dark tones. This is most obvious in the depiction of the large rectangular opening surrounded by heavily rusticated stonework and then criss-crossed by strong horizontal and vertical bars. Above it is a deeply cut cornice, which gives it an increased feeling of weight and accentuates its roundness. The steps in the lower foreground leading up to it are also emphasised, particularly the one going round to the left, which has a sharply defined shadow below and at the top. The arches above the circular cornice appear to be very solid in the way that they are drawn, with their curved edges marked out by further strong contrasts. The flat surfaces here are more softly drawn than those in the foreground, showing the influence of the softer ground etching already referred to.

However, as soon as you try to look further into this print you realise that everything about it is ambiguous. The area at the base of

the cylinder is lighter in tone, so that it does not appear to have proper foundations. The dark steps in the foreground do not seem to be supported properly at the top; when you try to see where they are going your eye is prevented from doing so by a small cylindrical structure and another cornice running along above a line of windows. Where are those windows supposed to be? Are they on the ground floor or higher up? Where are the stairs beyond supposed to lead to and where does the arch next to it spring from? It is also not clear where many of the other arches at the top have their foundations.

Whichever part of the print you look at, you seem to come to a dead end. Then ask yourself where you are supposed to be standing, and you realise you are far below, that all the figures are very small, and that the perspective of the steps is tilted in the opposite direction to the expected one. This disorientates you, as does the size of the cylindrical structure in the centre. You would expect it to be a small detail of a much larger building, but here it forms a colossal centrepiece totally out of scale with its surroundings. Also, the corbels under the round cornice are much larger than they need to be for what they are apparently supporting. What, then, about the lighting? Where is it coming from? Certainly, the strongest shafts of light come from high up on the right, but there are many other light sources, too, filtering through from many directions, rather as you might find in a theatrical setting.

Gradually, your sense of where you are in relationship to this interior is disrupted and you feel an atmosphere of uncertainty, of indeterminate menace and claustrophobia, rather like being in a nightmare. You want to turn away and yet you are fascinated and continue to try to work out your position. You feel imprisoned by the combination of illogical light, shadow and space. It is a fantasy or a dream which is made to seem convincing by Piranesi's skilful use of tone, perspective and scale, making you believe in the image at the same time as knowing it to be impossible. Piranesi called this series of plates *Carceri d'Invenzione*. The *idea* of a prison is expressed here rather than a description of an actual place. This print portrays an ambiguous, ambivalent and menacing realm which is psychological rather than physical.

THE DEVELOPMENT OF A PRINT FROM ITS ORIGINAL DRAWING: ETCHING AND AQUATINT

Plates 76a, b, c, d and 77 *Love and Death*, 1797–99 number 10 from *The Caprichos* series and *Portrait of the Countess of Chinchon*, c. 1800 by Francisco de Goya y Lucientes

The process of developing a print from its original idea can tell us a great deal about how the control of technique and tone can add to the expressive power of a particular design. The different stages allow the artist to develop the original idea far beyond what he or she might initially have considered doing. Goya was greatly helped in what he could achieve with the etcher's needle by the addition of aquatint. This was a relatively new technique (perfected in 1768) which involved the use of granules of gum sprayed onto a warm plate so that they melt slightly and stick to it. When the plate is dipped in the acid it eats its way round the gum particles, enabling the artist to get a spread of tone which flows almost as delicately as watercolour. This technique can be used by itself instead of the usual wax or in combination with it so that some parts of the plate are covered with wax and other parts with the granules of gum.

Usually, Goya produced his etchings in series, one of which was *The Caprichos* of 1799 satirising the manners and morals of Spanish society at the time. If we look at the sketches for *Love and Death* we can see a remarkable build-up of tonal expression. The print is commenting on the waste of life caused by duelling and, like all the other plates in the set, it is accompanied by a caption:

> See here a Calderonian lover who, unable to laugh at his rival, dies in the arms of his beloved and loses her by his daring. It is inadvisable to draw the sword too often.

Goya starts with a quite ordinary pencil sketch (Plate a) of a woman supporting her dying lover. She looks up to heaven and holds him against a wall which moves at a shallow angle across the picture. The mood is gentle and banal in comparison to the next sketch (Plate b) which is done with a brush and grey wash, where he plays with the light and dark to make the woman's body bend at a steeper angle; her face now expresses sorrow and he looks as though he is really leaning against the wall. But the most interesting aspect of this is the way the dark and light contrasts have been manipulated

to increase the drama; the dark angle of her body straining to support him and his light sagging form outlined against her and against the dark patch of shadow on the wall. The clothes are less detailed, too, allowing us to concentrate more closely on the emotions involved. The same is true of the final pencil drawing (Plate c), where the attitudes of the figures and the expressions on their faces are explored more fully. Notice the way the angle of her body becomes even steeper, the dark hair swings out into the light void at the side and the wall is used as a support but falls away to the left so as not to distract our eyes from the main theme. In the final print (Plate d), the effects of these sketches are put together to create the emotional impact which relies on a combination of superlative draughtsmanship and a mastery of light and shade. The figures are drawn mainly with the etcher's needle and in the background you can see the more granular surface of the aquatint; in places, like the bottom of the man's coat and the woman's face and neck, you can see where aquatint has been added to create a more subtle tonal effect.

Goya learnt from Rembrandt and from the study of Velazquez (Chapter 4) about the manipulation of light and shade, particularly in relation to atmosphere and space. The way the eye is led into the central section of the print with the light areas concentrated in the figures is similar to that which we saw in Rembrandt, and the use of the pale tonal background is typical of Velazquez. But there is also an element of ambiguity in this design which needs exploring further. Goya does not just modulate the tones in the background to create air and space, as Velazquez would have done. Instead, the background is divided into a darker and a lighter area by a wavy diagonal line as if it was leading somewhere. It is not clear what the line represents or where it is in space, and because of the uncertainty it engenders you feel that somebody or something could appear out of the background at any time. This understanding of how to create ambiguity with tones was derived to some extent from the work of Piranesi. The series of prints of *The Prisons*, which we have just looked at, were widely known amongst artists throughout Europe in the later eighteenth century.

The same kind of expressive ambivalence found in Goya's print of *Love and Death* exists in his paintings, too. There is a clear example of this kind of interaction in his *Portrait of the Duchess of Chinchon* painted at the same time as he was working on *The Caprichos*. The Duchess is a light figure set against a dark background in which you

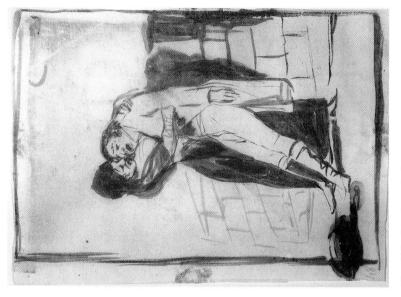

Plate 76a Francisco de Goya y Lucientes, *Woman Holding up her Dying Lover*, 1797. Brush and grey wash touched with brown wash, 23.6 × 14.6 cm.

Plate 76b Francisco de Goya y Lucientes, preliminary drawing for the print *Love and Death*, No. 10 from *The Caprichos* series, c. 1799. Sanguine wash, 19.7 × 14.1 cm.

Plate 76c Francisco de Goya y Lucientes, preparatory drawing for the print *Love and Death*, c. 1799. Red chalk, 19.7 × 14.1 cm. Prado Museum, Madrid.

Plate 76d Francisco de Goya y Lucientes, *Love and Death*, c. 1799. Etching burnished, aquatint and burin, 21.6 × 15.2 cm. The Art Institute of Chicago.

Plate 77 Francisco de Goya y Lucientes, *Portrait of the Countess of Chinchon*, c. 1800. Oil on canvas, 216 × 144 cm. The Duchess of Sueca Collection, Madrid.

feel that all sorts of strange and shadowy things might have their existence. We know that Goya often finished his portraits by candle-light to lend his figures luminosity, and this is indicated here in the highlights on the dress.

Instead of the illumination of the figure in daylight, as in Velazquez's *Portrait of Pablo de Valladolid* (see Chapter 4), Goya puts The Duchess of Chinchon in a gloomy and unfathomable setting. This creates a mood of sombre melancholy which makes the sitter look isolated and alone. We know that she was unhappily married to the lover of the Queen of Spain, General Godoy, and that she was pregnant at the time this portrait was painted. Her vulnerability and loneliness are clearly communicated through Goya's use of light and dark, and the influence of the work he was doing on *The Caprichos* is clear. The interrelationship between Goya's painting and graphic work continued throughout his *oeuvre*.

LITHOGRAPHY

Plates 78 and 79 *The Past, Present and Future*, 1834 and *Literary Discussion in the Second Balcony*, 1864 by Honoré Daumier.

We can see a further example of the interaction between painting and printing in the work of the great nineteenth century litho-grapher, Honoré Daumier. He made his living out of designing lithographs for newspapers and journals. Lithography was invented by Senfelder in 1798. As explained in the Introduction to this chapter, it is a planar or surface technique. You do not have to gouge out metal either with a burin as in engraving or with acid as in etching and aquatint. Lithography works instead on the principle of the incompatibility of oil and water.

The artist draws the design on a stone (usually limestone or nowadays more often a zinc plate) with greasy ink or crayon, and the plate is washed with chemicals to fix the drawing. Water is then applied. The moisture is repelled by the greasy ink or crayon and accepted by the porous surface of the stone or plate. When the greasy ink is rolled on, it only sticks to the drawn section of the surface. So, a lithograph can be described, literally, as a printed draw-ing. It is also very convenient because the technical part is carried out by a lithographic printer and so the artist has a technician to help him get the best results. Senfelder also developed the use of transfer paper so that the design can be transferred to the stone the right way

round. It is also very flexible and versatile because parts of the ink and drawing can be scraped away if a change has to be made. This is much easier than the more laborious process of burnishing used in the intaglio methods.

Above all, of course, the advantage of a lithographic print is that the process can be repeated endlessly. For this reason, lithography became widely used for illustrations in newspapers and journals. Daumier made his name with prints for a paper called *La Caricature*, in which he satirised the government of Louis-Philippe after the July revolution of 1830. The most famous of these was *The Past, Present and Future* of 1834, also known as *Louis Philippe as une Poire* (the French word '*poire*' means both pear and fool). The king is presented as a three-sided face showing the past, present and future with increasingly disillusioned expressions. You can see the grainy texture lent to the shadows by the greasy crayon on the surface of the stone and the softness around their edges. It also has a strongly sculptural quality; Daumier had practised sculpture in the famous series of plaster busts he did of French politicians around 1832.

The use of light is important here and becomes increasingly so in the later work. In the *Literary Discussion in the Second Balcony* of 1864 the light comes from the right-hand side in the front and is used to reveal the forms of the figures, particularly in the out-stretched arms of the man lunging forward and his victim forced backwards over the parapet of the balcony. It creates strongly defined abstract shapes on the surface of his arms and on the shoulders of the man in front and on the faces and bodies of the figures behind and to the sides. The faces especially are very simplified. The most basic expressions are described with a few lines.

But above all it is the tones of light and dark and the lines created by their edges which fuel the expressive power of this print. There is tremendous variety in the pressure with which the lithographic crayon has been applied, just as there would be in a drawing. Etchers and engravers have to be good draughtsmen, too, but here the effect is much more immediate because the print is made without the intervention of the acid or the burin.

La Caricature (Journal) N.° 166.

Pl. 349.

H.D.

Le passé. *Le présent.* *l'Avenir.*

Plate 78 Honoré Daumier, *The Past, Present and Future*, 1834. Lithograph.
Armand Hammer Museum of Art and Cultural Center, California.

**Plates 80 and 81 *The Lawyer Without Cases who Pretends to be
Busy, c.* 1840 and *The Three Lawyers in Conversation,
c.* 1856 by Honoré Daumier**

The other important point about lithography is its flexibility. The
artist can intensify the light areas by simply removing some of the
crayon and ink. But, if the etching or the engraved plate has been
gouged to make a shaded area, it cannot be so easily filled in to
increase the lightest parts. Daumier's late lithographs are so fluent
that there is very little evidence of changes but in earlier ones, like
The Lawyer without Cases who Pretends to be Busy of 1840, you can

Une discussion littéraire à la deuxième Galerie

Plate 79 Honoré Daumier, *Literary Discussion in the Second Balcony*, 1864.
Lithograph. The Armand Hammer Museum of Art and Cultural Center, California.

see clearly where he has increased the lightness here, for example, in the cravat around the neck of the lawyer in the foreground and on the fingers of his left hand to emphasise the contrast and to lead the eye to the expression on his face.

Even more interesting is the interaction between the graphic work and the paintings. Daumier always wanted to be a painter but had to earn his living as a lithographer. He began that work in the 1820s and was not able to start painting until after 1850. The subject-matter of his paintings is often similar to that of his prints, as in *The Three Lawyers in Conversation*, which is monochromatic with the same sharp contrasts of dark and light, lack of detail and simplified caricatural expressions. But there is another aspect of his work which we have not explored, and that is his use of theatrical lighting to make the tonal qualities more exciting.

In this painting, the figures are lit from behind so that they appear dark against a lighter background. This means that Daumier can put the light and dark where he likes, just as a theatrical designer would in order to emphasise the dramatic focus. It reminds us of Caravaggio in the *Supper at Emmaeus* (see Chapter 4), although here the purpose is secular and there is a much greater degree of simplification. So, the faces, the hands, the cravats and the bundles of papers are picked out in contrast to the black gowns and the background. The tones are divided up in the way they would be in a print in order to make the impact clearer. The expressive language of tone is exaggerated so that the spectator is led to imagine him- or herself listening to the animated and argumentative dialogue that is going on.

THE COLOURED LITHOGRAPH

Colour plate 24 *The Englishman at the Moulin Rouge* by Henri de Toulouse-Lautrec, 1892

This print shows Mr Robert Warrener, an English impresario chatting to two girls in a slightly commanding but animated and flirtatious manner. Lautrec became an outstanding lithographer both on the large scale required for the posters and in the much smaller sizes he used for designs like this one. The development of the coloured lithograph came towards the end of the nineteenth century, partly through the fashionable influence of Japanese prints with their flat overlapping planes, bright colours and strong tones (see the section on Degas in Chapter 1). Lautrec became such a master of the basic

LES PARISIENS.

Mᵉ Tout affaires, avocat sans causes, se donne l'air empressé, et renverse, chaque jour, dans la salle des pas perdus, une douzaine de moutards, écrase cinq ou six carlins, et espère grace à cette gymnastique, faire croire à ses nombreux clients.

Plate 80 Honoré Daumier, *The Lawyer without Cases who Pretends to be Busy,* c. 1840. Lithograph. The Armand Hammer Museum of Art and Cultural Center, California.

Plate 81 Honoré Daumier, *Three Lawyers in Conversation*, c. 1856. Lithograph. Oil on canvas, 40.6 × 33 cm. The Phillips Collection, Washington, DC.

technique of lithography that he could draw his design straight onto the stone without the use of transfer paper. In this fine print he shows consummate draughtsmanship in the drawing of the subtly varie-gated lines and the juxtaposition of the simplified coloured shapes which convey the forms.

Like most of his lithographs, this one was produced in a limited edition. In its first state it was executed in black ink with a brush and then in the second, more developed form, the colour was added with some variation from print to print. Lautrec was able to employ expert technicians to help him with the complexities of printing in colour. There are entertaining stories of how, after a night out on the town in Montmartre, Lautrec would sleep in his carriage and then order the driver to take him to the lithography shop early in the morning. There he would supervise the printing of his designs with great care. The process requires considerable precision, because each coloured area has to be put on a separate stone. Then, as each section is added to the final print, the whole effect is gradually built up. The term used for this is 'registering', which means making each of the designs on each of the stones exactly the same size so that the different colours will print in the right place. Even more than with monochrome print-ing, every detail of the final arrangement has to be thought out beforehand.

It is possible to work out what each of the stones would have looked like by following where each of the colours go. One would have had the yellow sections in the background, including the indentation of the white hat in the top left-hand corner. Another would have had the reddish-brown of the Englishman, the hat and shoulder of the woman behind and the drawn decorations in the background, as well as the outline of the chair in front. The green dress in the foreground shows Lautrec's use of a spray technique achieved either by flicking the ink off the end of a loaded brush or shaking it through a sieve. It helps to add variety of texture and a feeling of lightness. The same green is used to mark off the shape of the dress and to define the white areas, the hat and features of the girl's face and those of her companion. Green is then carried into the lattice work and some of the spaces on the balustrade behind.

Then there would have been a stone with the orange areas in the hair and mouth of the girl in the foreground and in the two decorative shapes at the top of the design. Lautrec has even super-imposed the orange of the hair over a yellow patch, as though he changed his mind about the colour relationships and wanted to give

the surface more variety. For this reason he did not worry that it was not perfectly registered, and there are several places where similar overlaps occur. Then there would have been another stone with the black lines of emphasis on Mr Warrener, the solid black glove, the sleeve trimming and the ribbon around the foreground girl's neck and the hat, kisscurl and eyebrows of the girl behind. This helps to draw the whole picture together and bring it alive. Finally, you notice that in two of the white areas there is a degree of orange spattering to make the ear of the left-hand girl and to emphasise the eyes of the one behind; in an extraordinary way this effect indicates recession and gives form to the upper part of her face. The patch of grey behind the chair on the left provides an element of visual surprise which also adds life to the design, as does the blue behind the green squares in the background.

The complexity of this print is impressive and yet its effect is one of simplicity and spontaneity. Lautrec has achieved this through the vitality of his drawing and the experience of knowing just how much it is possible to leave out without losing the conviction of his design. It has caricatural and expressive characteristics laced with humanity and realism.

SILK SCREEN PRINTING AND THE USE OF MODERN PRINTING TECHNIQUES

Colour plate 25 *Moonstrips Empire News* by Eduardo Paolozzi, 1967

Silk screen printing or serigraphy is different from the relief, intaglio or planar methods of making prints which we have so far discussed. Essentially, it is based on the stencil principle, in which the design is cut or stamped out, inked and then printed. The simplest version of the process consists of stretching silk across a frame; then the places where no ink is required are painted with gum or, alternatively, a paper stencil can be glued to the back of the silk. This means that the material becomes impermeable in those sections the artist wishes to remain light. Then the ink is pressed into the silk in the untouched areas, forcing it through the warp and weft of the material. This is done with an instrument called a squeegee, which is a rubber flap attached to a wooden handle. The effect this creates is one of flat and smooth areas of colour, which can be made to look solid or transparent as in watercolour.

In *Moonstrips Empire News* Paolozzi uses screen printing to create a limited edition of 100, involving a variety of images within one sheet. Here, we see a line of orange faces with different expressions set against a blue background at the top. Below them are a series of what appear to be internal-combustion engine parts in pink and black with green stripes between. Then, on the bottom line, are a number of cartoon characters looking like jelly babies in a variety of colours; here you can see clearly where the screen has been completely protected in order to leave white areas. The sharp and acid pinks, oranges and greens are typical of printing inks in advertisements and magazine photographs, and the random juxtaposition of the images is like collage. It looks simple, even naive, but in fact the process is quite complex. In the same way that coloured lithography requires different stones for each colour, so screen printing needs a separate screen. Paolozzi's print can be analysed in a similar way to the lithograph by Lautrec which we looked at in the previous section.

Commercially, screen printing is used in advertising and on packaging, fabrics and ceramics. Artists have taken to it more particularly since the advent of the Pop Art movement in the 1960s, with its desire to explore the visual language of the media and the culture of consumerism. The relationship between painting and screen printing has become blurred, just as the demarcations between various aspects of the visual arts have done in other fields. We saw the same thing happening between painting and sculpture in Chapter 3, and with installations in Chapter 5. In the first chapter of this book, we saw how screen printing was combined with oil painting by Robert Rauschenberg to create a collage composition redolent of twentieth-century imagery. The smooth, flat, hard-edged characteristics of screen printing are reflected in the work of many painters, like Andy Warhol for example (see Chapter 6). Screen printing is certainly a very versatile technique which has influenced painting.

Warhol's portrait of Marilyn Monroe and Paolozzi's screen print also explore something else which is very much part of the modern world; that is, the multiple and repetitive image. The concept of repetition is as fundamental to the graphic arts as it is to advertising, photography and film. The idea has also affected the work of minimalist artists like Carl Andre in his famous *Bricks* in the Tate Gallery of 1972. Here, he takes one manufactured unit and uses it repeatedly, flat on the floor in a logical arrangement which addresses the issue of multiplicity in mass-production and prefabrication. The

idea of works of art in series is not new – think of fresco cycles, tapestry design and indeed the series paintings of Monet and Pissarro. But each of these could have been enjoyed on their own, whereas the emphasis today is on the concept of repetition itself, and it is that which connects other arts with print making.

CONCLUSION

The repetitious aspect of the graphic arts can present problems for the connoisseur and collector. It is important to know which impression a particular print comes from. This is especially important where the intaglio methods are concerned, because it makes a difference to the quality; in later editions the effect will be less crisp because the incised lines become more imprecise according to the number of times the original plate has been through the press. This is not so crucial with planar and stencil methods, where the problem lies more with the possibility of uncontrolled reproduction. This is why lithographs and screen prints are produced in limited numbers in order to preserve exclusivity and value.

Although the divisions between one type of art and another have become increasingly less defined in our own time, connections between painting and print-making have existed since the Renaissance. The majority of artists try out graphic techniques at some stage in their careers, and we have seen how there can be an interaction between one type of work and another. Regarding prints as integral to the visual arts rather than a separate genre can make viewing them a much more exciting and rewarding experience.

Conclusion

The use of comparison as an aid to looking

The advantage of comparing pictures by looking at them side by side is that it can enable you to see aspects of both of them more clearly. But it is a skill which needs to be used appropriately, because if you start juxtaposing one work of art with another indiscriminately the process can be meaningless. The comparisons then are random, as they might be in the street or in newspapers and magazines. However, except when two pictures happen to be in the same museum, comparison cannot be carried out easily unless they come together for an exhibition, which is inevitably a rare occurrence. So any comparison usually relies on the use of pairs of reproductions and on knowing the basis upon which the comparison is being made.

In exploring different approaches to picture making, comparison has been implied throughout this book and in places it has been explicit. For instance, if you look back to Géricault's *The Charging Chasseur* in Chapter 1, you will remember we noticed the differences between the sketches and the finished picture. We could see how Géricault modified the final version. This leads to an understanding of the process, particularly in relation to composition. There are many ways in which more direct comparisons can be made, and I cannot possibly cover them all here. So, I propose to use pictures from previous chapters in order to give examples of how it can be done.

One common type of comparison involves seeing the influence of one artist upon another. The Cubist painters Braque and Picasso claimed that they were influenced by Cézanne. If you compare Cézanne's *Still Life with Apples and Oranges* (Chapter 2) with Braque's *Bottle and Fishes* (Chapter 4) you will see that both artists are using multiple-viewpoint perspective and disrupting the ordered arrangement of planes that you would expect to see in a painting with

a single vanishing point. But Braque's painting is more geometrical and abstract than Cézanne's. Although we do not know for certain whether Braque saw this particular painting by Cézanne, we can say that he seems to have learned from him and then moved on to a less naturalistic treatment of still life. In other words, he appears to have taken what he wanted from Cézanne and used it in a different way. We know Matisse admired Cézanne's use of colour to build form and his ability at the same time to express the essential flatness of painting. In the *Portrait with a Green Stripe* (Chapter 3 and colour plate section) Matisse achieves this, but in a more extreme and less naturalistic way than Cézanne would ever have countenanced.

Braque and Cézanne often painted similar subjects, and comparison within a particular genre can be very enlightening from the point of view of differences in interpretation. We could compare two landscapes such as Claude Lorraine's *Ascanius Shooting the Stag of Sylvia* (colour plate section) with Corot's sketch of *Le Petit Chaville at Ville d'Avray* (both discussed in Chapter 2). We could then see more clearly that Claude's painting presents an idealised view and Corot's is closer to what we might really experience. This is partly because Claude includes far more detail than you would actually see, because his is a highly finished painting and Corot's is an oil sketch. But this does not mean that Claude was not interested in studying from nature, as we saw in the example of his pen and wash drawing *View with Trees* (Chapter 7). Instead he wanted to convey a poetic rather than a literal meaning in his completed pictures. A comparison could help us to see this more clearly, especially as both pictures are in the same room at the Ashmolean Museum in Oxford. There, we can see the difference in scale between the two, as Claude's is large and Corot's very small. We have seen how important size can be in terms of how the spectator relates to a picture. Reproductions do not necessarily show this, as they are often photographed as if the works were the same size.

Another area where comparison can be particularly interesting is the question of continuity between the past and our own time. We have seen, for instance, that, although Raphael's *The School of Athens* and Jackson Pollock's *Autumn Rhythm* (both in Chapter 2) look completely different in terms of their subject-matter, style and technique, both artists are working on a large scale and are concerned with the interpretation and experience of space. The expressive power of colour is important in the work of both Van Gogh and Rothko (Chapter 5) and light matters to both El Greco (Chapter 4)

and Bruce Naumann (Chapter 5). Being able to tease out these threads can help to make twentieth-century art more comprehensible and that of the past less remote and alien.

Sometimes, though, it can be more appropriate to compare pictures from the same period if you want to consider similar preoccupations. In Chapter 3 we looked at Michelangelo's painting of *Jonah and the Whale* from the Sistine Chapel ceiling and Titian's *Portrait of a Man*. We discussed how they had arrived at contrasting ways of expressing the form of the human body in space. Here, though, there is a problem because these two artists were using the very different techniques of fresco and oil painting. Fresco will always have a chalky quality because it is painted on plaster. This is true whether it is *buon fresco*, where the pigment is put on the plaster while it is still wet and is bonded with it as it dries, or whether it is done *a secco*, when the plaster is already dry. With oils, on the other hand, the artist can achieve depth and luminosity of tone and colour through the use of glazes, where the colour is thinned with oil and applied in layers.

So, contrasts in technique must be taken into account when making comparisons, because of the way they can alter the appearance of a picture. For instance, the nature of watercolour is translucent whilst oils are more opaque. So, the surface of Thomas Girtin's *The White House at Chelsea* (Chapter 7) appears luminous and fragile, whereas Turner's *Interior at Petworth* (Chapter 1) seems more solid. Both artists convey light and atmosphere but in different ways, which are largely dictated by the techniques they are using. Oils lend themselves to impasto, where the variable thickness of the paint can help to convey form and space. The surface in the foreground of the *Interior at Petworth* is thicker than in parts of the background, whereas in Girtin's painting the washes make the surface more even.

Other techniques provide different effects, such as the grainy texture of aquatint (Goya, Chapter 8) or the matt surface of pastels (Degas, Chapter 7). However, oil paint is extremely versatile, and the smoothness of the surface in Caravaggio's *Supper at Emmaeus* (Chapter 4) is very different from the rougher appearance of Rembrandt's *The Jewish Bride* (Chapter 4). Oil paint can also be diluted with turpentine so that it is much thinner and can be made to behave more like watercolour. In reproduction, it is sometimes difficult to tell which is which; this is evident in the work of artists like Turner and Cézanne, who used both techniques. Modern acrylics, like those used by Andy Warhol in the *Twenty-Five Colored*

Marilyns (Chapter 6), are water-based paints which have the fluidity of watercolour and the flexibility of oils, but with a much flatter appearance. They do not have the depth and richness which can be achieved with oils. In tempera painting, the pigment is mixed with egg yolk and water; this gives it an enamel-like quality. It has a sheen, delicacy and sharpness of definition, which is very evident in Piero's *The Baptism of Christ* (Chapter 1). It would have been painted in thin layers with small soft brushes to create an unruffled surface. The size and texture of the brushes varies enormously, of course. Large soft heads are required for watercolour washes, and a variety of hog's hair and sable ones are used for oil painting. Also, of course, palette and painting knives are often used to lay oil paint down thickly to create impasto.

In this book we have looked at a wide variety of paintings, drawings and prints. We have analysed their visual characteristics and how they convey meaning to the spectator. In order to help the reader in a more practical way I have devised a series of questions to ask yourself when standing in front of a picture in an art gallery. They follow the layout of the book, starting with a consideration of composition and moving on to space, form, tone, colour, subject-matter and the original function and intended setting of the picture. There are also two questions which apply specifically to drawings and prints. Together, they are planned to provide a framework so that you can apply for yourself the visual exercises we have tried out in the book.

Pictures which are generally accepted as good or great can often provide us with a touchstone of quality. They can give us insights which we might not otherwise experience. We can be stimulated by them into questioning and considering aspects of the visual world which we might not have thought about. This applies more obviously to pictures with recognisable subjects, but it can also be experienced with non-figurative work. The process of looking at paintings, drawings and prints is contemplative. It does not require an instantaneous reaction. Through acquiring some critical and analytical visual skills we can learn discrimination and discernment. Above all, we can add a deeper dimension to our appreciation, knowledge and enjoyment of works of art without losing our sense of wonder and delight in them.

Appendix 1

Some questions to ask yourself when standing in front of a painting

Composition: Where are the dominant lines of organisation?

Space: Where are you in relation to the picture? Is it much larger or much smaller than you expected?

Form: Is there a three-dimensional feeling about the picture. If so, where is it? Is it in some parts of the picture and not others?

Tone: What part does light and dark play in the picture?

Colour: Is the colour part of the structure of the picture or is it used more for expression?

Drawings: Can you see how many different ways the artist has used the medium?

Prints: How much variety can you see in the tones? If it is a coloured print, how much variety can you see in the shapes and shades of colour?

Setting: Are you seeing the painting, drawing or print as it was intended to be seen or has its location and lighting been altered? How much has restoration changed the original?

Subject-matter: How does the subject-matter, or lack of it, affect the way you see the picture?

Appendix 2

Glossary of some art terms

This glossary cannot be like a comprehensive dictionary of language as applied to art. Apart from some technical terms, it aims to include words whose normal meaning is extended when applied to paintings, drawings and prints.

Abstract Often used to describe paintings which do not have a subject; can also refer to the abstract or pictorial qualities, such as composition, space, form, tone and colour discussed in Chapters 1 to 5 of this book.

Aerial perspective In which blue as a cool colour is added to the background of a picture to enhance the spectator's sense of distance. Especially used in landscape painting, where a warm brown foreground and a green middle ground increase the recessive effect of the blue. See discussion of Rubens and Claude in Chapter 2.

After-image The image of the complementary colour which you see *after* the colour you have just been looking at. See Introduction to Chapter 5.

Allegory see mythological and allegorical.

Aquatint Intaglio print-making technique often allied with etching. Both methods employ acid, but aquatint uses granules of gum to protect the copper plate rather than wax. Its most characteristic effects are a grainy texture and very subtle variations in tone. See Chapter 8.

Avant-garde The 'advance guard', out in front, forward-looking. Used since the nineteenth century to describe art which is in advance of public opinion and only understood by members of artistic circles who know how to look at it.

Braccio A unit of measurement about 58 cm or 23 in. Used by Alberti in his description of linear perspective as a unit of measurement equivalent to about one-third of the height of a man.

Brightness/dullness Terms used to describe qualities of colour which are not tonal in the sense of being darker or paler.

Brushwork A general term to describe the texture of painting through the marks a particular brush makes. It may be rough, smooth, detailed, broad, fluid or flexible. Words like these are not precisely used, but some, like **impasto**, for example, are more specific.

Buon fresco See **fresco**.

Burin Plate cutting or scribing tool used in metal engraving. See Introduction to Chapter 8.

Camera obscura Like a simplified form of modern camera, except that the image is not fixed. The light from an object or a view which the artist wants to use comes through a hole in the side of a closed box and its image appears upside down on the opposite side. Inside the box, a mirror is placed at an angle from which the image is reflected the right way up. The artist can then trace off the outline to record his composition. See Chapter 1 on Vermeer and Figure 1 (p. 9).

Canvas A material upon which oil paint is used. Its roughness or smoothness is important for the final surface effect of the painting. So also is the priming – the colour put on first as the **ground**.

Cartoon A highly developed drawing done in preparation for a final painting. The design would then be transferred to the wall or panel by pricking through the paper and making a mark. Hence the expression 'pricked for transfer'. Can also refer to tapestry designs as tapestry cartoons.

Chiaroscuro An increased tonal range from very dark to very light invented by Leonardo da Vinci, particularly for conveying form. See Chapter 3.

Claude glass A piece of smoked glass used by artists to enable them to concentrate on the tones and a reduced amount of detail in a landscape. Named after Claude Lorraine. See section on Claude's landscape drawings in Chapter 7.

Collage, combine, composite image Found objects, photographs or other kinds of discarded material are arranged on a flat surface to form a composite image. It is a twentieth-century invention developed by Picasso and Braque in 1912. It has been used by many artists, including Kurt Schwitters in his **Merz** constructions and by Rauschenberg in his combines. See Chapters 1 and 3.

Colour field An area of flat saturated colour all over the surface of the picture. Usually applies to large abstract pictures like those of Rothko, but also used by Miró. See Chapters 1 and 5.

Colourist A term used to describe an artist who uses colour as his main means of expression. See Introduction to Chapter 3 and Chapter 5.

Complementary colours See entry on **primary and complementary**.

Construction A loose term which can be used to describe the compositional organisation and structure of a picture. Sometimes refers to works which are not carved or modelled and where the borderline between painting and sculpture has become blurred. Some types of **collage**, in which three-dimensional materials like wood are applied to the surface of the picture, are called constructions. See Chapters 1 and 3.

Contrast see **Primary and complementary**.

Cross-hatching A means of introducing tonal values by lines of varying density moving across the form in a drawing. Common in Renaissance drawings. See Chapter 7.

Distemper A paint in which powdered pigment is combined with animal glue or size. It is mostly found on painted scenery. Mantegna painted with it on linen and Degas used it as a base for some of his **pastels**.

Divisionism, Neo-Impressionism, Pointillism A technique invented by Georges Seurat to combat the lack of structure in Impressionist painting. It involved painting with spots or small strokes of primary and complementary colour which are all of equal size. The surface of the picture is thus more disciplined and controlled and the image becomes clearer. See section on Renoir and Seurat in Chapter 3.

Draughtsman Refers to an artist for whom drawing is of prime importance. It can also imply a preference for line over colour. See Introduction to Chapter 3.

Engraving on metal or wood Metal engraving is an **intaglio** method and wood engraving a relief method. Metal engraving involves gouging lines in a metal plate with a **burin**; the ink lies in the lines. In wood engraving the ink adheres to the raised parts of the design. See Introduction to Chapter 8.

Etcher's needle A thin shaft of metal with a point on the end for cutting through the wax and into the plate.

Etching An **intaglio** method of print-making where a copper plate is covered with wax. The artist draws into it with an etcher's needle to reveal the metal. Then the plate is dipped in a bath of acid and the areas where the metal is exposed are eaten away. The plate

is then cleaned and ink is rolled over it to fill up the recessed parts. See Chapter 8 for a fuller explanation and the difference between hard and soft ground etching in the section on Piranesi.

Foreshortening Where a figure or an object is depicted head-on. In order to create the effect of recession, the artist shortens a figure or an object to make it appear in the painting as you would see it. Sometimes this involves a certain amount of distortion. See section on Uccello in Chapter 2 and on Michelangelo in the Introduction to Chapter 3.

Foxing Dark marks or discolouration on paper usually caused by damp or fungal growth. See Introduction to Chapter 7.

Fresco A technique for decorating walls and ceilings which involves painting with pigment dissolved in water directly onto the plaster. There are two main ways of doing this. **Buon** or true fresco, in which the paint is put on fresh plaster so that as it dries the two bond chemically together, or fresco *a secco*, in which the paint is put on dry plaster. The first lasts much longer than the second because the paint becomes integral with the wall or ceiling, as long as it does not become damp and make the plaster crumble. See Conclusion.

Fresco cycle A series of frescos in which a story is usually told or a set of ideas expressed. See Introduction to Chapter 3 on Masaccio and Michelangelo and section on Raphael and Andrea del Pozzo in Chapter 2.

Genre A term to describe different types of subject-matter. Also used to refer to pictures of everyday scenes. See section on Vermeer in Chapter 1 and the discussion of subject categories in the section on Poussin in Chapter 6.

Gesso An Italian word for fine plaster mixed with glue which is put onto a wooden panel as a base for painting. It is most commonly found in tempera paintings, but can be used for oils on panel as well. Respective examples would be *The Baptism of Christ* in Chapter 1 and *The Rainbow Landscape* in Chapter 2.

Glazes Used in oil painting to create luminosity. The pigment is thinned down so that light can travel through it. Used by most artists in oil paintings to a greater or lesser extent, particularly the Old Masters. Rembrandt is an outstanding example. See Chapter 4 and Conclusion.

Golden section The proportion of roughly three-eighths to five-eighths whose exact mathematical calculation is complex. It is a proportion whose regularity occurs not in its measurement into equal parts like a half or a quarter or a third, but in the fact that the

relationship of the small part to the large part is the same as the large part to the whole. See section on Piero della Francesca in Chapter 1.

Gouache Opaque watercolour.

Grisaille Tonal painting in shades of grey. Can also refer to preparatory compositional studies. See section on Mantegna in Chapter 3 and on Gainsborough and Constable in Chapter 4.

Ground The colour spread over the canvas or paper first. This process is important for colour, because if the ground is dark, the colour will appear more opaque, and if light, more luminous.

Highlights Another word for describing the palest tones in a painting. Points out where the light is falling, even if it comes from several different directions. See Chapter 4.

History painting Heroic and high-minded subject-matter from the past, especially from classical times. See section on Poussin in Chapter 6.

Horizon line In the organisation of perspective, this creates the furthest limit of space within the picture.

Hue The **intrinsic** character of a colour. See Introduction to Chapter 5.

Iconography Connected with the understanding of subject-matter and its meaning, with particular reference to painting of the past. The study of what a subject meant to the patrons and spectators of the period in which a painting was made. See section on Botticelli in Chapter 6.

Iconology A broader term than iconography, referring to the study of **symbols** and the development of their meaning in the visual arts.

Ideal and idealisation Making objects or people more beautiful than they really are. It achieves a kind of generalisation, so that the representation of a tree, for example, can stand for all trees. This would be true of ideal landscape, as in Claude's *Ascanius Shooting the Stag of Sylvia* in Chapter 2, or of idealised womanhood, as in Leonardo's *The Virgin and Child with St Anne* in Chapter 3. As an idea it goes back to Classical times. Connected with the concept of perfection in terms of looks and proportion. Revived in the Renaissance particularly by the Neo-Platonists. It is related closely to Poussin's theory of the 'Grand Manner', see Chapter 6.

Illusion and illusionism Illusion relates to the depiction of space and form, particularly in creating the appearance of three dimensions on a flat surface. Illusionism, on the other hand, suggests that the onlooker no longer knows where the illusion begins and ends.

The same applies to trompe-l'oeil effects. See section on Andrea del Pozzo and illusionistic ceiling decoration in Chapter 2.

Impasto The technique, which usually refers to oil painting, where the paint itself becomes thicker in order to convey form. It stands out from the surface of the **canvas** and creates a feeling of solidity. **Palette knife**, fingers or brush can be used to achieve this. Rembrandt in Chapter 4 and Van Gogh and Bonnard in Chapter 5 are good examples, but so are many other artists. It is difficult to show it in reproduction but it is a characteristic to look for when viewing oil paintings in the original.

Intaglio A generic term for print-making where the ink lies in the areas of the plate which have been cut away. See Introduction to Chapter 8.

Intensity When applied to colour it means that the power of colour may be increased by the colours that are put next to it. See Introduction to Chapter 5.

Intrinsic see **hue**.

Life class Where a group of art students come together to draw the nude human figure with an artist/teacher to set the poses and guide the students.

Life drawing Drawing from the human figure posed nude in the studio. Encourages the co-ordination of hand and eye through constant practice. Develops the ability to interpret the complex forms of the body. A central tenet of the academic training which emphasised the importance of drawing and the control of tone to express form and space. It fell out of favour in art schools in the last decade or so, but is now returning. Most artists agree that it is a necessary discipline and skill. See the Introduction and relevant sections in Chapter 6.

Life model The person who poses nude in the artist's studio. It requires certain skills, like sitting still, of course, but also the ability to hold the same pose for long periods and to go back into it accurately after a break. The short pose is also important, and so the model needs to have the flexibility to move from one pose to another in quick succession.

Linear A term used to describe paintings where drawing is regarded as more important than colour. See the comparison between Ingres and Delacroix in Chapter 5 and in the Introduction to Chapter 3.

Linear or single-viewpoint perspective A geometrical system for creating the illusion of space on a flat surface. Diagonal lines of

direction called **orthogonals** converge at what is called the **vanishing point**, which is most usually placed on a horizontal line about half to two-thirds of the way up the picture. Parallel lines are then drawn across at intervals, which get closer together as they get nearer to the vanishing point. These are called planes and the one nearest to you and the surface of the picture is known as the picture plane. See Introduction and sections on Uccello and Raphael in Chapter 2.

Lithography A planar technique for making prints based on drawing on a stone or plate rather than incising it. A drawing in greasy crayon is made on a stone or zinc surface which is then wetted so that the greasy printing ink sticks only to the drawn sections. This can be done in black and white or colour. See Introduction and sections on Daumier and Toulouse-Lautrec in Chapter 8.

Merz A term used by Kurt Schwitters to describe his work. He arrived at it when fitting the letterhead of the Commerz und Privatsbank cut out of a newspaper into one of his collages. It exemplifies the idea of using rubbish to make compositions and expresses the anti-establishment attitudes of the Dada movement, with which Schwitters was loosely connected.

Modulation Most commonly used in connection with colour rather than tone. Refers to subtle variations in colour which depend on altering the brightness, dullness, opacity, translucence, warmth and coolness of a hue to achieve a feeling of form. This method is particularly associated with Cézanne (see Chapter 2) but could be discussed in relation to other colourists, too, such as Delacroix or Bonnard in Chapter 5.

Monochrome or monochromatic Black and white or single colour. Drawings and prints are mostly monochrome because they usually only use black and white or a single colour in varying tones. The term can be applied to painting in some contexts as in *grisaille*, for instance.

Multiple-viewpoint perspective Paintings which include more than one viewpoint for their depiction of space and form. See sections on Cézanne, Picasso and Pollock in Chapter 2 and Braque in Chapter 4.

Mythological and allegorical Adjectives used to describe subject-matter taken from the myths of the ancient world as written down by classical poets like Ovid in the *Metamorphoses*. When mythological, the subject-matter is narrative in the sense that it tells a story. Very closely related is the allegorical subject, where the story is told as a metaphor for the communication of an idea. See section

on Botticelli's *Primavera*, which has mythological and allegorical meaning, in Chapter 6.

Neo-Impressionism see **divisionism**.

Non-figurative Pictures without a recognisable subject. A more specific way of describing abstract painting.

Odalisque A female nude form from the East; similar to a Venus figure in the European tradition and represented in an Eastern setting. The term applies particularly to the work of Ingres and the so-called Orientalists of the nineteenth century, who were mostly fascinated by North Africa. It is not usually used to describe the Tahitian nudes of Gauguin. See Chapter 5.

Oil painting A technique where the pigment is mixed with oil in varying amounts and a solvent like turpentine. It can be thinned down to make glazes or mixed thickly to create **impasto.** Dries more slowly and so is altogether more flexible than other techniques; if you change your mind you can scrape it all off and start again. Most commonly used on canvas or panel.

Oil sketch Usually a small oil painting done in preparation for a picture or as a landscape outside, or simply to record an idea. Making oil sketches was regarded as an important stage in the preparation of academic paintings and it has a long history in that context. It offers the opportunity for a more spontaneous and expressive way of painting. In the nineteenth century it became particularly important in discussions about what constituted a finished picture. Impressionist paintings, for instance, were criticised as unfinished. See sections on Géricault in Chapter 1, on Corot in Chapter 2 and on Renoir in Chapter 3.

Opaque A word used to describe density in colour. Also for techniques like pastel or gouache which are not translucent. It could also be applied to fresco painting.

Orthogonal The name given to the diagonal lines which meet at the vanishing point in the linear perspective system.

Painterly The opposite of linear. A term which loosely describes those paintings in which colour, brushwork and the achievement of texture are more important. See introduction to Chapter 3.

Palette knife Strictly speaking, this is the thin-bladed unsharpened knife used to put the paint onto the artist's palette and to mix the colours. But, in discussing paintings, it is more often used to describe a technique in which a variety of different types of blade are used instead of or in addition to the brush. See section on Courbet in Chapter 3.

Panel A surface for painting on with either tempera or oils. Made of wood, particularly oak or poplar. Sometimes carved beforehand so that the frame and the panel itself are integral with one another. See section on Masaccio and Pisanello in Chapter 6.

Panoramic Most commonly applied to a type of landscape in which the spectator's view extends almost endlessly into the background of the picture and the foreground is made wider than you would actually see it. The viewpoint is often from slightly above, as if standing on a hill. Aerial perspective is used to enhance the effect of the far distance. See Chapter 2 on Rubens.

Pastel A pigment bound in glue so that it becomes solid like chalk. As in gouache, the colours are opaque. Although you hold it like a chalk or crayon, the effect is more like painting, so it is sometimes referred to as pastel painting. See section on Degas in Chapter 7.

Pictorial The characteristics or elements in a picture which are connected with its visual qualities such as composition, space, form, tone and colour discussed in the first five chapters of this book.

Picture plane In linear perspective it is the horizontal line nearest the viewer which corresponds with the surface of the picture. You look through it as if through a pane of glass. But it can be disrupted in various ways through illusionism and the creation of space in front of it rather than behind. See Chapter 2.

Planar Methods of print-making, like lithography, which do not involve indenting the surface of the plate.

Planes The horizontal lines which recede at diminishing intervals towards the horizon in linear perspective. The planes of a three-dimensional object are the directions of its different surfaces. See Chapter 2.

Plasticity Modelling. The conveying of three-dimensional qualities generally. Sometimes referred to as sculptural; in this sense, the term plastic can be applied to sculpture and architecture as well as painting. All three can be referred to as the plastic arts.

Plein-air painting Painting out of doors. Most often associated with the Impressionists, but had been done by many artists before, such as Constable.

Poesie A type of picture in which the feeling it conveys is more important than any moral or narrative content. See section on Watteau and the following section and conclusion in Chapter 6.

Pointillism See **Divisionism**.

Polyptich A many-panelled structure, usually for an altarpiece, in which a number of pictures are placed together. The diptych is

similar but with two panels and the triptych has three. See section on Masaccio in Chapter 6 and Figure 4 (pp. 138–9).

Predella Small panels below the main altarpiece picture.

Primary and complementary colours The constituents of white light as revealed through the prism or in a rainbow. There are seven prismatic colours: red, yellow and blue are the primaries, and green, orange, indigo and violet are the complementaries. All these colours contrast with one another, but the strongest contrasts are between the primaries and complementaries. See Introduction to Chapter 5.

Pyramidal composition An arrangement of figures in the form of a pyramid. Popular with artists like Leonardo and Raphael. See section on Leonardo in Chapter 3.

Quadratura An italian word for illusionistic architectural painting, particularly related to wall and ceiling decorations. See section on Pozzo in Chapter 2.

Registering A term used in print-making where more than one plate is involved, as in colour printing. After the first plate is printed, it means making sure that subsequent ones will be positioned in the right place.

Relation(ship) Relating objects together visually in a picture by means of the pictorial elements, so that they create a unity which is aesthetically pleasing to the eye.

Relief Usually refers to a type of sculpture in which the forms are presented within a frame. Can also be applied to painting, in the sense of achieving a feeling of form or imitating sculpture. See section on Mantegna in Chapter 3

Repoussoir From the French word meaning 'to push back'. The effect of using dark and well defined objects in the foreground of a picture to increase the feeling of recession. See section on Claude in Chapter 2.

Rhythm The creation of connected movement through the picture to enhance its unity and vitality. See section on Fragonard in Chapter 1.

Saturated A term for colour which is concentrated and undiluted. It cannot be added to any more, like a material which is completely soaked.

Screen printing and serigraphy A stencil method of making prints where the design is stamped out of protective sheets and the ink is pressed into the vacant spaces with a squeegee.

Sfumato From the Italian word for smoke: *fumo*. The technique

for softening the edges of objects to increase the feeling of life and movement. See section on Leonardo in Chapter 3.

Shade Used in preference to tone when describing a colour as darker or lighter. But like many of these terms in relation to colour, it is not precise. The term tint is used in a similar way.

Sotto in su Italian for 'below upwards'. The exact expression is *di sotto in su*, meaning 'from below upwards'. Applied particularly to illusionistic ceiling decorations where the viewer looks up from below and sees foreshortened forms which appear to be suspended in space. See section on Pozzo in Chapter 2.

Squeegee A rubber flap on a wooden handle for pressing ink into the stencilled spaces in a screen print.

Stencil A method of printmaking where the design is stamped out of a protective sheet. See **screen printing** and **serigraphy**.

Symbols and symbolism Using an object from the visual world to represent an idea, like the corn in the hair of the *Portrait of the Duchess of Chinchon* by Goya (see Chapter 8) to represent fertility because she was pregnant at the time the portrait was painted. Very prevalent in religious art. In the late nineteenth century symbolism had more to do with the power of suggestion. See section on Gauguin in Chapter 5.

Tactile The feeling that if you put your hand out you could touch something in a picture. Applies particularly to form and texture.

Tempera A technique where the pigment is mixed with egg yolk and water. Painted usually on panel covered with a **gesso** ground.

Tenebristi Tenebrous or shady, from the Italian for shadow. Describes those artists who followed Caravaggio in their dramatic use of chiaroscuro. Particularly characteristic are the dark obscure backgrounds from which light figures or objects emerge. See section on Caravaggio in Chapter 4.

Tint see **shade**.

Tonal range The variety and extent of tonal variation between very dark and very pale.

Tonal value The weight that a particular tone carries in the over-all range of light and dark in a painting, drawing or print.

Topographical A type of picture in which the aim was to record a particular place or building in great detail. Often a drawing with a watercolour wash. See section on Paul Sandby in Chapter 7.

Torso The human body excluding the head, arms and legs.

Translucent Usually applied to colour which can be seen through, as in thin watercolour washes. See section on Girtin in Chapter 7.

Triptych see **Polyptich**.

Vanishing point In linear perspective, the point where the orthogonals converge.

Viewpoint The position in which the spectator is supposed to be standing in relation to a picture.

Warm and cool colours Within the spectrum some colours are warm and have a shorter wavelength and others are cool and have a longer one. When placed in a picture, the warm ones will tend to come forward and the cooler ones stay back. See sections on Turner in Chapter 1 and on Matisse in Chapter 3.

Wash A thin or well-diluted use of watercolour applied with large soft brushes to achieve an effect of luminosity.

Watercolour Pigment mixed with water and a soluble glue and used usually on paper. A fluid medium which dries quickly, where the lightest areas are made by dilution with water, allowing the pale paper to show through, rather than by the addition of white.

References and further reading

This is not a bibliography in the usual sense because it would be impossible to acknowledge all the different kinds of sources I have consulted. But there are some books which have been directly referred to in the text and they are listed, together with a selection of others which have been included for further exploration. The titles are divided into different groups under headings in order to help the reader to see how they might be used. It is intended as an *aide mémoire* rather than a comprehensive reading list.

OTHER BOOKS ABOUT LOOKING AT PICTURES

Berger, John, *Ways of Seeing* (BBC Publications and Penguin Books, 1972).

Clark, Kenneth, *Looking at Pictures* (John Murray, 1960).

James, Merlin, *Engaging Images* (Menard Press, King's College, London, 1992).

Lynton, Norbert, *Looking into Paintings* (Open University Press and Channel Four, 1985).

Welton, Jude, *Looking at Paintings: Eye Witness Art Series* (Dorling Kindersley in association with the National Gallery, London, 1994).

Woodford, Susan, *Looking at Pictures: Cambridge Introduction to the History of Art* (Cambridge University Press, 1983).

GENERAL AND REFERENCE BOOKS

Chipp, Herschel B.(ed.), *Theories of Modern Art* (University of California Press, 1968).
A useful collection of extracts from the writings of twentieth-century artists.

Clark, Kenneth, *Civilization* (BBC Publications and John Murray, 1969).

Clark, Kenneth, *Landscape into Art* (Harper & Row, 1979).

Clark, Kenneth, *The Nude* (John Murray, 1956).

Gage, John, *Colour and Culture:* (Thames & Hudson, 1993).
A fascinating history of the changing attitudes to colour from ancient times to the present day.

Gombrich, E.H., *The Story of Art* (Phaidon, 1960, new edition 1995).

Hale, J.R. (ed.), *Encyclopedia of the Italian Renaissance* (Thames & Hudson, 1989).

Hall, James, *Hall's Dictionary of Signs and Symbols in Art* (John Murray, 1985).
Contains clear descriptions of different types of subject and their meaning.

Harvey, Sir Paul (ed.), *The Oxford Companion to Classical Literature* (Oxford University Press, 1980).

Holt, Elizabeth G., *A Documentary History of Art, Volumes 1–3* (Doubleday Anchor Books 1986).
A useful selection of extracts from the writings of artists and their contemporaries up to the end of the nineteenth century. There are references to the original sources. Many of the quotations used in *Learning to Look at Paintings* come from volumes 2 and 3 of this book.

Langmuir, Erika, *The National Gallery Companion Guide* (National Gallery Publications, 1994).

Osborne, Harold (ed.), *The Oxford Companion to Art* (Oxford University Press, 1970).

Osborne, Harold (ed.), *The Oxford Companion to Twentieth Century Art* (Oxford University Press, 1981).

Osborne, Harold (ed.), *The Oxford Dictionary of Art* (Oxford University Press, 1988).
The first two are very helpful because they are more than dictionaries, having very informative shorter and longer essays on often complex subjects which make them closer to encyclopedias. The third one has shorter entries, some of which are not included in the two companions.

Rodman, Selden, *Conversations with Artists* (Capricorn Books, 1961).
A useful supplement to Holt's *A Documentary History of Art* and Chipp's *Theories of Modern Art* referred to above.

WRITINGS BY ARTISTS AND THEIR CONTEMPORARIES DISCUSSED IN THE TEXT

Alberti, Leon, Battista, *Treatise on Painting*, ed. Martin Kemp (Penguin, 1991).

Baudelaire, Charles, *Les Fleurs du Mal*, trans. Alan Conder (Cassell, 1952).

Baudelaire, Charles, *The Painter of Modern Life and other Essays*, trans. and ed. Jonathan Mayne (Phaidon, 1964).

Cézanne, Paul, *Letters*, ed. John Rewald (Bruno Cassirer, 1978).

Constable, John, *Letters*, (Suffolk Records Society, 1964).

Delacroix, Eugène, *Journal*, ed. Hubert Wellington, trans. Lucy Norton (Phaidon, 1951).

Degas, Edgar, *Letters*, ed. Marcel Guerin (Bruno Cassirer, 1947).

Friedenthal, Richard (ed.), *Letters of the Great Artists* (Thames & Hudson, 1965).

Gauguin, Paul, *Intimate Journals* (K.P.I. Ltd,1985).

Kandinsky, Wassily, *Concerning the Spiritual in Art*, trans. Ralph Manheim, *Documents of Modern Art Vol. 5* (George Wittenborn, 1947).

Leonardo da Vinci, *Leonardo on Painting*, ed. Martin Kemp, selected and trans. Martin Kemp and Margaret Walker (Yale University Press, 1989).

Michelangelo, Buonarroti, *Complete Poems and Selected Letters*, ed. Robert N. Linscott, trans. Creighton Gilbert (Princeton University Press, 1980).

Mondrian, Piet, *Plastic Art and Pure Plastic Art*, ed. Robert Motherwell, *Documents of Modern Art Vol. 1* (George Wittenborn, 1951).

Van Gogh, Vincent, *The Complete Letters of Vincent Van Gogh* (Thames & Hudson, 1958).

Vasari, Giorgio, *Lives of the Artists: A selection*, trans. George Bull (2 vols; Penguin Classics, 1987).

A FEW USEFUL BOOKS ON TECHNIQUE

Gascoigne, Bamber, *How to identify Prints* (Thames & Hudson, 1991).
A comprehensive guide with a detailed glossary.

Hayes, Colin, *The Complete Guide to Painting and Drawing Techniques and Materials* (Phaidon, 1986).
A very useful reference book because it includes drawing as well as painting techniques with good explanatory illustrations.

Martin, Judy, *The Encyclopedia of Print Making Techniques* (Quarto, 1993).

CATALOGUES OF EXHIBITIONS AND COLLECTIONS

A very good source of information, particularly about more recent art. Here is a selection relevant to the art and artists discussed in the text. They are often contributed to by a multiplicity of authors so they are listed alphabetically by subject.

American art of the Twentieth Century (Royal Academy of Arts, London, 1993).

The Berggruen Collection (National Gallery, London, 1991).

Bonnard at Le Bosquet (Hayward Gallery, London, 1994).

British art of the Twentieth Century (Royal Academy of Arts, London, 1987).

Claude: The Poetic Landscape (National Gallery, London, 1994).

Constable (Tate Gallery, London, 1991).

Daumier, Honoré: The Armand Hammer Daumier Collection (Royal Academy of Arts, London, 1981).

Dix, Otto (Tate Gallery, London, 1992).

Gainsborough, Thomas (Tate Gallery, London, 1980–1).

German Art of the Twentieth Century (Royal Academy of Arts, London, 1985).

Goldsworthy, Andy: Retrospective Exhibition, 1990–1 (book of photographs published by Viking).

Goya and the Spirit of Enlightenment (The Prado Museum, Madrid; Boston Museum of Fine Arts; Metropolitan Museum of Art, New York. Bullfinch Press, 1989).

Great Age of British Watercolours, the (Royal Academy of Arts, 1993).

Hogarth, William (Tate Gallery, London, 1971).

Hokusai: Prints and Drawings (Royal Academy of Arts, London, 1991–2).

Impressionist and Post-Impressionist Masterpieces in the Courtauld Collection (Yale University Press, 1987).

Johns, Jasper: Drawings (Hayward Gallery, London, 1990–1).

Leonardo da Vinci: Drawings (Hayward Gallery, London, 1989).

Moore, Henry (Royal Academy of Arts, London, 1989).

Oldenburg, Claes (Tate Gallery, London, 1970).

The Orientalists: Delacroix to Matisse (Royal Academy of Arts, London, 1984).

Pop art (Royal Academy of Arts, London, 1991).

Post-Impressionism (Royal Academy of Arts, London, 1980).

Poussin, Nicholas (Royal Academy of Arts, 1995).

The Pre-Raphaelites (Tate Gallery, London, 1984).

Riley, Bridget (Hayward Gallery, London, 1971).

Rothko, Mark (Tate Gallery, London, 1987).

Schwitters, Kurt (Tate Gallery, London, 1985).

Toulouse-Lautrec (Hayward Gallery, London, 1992).

Turner (Tate Gallery, London, 1974).

Vermeer, Johannes (Mauritshuis, The Hague, 1996).

SOME USEFUL HISTORY OF ART BOOKS ABOUT PERIODS AND ARTISTS REFERRED TO IN THE TEXT

Blunt, Anthony, *Artistic Theory in Italy* (Oxford University Press, 1962).

Bowness, Alan, *Modern European Art* (Thames & Hudson, 1972).

Dunkerton, Jill, Foister, Susan, Gordon, Dillian, Penny, Nicholas, *From Giotto to Dürer: Early Renaissance Painting in the National Gallery* (Yale University Press and the National Gallery, 1991).

Gombrich, E.H., *Norm and Form: Studies in the Art of the Renaissance* (Phaidon, 1966).
In particular, see the essay on 'The Renaissance Theory of Art and the Rise of Landscape'.

Gombrich, E.H., *Symbolic Images: Studies in the Art of the Renaissance* (Phaidon, 1972).
In particular, see the essay on 'Botticelli's Mythologies'.

Herbert, Robert, L., *Impressionism: Art, Leisure and Parisian Society* (Yale University Press, 1988).

Hirst, Michael, *Michelangelo and his Drawings* (Yale University Press, 1988).

Lavin, Marilyn Aronberg, *Piero della Francesca* (Thames & Hudson, 1992).

Levey, Michael, *Rococo to Revolution: Major Trends in Eighteenth-Century Painting* (Thames & Hudson, 1992).

Murray, Linda, *The High Renaissance and Mannerism: Italy, the North and Spain* (Thames & Hudson, 1990).

Murray, Peter and Linda, *The Art of the Renaissance* (Thames & Hudson, 1989).

Myers, Bernard, *Expressionism* (Thames & Hudson, 1963)

Rosenberg, Jakob, Slive, Seymour, Terkuile, E.H., *Dutch Art and Architecture: 1600–1800* (Pelican History of Art, Penguin, 1991).

Rosenblum, Robert and Janson, H.W., *Art of the Nineteenth Century: Painting and Sculpture* (Thames & Hudson, 1984).

Russell, John, *The Meanings of Modern Art* (Thames & Hudson, 1981).

Vaughan, William, *Romanticism and Art* (Thames & Hudson, 1994).

Waterhouse, Ellis, *Painting in Britain: 1530–1790* (Pelican History of Art, Penguin, 1988).

Wilde, Johannes, *Venetian Art from Bellini to Titian* (Oxford University Press, 1981).

Wittkower, Rudolf, *Art and Architecture in Italy: 1600–1750* (Pelican History of Art, Penguin 1986).

Index

Note numbers in bold refer to plates. Plates without a number in bold are in the colour plate section between pp. 114–15.